THE ARTISTS'
SURVIVAL MANUAL

Toby Judith Klayman
with Cobbett Steinberg

THE ARTISTS'
SURVIVAL MANUAL
A Complete Guide to
Marketing Your Work
Updated Edition

Charles Scribner's Sons · New York

Charles Scribner's Sons
Macmillan Publishing Company
866 Third Avenue, New York, NY 10022
Collier Macmillan Canada, Inc.

Library of Congress Cataloging-in-Publication Data
Klayman, Toby Judith.
 The artists' survival manual.
 Includes index.
 1. Art—Marketing. I. Steinberg, Cobbett.
II. Title.
N8600.K53 1987 706'.8'8 87-9623

ISBN 0-684-18882-1

Macmillan books are available at special discounts for bulk purchases for sales promo-
tions, premiums, fund-raising, or educational use.
For details, contact:
 Special Sales Director
 Macmillan Publishing Company
 866 Third Avenue
 New York, NY 10022

10 9 8 7 6 5 4

Printed in the United States of America

For Larry Friedlander,
whose constant search for knowledge
has been a great example to me

CONTENTS

PREFACE

The first edition of this book was published in February 1984. It was born from years of hard work as an artist and years of hard work as a businessperson—years during which I repeatedly wrestled with the complicated notions of "success" and "failure." I am happy to say that, after all these years, I know that I am a success because I am still doing what I love to do: making my work. But it has not always been easy, and I remain fascinated by the puzzle of how to live my life as an artist. In many ways, this book documents my ways of "solving" this puzzle.

Over the years, I have come to realize that there is no magic formula for artists: connecting art and business is usually, if not always, a difficult task. This book is for artists who do in fact want to try that connection, who believe that the business world of art might be a useful way of keeping the work life itself going. I originally wrote this book to share some of the information I've learned about the art-and-business connection, and I have recently updated it to address some of the new tax laws, but no one can really be an "expert" in this field. No one can devise a foolproof formula for "making it" in today's can-you-climb,

who-do-you-know, how-can-you-get-ahead art world. It's im-
portant to remember that many artists (myself included at times)
might understandably find the entire ''machinery'' of the busi-
ness world unfulfilling and of little value—that ultimately what
counts is the work itself and not the selling thereof. Thus, my
hope for this book is this: may it give you the ability to enter
the business world knowledgeably and may it also give you the
courage to remember that the art-and-business connection is only
an option, not a necessity.

San Francisco TOBY JUDITH KLAYMAN
March 1987

ACKNOWLEDGMENTS

In 1980, when I was guest lecturing on artists' rights in Santa Barbara, Gary Sampson of the Santa Barbara Arts Services suggested that I write a book based on my lectures. Following his advice, I contacted the California Arts Council and proposed a series of articles on artists' problems; the Council generously approved the project. Without the Council's funding and the kind support of its administration and staff (especially William B. Cook, Gloriamalia Flores, Paul Minicucci, and Les Johnson), *The Artists' Survival Manual* would not have been possible.

Numerous individuals and organizations provided further help during the planning, researching, and writing of this book. Bernard Dietz of the United States Copyright Office, Shirley Levy of the Boston Visual Artists Union, and Barbara Kibbe of the Bay Area Lawyers for the Arts gave many valuable suggestions on copyright. Monona Rossol of the Center for Occupational Hazards provided a wealth of information on health hazards. San Francisco photographer Richard Goldwach answered many questions about photography. California attorneys Steven Riskin, Marilyn Garber, and Richard Harmon generously handled the bulk of my legal questions, and gave this project great sup-

port. Framer Patrick Reilley and conservators Steve Shapiro and Anita Noennig supplied useful information on the care and preservation of artwork. The Center for Arts Information in New York, the Chicago Artists Coalition, the Boston Visual Artists Union, and the Atlanta Art Papers provided great assistance with the book's appendices, as did both Sandy Steely, who spent many long hours compiling the bibliography, and David Pineo who organized and typed it. I should like to give special thanks to the Bay Area Lawyers for the Arts (BALA), its current board of directors, its staff (especially Alma Robinson, Nan Budinger, Claire Boddy, Loren Partridge, and Paul Kleyman), and its former board members (especially Hamish Sandison, Jerry Carlin, and Arlene Goldbard). BALA's services, presence, and indefatigable support have been of incalculable value to *The Artists' Survival Manual.*

This book stems from an artists' survival seminar I have been teaching since 1974 at the Fort Mason Art Center in San Francisco. Without the support of the many students who have passed through my Friday Seminar during the past ten years, I don't think I would have been able to write this book. These students gave me the opportunity to examine (at great length and in considerable detail) the problems of being an artist in contemporary America. The students' stories, opinions, and ideas have been invaluable not only to *The Artists' Survival Manual,* but to my own survival. Although it would be impossible to name the many, many students who have graced my seminar and influenced this book, I should like to thank a few who have been attending the seminar almost from its beginning: Antonia Anderson, Lorraine King, Carol Martin Davis, S. Elizabeth Raybee, Lewis H. Siegel, Sandy Steely, John Detweiler, Joni Eisen, E. Randall Keeney, JoAnn Lamb, Leslie Wasserberger, Cleo Laimyn, Le R. Williams.

I should also like to thank Dr. Alfred J. Azevedo, Dr. Carolyn Biasiadecki, Francis Baron, and George Schell of the San Francisco Community College District for supporting the seminar and for allowing me to teach it as I thought it should be taught.

Over the years, I have of course discussed "survival issues" with many artists outside my seminar, and I should like to thank some of them for their ideas, example, and inspiration: Ruth Asawa, Lenwood Sloan, Norma Fox, Marilyn Hill, Lyn Freeman, Geoff Spence, Mary Stofflet, Rick Rodriguez, Karen Sherr, Ilka Hartmann, Philippe Burdet, Katina Sifakis, Dick Stroud, Jim Woodman, Shirley Levy, A. J. Holmes, Elio Benvenuto, Eva Bovenzi, Lew Thomas, Jack Greene, Crawford Barton, and Larry Fixel.

This book has been more than three years in the making, and has, needless to say, entailed its fair share of doubts, confusions, and uncertainties. During this time, I have fortunately enjoyed the strong and loyal support of many wonderful friends, most notably Ira Rosenberg, Jan Link, Bob Owen (who first got me interested in artists' legal rights nearly fifteen years ago), Jill Owen, Mae Margaret Nettles Van Loan, David J. Macy, John Levin, Sofia and Aspasia Manusachi (whose village home in Crete provided me with great memories and warm friendship during part of the writing of this book), and Haden Peterson. I also thank my parents, Estelle and Max Klayman, for the obvious: they gave me my life and the power to carry it on.

My literary agent, Barbara Lowenstein, deserves much acknowledgment for her faith in this project, as does my editor, Susanne Kirk, who edited the manuscript with exemplary care and grace. And a very special thanks to my friend and collaborator Cobbett Steinberg, without whose hard work and organizational skills this book would have been impossible to write. I shall also like to thank the many artists I have met since the first edition of this book was published for their wonderful feedback.

THE ARTISTS' SURVIVAL MANUAL

1

ARE YOU READY
TO MARKET YOUR WORK?

I'm an artist: I paint, draw, make serigraphs, water-colors, blockprints, soft sculpture, and the like.

I'm also a business person: I write contracts with galleries, send invoices to collectors, keep elaborate tax records for the government, and try to stay up-to-date on art-related legislation.

I'm not crazy about being a business person, considering the toll it takes: in fact, I hate it. I'd rather be in my studio drawing and painting and living with my work than scrutinizing the small print of a contract. But I *am* interested in surviving: in knowing how to make a sale to a collector, how to apply for a grant, or how *not* to get taken advantage of by a gallery. My work means too much to me to treat it lightly. And so I'm a business person exactly because I want to survive as an artist when marketing my work.

Unless you have a trust fund or a phenomenally generous patron, you're forced at least to consider the business world of art. All of us—whether it's our first, fifth, tenth, or twentieth year as an artist—are faced with the same dilemma: what to do with our work once we finish it, besides, of course, love it, enjoy it, and have it to keep us company.

Sooner or later, most artists do indeed want to share their work

with the rest of the world. That's when the problems can begin. As soon as you decide to set one foot in that gallery to ask for a show, you're a business person as well as an artist, and you should be aware of the difficulties—the many, many difficulties—inherent in the art business.

Of course, showing and selling your work can be a wonderful, exhilarating experience, and there are many honorable gallery owners and curators. My first major show was as moving and important an event as any in my life: I was wedding the world, connecting to it through my work, and I was overjoyed by the connection. My first few sales were invaluable. They were worth much more than the actual money received.

All our lives we've been brainwashed into believing that unless you produce something "functional" people aren't going to respect your work, that art somehow isn't "serious," isn't vital and practical and necessary. But an artist's first sales can free him or her from that brainwashing. Through those first sales, an artist discovers that people other than himself can love, respect, and know the value of his art.

So the art marketplace isn't all trauma and travail. There *are* highs, pleasures, joys, and rewards. But however rewarding showing and selling your work can be, it's best to know the ins and outs of the art business world—to know the pitfalls.

Artists are often said to be scatterbrained, irrational, over-emotional, and absentminded: dreamers with their heads in the clouds—the worst possible candidates for success in the business world. But I don't think that's true. We *can* handle our own business affairs, we *can* negotiate with great skill, intelligence, and business know-how. It's important to remember that we *can* put ourselves in a strong position when entering the business world, that we *don't* have to succumb to crisis. But first we have to know the ways of that business world.

Forewarned is forearmed.

The first thing you should consider before entering the marketplace is: Are you ready to market your work? You can dam-

age your productivity and your ability to keep your work—and yourself—going well by trying to market your work at the wrong time.

Waiting can be difficult. We've all been pressured into thinking that unless we make money from our work, we're not really *serious* artists. So we have to learn how to handle the pressure, how to tell anyone pressuring us to "cool it," that we're just not ready, that we're going to enter the marketplace in our own way and at our own pace.

Of course, it's not always easy to know when it is indeed the right time to show and sell our work. There are no foolproof guidelines, no steadfast rules. I used to show my work almost every chance I could get. I wanted some action and I got action. Now, I'm not having any major shows at all, because I feel the time isn't right. I'm trying to "shake up" my work and explore several new ideas that may lead to something new, something that I could call my own. I want to be able to do one or two of something and not feel any pressure to do a "body" of them. I want some privacy, some relief from the pressures of the marketplace.

It's a personal issue, a very personal issue. William de Kooning didn't have his first major show until he was over forty. Jasper Johns, on the other hand, had already had his first retrospective by the time he was thirty-four.

Of course, none of us can know everything in advance. We can't plot out all the variables to "compute" the exact moment to market our work. But if you have a general idea of the important issues involved in showing and selling artwork, you will be that much more prepared, that much more successful in protecting your work life.

Here are the issues I find most important to consider:

(1) If you are not ready to hear—for better or for worse— what other people say and think about your work, you are not ready to show your work. Most gallery people are not in the habit of simply saying, *I'm sorry, but we're not interested in handling you.* Many dealers will give

you a good reason (or wha
for rejecting you: your w
or *Too Small* or it has *Too*
or it's *Too Much Just Lik*

Such remarks, needless to say, are not
structive." But once you're in a dealer's "c.
you're a fair target. You can be crucified by
not to mention by collectors, critics, and even by your
friends. They *all* feel entitled to say anything about your
work once you start to show. You won't believe some
of the things you hear—everything from *You know, your
work would look great on greeting cards* to *Has anyone
ever told you that your work bears a marked resem-
blance to Wallace Stevens's late poetry?*

If you can't endure criticism, you're not ready to
market your work. If you're not your own toughest critic,
if you can't criticize your own work and feel confident
of its merit, you should stay home a while longer.

(2) You must believe in your work. To "market" your work
implies that you have in fact something to sell. If you
aren't sure of your work, if you don't indeed believe you
have something wonderful to sell, if you're "ashamed"
that you're an artist, you're at a disadvantage when you
go to a gallery: you're not going to make a go of your
business unless you believe in your work. You must be
ready to put away doubts, at least temporarily, when you
enter the marketplace.

I waited quite a long time to have my first solo show.
There were many reasons why I waited—some valid,
some I now regret—but finally there came a time when
I realized I had developed something in my work,
something I absolutely loved. It was just right, just what
I had always been looking for. My work completely fas-
cinated me. You couldn't tear me away from my studio.
That's when I realized, *I'm going to show these paint-
ings—they're good works. I love them. I don't care if*

they sell or don't sell. I want other people to see them, and after my show, I'll take them all home, if I have to, and be happy.

That's why I decided to have my first show: not just to sell, but to share my wealth with other people. I realized that selling would not necessarily make me a better artist. (And in fact I don't like my work more since it's been selling than I did before I started to sell.) But I was so confident about my work, so in love with it, that I wanted to show it and share that joy with others.

When you truly believe that your work can enrich other lives—that's the time to market and show your work.

(3) There are many reasons why we should show our work: to make money, to share our visions with others, to see how our work "travels" in the public world, to clear out our storage space, and so on. But whatever the reason, you should know *why* you want to market your work. It's not unusual, in fact, for a gallery owner to ask you why you want to exhibit. If you don't know why you want to show your work, if you haven't really thought about the marketing enterprise, what are you going to say? *Well, you see, it's like this . . . well, actually, you know. . . .*

If you have considered the issues, if you have pondered your own motives, you'll be able to give the dealer a reason: you'll be that much more prepared, that much more professional. The reason itself is not always that important. What is important is that you understand that it is a need and desire of yours, so that you feel good and strong about it, so that it doesn't seem that you're nonchalant or indifferent about what you're doing.

(4) Marketing your work takes time and incredible energy. It takes time first to establish a relationship with a gallery: time to make appointments for viewings, time to decide which works to bring, time to photograph your work, time to get your résumé in order.

Then it takes time to mount a show once a gallery accepts you: time to frame your work for the show, time to help design or supervise the announcements, time to compile a mailing list, time to talk over all arrangements with the curator, time to attend the opening, talk to collectors, listen to people's comments, wait for reviews, and so on.

It also takes time to maintain those business connections: time to keep your records up-to-date, time to keep in touch with your galleries and collectors, time to explore new avenues of exposure.

There are many details to attend to once you start to show your work and they take time—time away from your studio, away from your work, away from your friends and your other "lives." Before you start marketing your work, be sure you want to give up that kind of time. If, for example, you're in the middle of a "breakthrough" with your work, is it really the right time to start getting involved with the galleries? Your breakthrough could be destroyed by all the time it takes to be a business person.

So think about your time: protect your work life, protect your well-being.

(5) Marketing your work not only takes time, it takes money: there are résumés to photocopy, slides and photos to shoot, works to frame. Business cards, letterhead stationery, bulk mailing, phone calls, and any number of other items add to the expense. Although the cost of beginning to market your work may not be astronomical when compared to the start-up costs of most other businesses, they're still considerable. Being in business, any business, means spending money, so be prepared to lay out, or borrow, some cash.

Be prepared to spend money, but don't expect necessarily to *make* money. Just because a gallery decides to handle your work doesn't mean you're going to get

rich quick. In fact, according to a survey conducted by *Art Workers News,* 90.9 percent of the artists polled stated they could not support themselves solely from their art:

- 50 percent of the artists earned less than $600 gross from their artwork;
- 86 percent earned less than $4,000 from their artwork;
- and 22.7 percent earned *no* income from their art.

Because of this bleak economic reality, the majority of the artists (63 percent) had to have other full- or part-time jobs. And major overhead costs when compared with earnings from artwork revealed that most artists actually *lost* money creating art. "Artists," the pollsters concluded, "have themselves become the major patrons of culture in America." *

(6) Many artists don't believe they're ready to show their work until they have that elusive "it": a body of work. We've been told so many times that every artist must have his own vision, his own style, his unique mode of expression, that some artists are afraid to put one foot in a gallery because they don't have that "body of work."

Do I have enough work? Is it "consistent" enough? Is it wrong to have more than one body of work, more than one style? These are but a few of the questions that

Artworkers News (April 1976), 6(1):6–7. In 1981, a study of artists in Massachusetts was conducted at Northeastern University and funded by the Massachusetts Council on the Arts and Humanities. The results of this study were similarly bleak: the average Massachusetts artist earned $4,535 from art and incurred $3,524 in art-related expenses: that is, for every $4 earned as an artist, $3 was spent on expenses. "There is no other example of an occupation in which such highly trained people find it necessary to earn most of their income outside their field," the authors of the study concluded. For other statistics from this Massachusetts survey, see *American Artist Business Letter* (December 1982), 9(7):1–3.

plague us when we want to enter the marketplace. It's up to each artist to answer these questions before he or she approaches the galleries.

Personally, I think a body of work can be whatever an artist says it is: it can be your last ten years' worth of work or the last six months' worth. Or it can be all the artist's drawings or all the artist's sculptures or all the artist's landscapes or whatever the artist wants to put together and call a group: it can even be *one* monumental and masterful piece of work. For me, a body of work does not have to be pieces that are similar in content, style, or technique. For me, a body of work could be any well-resolved works that relate to a common thread of investigation.*

But in the "real" world of the art marketplace, people do care about distinctions and categories. A curator might think your watercolors are not exactly like your paintings which are not exactly like your pen-and-ink drawings. Such divisions might strike us as unimportant and unnecessary, but the divisions are useful in the business world.

If the last five years of your work don't hang together in any way except for your name, the gallery might complain because it wants something to hold on to, some "tag" to identify you. It's simply one of the ways—a useful tool—of the business world. Most galleries can't relate to your having a drawing show and sticking one six-foot-square oil painting in it.

Being ready to market your work means knowing your work, knowing which bodies of work you believe in and want to show. Being ready means identifying what you have, figuring out what your "product" is, which of course isn't easy when you have a lot of work in a lot

*I have borrowed this definition of a "body of work" from Michael Jones, the curator of the University Gallery at Wright State University in Dayton, Ohio.

of styles. But remember, when you approach the galleries, you're starting to do business and you must begin to talk in business language which is thick with "body of work" talk.

(7) Don't think that you're not ready to show just because you're still a "young" artist. Many times we're told that a young artist's work is unimportant, that an artist has to put in ten or fifteen years before he can produce anything "worthwhile," anything "unique" or "original."

I don't swallow that argument. (I know I would love to see the first works of a Max Beckmann or a Paul Klee.) You may not be ready for a one-person show, you may not have several bodies of work or even one strong body of work, but if you do have several individual pieces—pieces you really believe in and want to show—why not try to show them? What's wrong with a talented young artist having a few pieces in a gallery to help him or her along?

When I was starting out in Boston in 1956, none of my artist friends suggested that I try to sell some of my work. It was assumed that your first work was just "experimental," not really good enough to sell. Unless you had been working for twenty years and had a thirty-foot long studio filled with a hundred paintings all four-foot-square, art was just your "hobby."

Actually, when I was twenty-five, I was doing some pretty good watercolors, and I'm sure I could have sold some of them for $15 to $20 apiece. Back then, that could have helped pay the rent or get me an extra set of paints or whatever. If I had had the guts to go to a gallery twenty or so years ago, to see if it might handle a few individual pieces, my life as an artist might have been a lot easier. It would, perhaps, have taken a lot less time to be proud of myself, to understand that my work was worthwhile.

Don't let someone pressure you into thinking that you haven't "paid your dues" because you've only been

working five years. If you feel strongly about some of the pieces you now have in hand and feel the need to show them, don't be afraid to approach the galleries.

(8) You must be ready to endure any number of emotionally difficult situations when you market your work. The art marketplace makes no claims to fairness, goodwill, or warmth: don't, in other words, always expect the marketplace to be "one, big, happy family." As Albert Notarbartolo has written, the commercial gallery— "swollen with petulant self-importance, pin-striped glamour, and an antipathetic mystique"—frightens the hell out of most young artists.*

Unfortunately, the marketplace is full of dealers who, as a matter of form, turn away new artists who approach them. Many dealers figure: *Since art is a business, doesn't it make more sense to stick to the few "name" artists the public already knows than to confuse them by showing too many new faces each season?* Some dealers know little about the full scope of contemporary art because they're lazy or too indifferent to look at art outside their own galleries. And some dealers are apparently too lazy to look at the art *inside* their own galleries. When one well-known Boston dealer was recently asked whom she was currently showing, she couldn't even remember the artist's name!

Some dealers *are* wonderful, but don't expect every one of them to be waiting for you with open arms! Quite simply (but I hope not too cynically), if you can't handle a crazy, often terribly unfair and terribly cruel world, then you're not ready to enter the marketplace.

If you've considered these issues and believe you are ready to market your work, start to make the first contacts.

**Artworkers News* (March 1974), 4(1):1.

But if after pondering these issues, you feel you're not ready, there's no shame in waiting. Artists have to understand there's nothing wrong in not making money from their work right away—or ever, for that matter. There is absolutely no reason why we have to show and sell our work unless we're ready. This goes for *all* artists—whether you're an artist who's never had a show or an artist who's had dozens of exhibitions but who's no longer ready to have other shows because you're reexperimenting or just plain exhausted. You should market your work in your own way, at your own pace—when you're ready.

2

HOW TO RESEARCH
THE ART SCENE

To be blunt, the best way to get into a gallery is to marry the gallery owner.

I say this not to be crude or cynical, but to remind you that in the world of business, connections count. If you know someone who owns a gallery, you have a better chance of getting in a gallery than if you don't know someone who owns a gallery. That's a fact. Don't expect the art marketplace always to be fair and just and friendly. It's not, not by a long shot.

Of course, there *are* ways to get into a gallery besides marrying the owner. If you're ready to market your work, the first thing you should do is thoroughly research the gallery scene in your town. Look up the gallery listings in the Yellow Pages, go through the art pages of the Sunday newspaper, pick up local "alternative" publications and the national art magazines to look at the ads and announcements. Many large cities even have publications devoted to art listings—gallery "guides" that list addresses, phone numbers, and current shows. Find out if your town has such a publication and if so, use it. (See Appendix 1.)

Once you have a list of your local galleries, visit some of them. See which spaces turn you on, which dealers turn you on, which

galleries handle work that turns you on, and which galleries show your "kind" of work. (After all, it's nicer to be in a gallery where you respect the other artists' work than in a gallery where you can't stand even to look at the other work. On the other hand, chances are slim that you'll find a gallery where you like *all* the work, so don't be too uncompromising or demanding.) You'll be amazed at just how much you will learn simply by going around to the galleries and looking at their current shows.

During your visits, you may even want to make some initial inquiries at the desk: is the gallery interested in new work: does it have a waiting list: does the gallery set aside one day a week when artists seeking representation can show their work? does the gallery ask artists seeking representation to make the first contacts by mail? One well-known gallery in New York's SoHo district is so frequently approached by new artists (the gallery receives over 150 artist-applicants every week, or more than 6,500 per year), that the gallery has printed up an Information Sheet outlining the gallery's policies about taking on new artists.

Don't forget to check out the reliability of any gallery that interests you. Call your Better Business Bureau to find out more about the gallery. Ask other artists what they know about the gallery. Ask questions: is the gallery a member of the local arts business organization? does the gallery do business at a known location, that is, at a street address and not at a post office box number? have the business relationships between artists and the gallery been mutually satisfactory? does the gallery keep regular business hours?

If, after visiting several galleries, you are interested in some of them and would like to find out more about them, you might want to attend their openings. A lot can happen at a gallery opening. Of course, you can't stand in front of a curator at an opening with a slide in your hand asking him for a show. Nor can you expect that just because you socialize with some gallery people they're going to beg you to take them to your studio to see *all* your work *right this minute*.

But if you go to several openings, especially at the same gal-

lery, the opportunity might arise to chat with the curator—you might get the chance to ask him or her if you could make an appointment to show your work. Sometimes this works, sometimes it doesn't. I have a friend who has gone to every opening in Los Angeles for the past two years, and he still can't get a show. And on the other hand, I have one friend who went to a gallery opening and got so drunk, so very very drunk, that he went right up to the curator and said, *Listen, you damned fool. You'd better give me a show. I'm the best artist in this town.* Believe it or not, that friend is now in the gallery's stable.

And speaking of friends, don't forget to "research" them as well. If you have friends who are already in galleries, ask their advice: they might be able to make an introduction or give you that little push to distinguish you from the many other artists trying to get a show at that gallery. Artists who are currently with a particular gallery often give "hints" to that gallery about new artists. It has been said the late Peggy Guggenheim (whose Art of the Century Gallery provided the springboard for the Abstract Expressionist boom in the 1940s) depended very heavily on the advice of Marcel Duchamp and Max Ernst, while Betty Parsons (another influential New York dealer) was guided by Barnett Newman. And Leo Castelli—often considered the most influential dealer of contemporary art in the world today—has been greatly influenced by Jasper Johns and Robert Rauschenberg.*

While you're researching your local scene, don't be too "hoity-toity." Your first show doesn't have to be in the classiest gallery in town. Exposure—as well as prestige—is the name of the game when you're marketing your work. Prestige helps, so try the "classy" galleries first if you want. But don't forget that showing anywhere you feel comfortable—be it in a small gallery in a small town or whatever—can provide invaluable experience. It lets you figure out what showing is all about: how gallery owners operate, what people are like when they look at

*See Calvin Tomkins's profile of Leo Castelli in *The New Yorker* (May 26, 1980).

your work, how critics approach your art, and so on. You may also make some sales, gain new collectors, and be seen by a large gallery.

You don't have to go straight to New York and camp out on Leo Castelli's doorstep. Remember, people everywhere need to see good artwork, so if you live in a large city, you might also want to check out the galleries in the surrounding suburbs and small towns. And if you live in a small town, you might want to travel (after you try your home galleries) to the nearest good-sized city and approach the galleries in its environs. Start wherever you can. Just try to get yourself some exposure and some experience.

When you've finished your "research," write up a list of the galleries you're interested in. Then sit down, call each one, and ask if it's possible to make an appointment for a viewing. Always phone. Don't walk in and expect a viewing on the spot. Remember, when you're marketing your work, you're in the business world so you should act businesslike. If you simply walk in for a viewing, the gallery people will, in all likelihood, be impatient or furious or worse! I've seen gallery owners tear people apart who have just walked in without calling first. It's rude and disrespectful to expect that the curator has nothing better to do than hang around, waiting for new artists to walk in. After all, curators have their job to do: they plan shows, make sales, keep books and records, and if you walk in off the streets with fifty pieces of your work in a suitcase expecting a viewing right then, you're interrupting their concentration.

When I recently polled approximately one hundred art dealers across the nation, no other issue evoked such a consensus of anger as this "walk-in" business. "Drop-ins are the biggest problem," said one Houston dealer, and his sentiments were voiced again and again. "It is *very* difficult for us to see work or slides without appointments," agreed a New York dealer, noting that often "an artist will come in and say he is only in town for the

day. It may look to them as though we are not busy, but every minute is scheduled for correspondence, planning, or selling.''

When you phone a gallery, ask if they are looking at new work and, if so, could you make an appointment for a viewing. The gallery people get so many such calls that they'll know right away what you want.

But be prepared for a variety of answers. Some galleries will tell you, *No, we're not looking at any new work right now. We have all the artists we can handle at the moment.* Other galleries might tell you, *Just mail in your slides and résumé, and we'll call you if we're interested.** And still other galleries might say, *Well, we do have a few openings, but we have many people we're already considering. What kind of work do you do?*

*If you mail your résumé and slides to a gallery, please make sure to include a cover letter. The cover letter should be clear and concise, and all correspondence should be typed whenever possible. Don't forget to make a copy of the letter for your own files. And if you want your slides returned, enclose a stamped, self-addressed envelope.

A cover letter should look something like this:

<div align="right">

Your street address
Your city, state, zip code
Your telephone number
Today's date

</div>

Name of Dealer
Name of Gallery
Gallery's Street Address
Gallery's city, state, zip

Dear So-and-So:
Following our telephone conversation today, I am enclosing a set of ten slides and my résumé for your perusal.
Thank you for your time and attention. Should you have any further questions or want to see the originals of my work, please don't hesitate to call me.
Enclosed is a stamped, self-addressed envelope for your convenience. I look forward to hearing from you.

<div align="right">

Sincerely,
Your Signature

</div>

This is a tricky question—it's not really as easy to answer as you might first think. Let's say, for example, you answer, *Well, I do wonderful landscapes.* Then the gallery tells you, *But we don't like to handle landscapes.* That's it—all you can say is *Thank you* and *good-bye.* Do you really want to be classified with 10,000 other landscape artists? Wouldn't you rather have the chance to show the gallery your work, in person?

Because there's always a chance that if they had in fact *seen* your landscapes, they would want to show them. Although my own work is figurative, I have indeed been exhibited in galleries that were not known for handling figurative work. The curators at those galleries just happened to like my kind of figurative work once they saw it. On the phone they were interested in serial imagery or color field or whatever, but in person they discovered that they did indeed like my work, although it didn't fit their usual tastes. Galleries occasionally make changes, and you may be just the artist they feel courageous about.

So, without being too pushy, try to get to show your work in person. If they ask you on the phone what your work is like, you might answer, *If you have the time, I'd really like to show it to you. I've been to the gallery and think my work "fits in" with the artists you handle.* That way, the gallery knows you have at least done your research, that you've made the effort to check out their work. And you may get the chance to show your work in person.

Whatever happens on the phone, always be professional: don't let your emotions get in the way. Yes, of course you *care* about your work; yes, of course you're vulnerable. But when you market your work you're doing business, so be professional in your approach.

Don't forget to keep a record—a journal or notebook or whatever—of your phone calls and viewings. Write down what each gallery tells you. If one curator lets you know they're not looking at new work, write it down so you won't make a mistake and call that gallery again.

This information can be quite useful: you might, for exam-

ple, want to call that gallery a year or two later. Just because a curator tells you they're not looking for new artists at the moment doesn't mean that will be true a few years later: curators change as do gallery policies. Or your work may change as well: what you're doing this year may not be what the gallery wants to handle, but what you do next year may indeed "fit" the gallery's tastes and interest. Or, during your phone calls, a gallery might tell you to call back in a few months. How will you remember to call back unless you have a record of your activities and calls? You may want to keep a simple "Contact Information Sheet" or you may want to get a little more elaborate and set up a dependable file system. Such a system doesn't have to suit an IBM executive. A simple one will do. You could have files for:

- galleries awaiting reply
- slides out on review
- galleries I want to try
- new galleries in town
- out-of-state galleries
- "reject" galleries
- competitions entered
- slide registries
- museum possibilities—rental galleries.*

Devise your own system if you wish, but have *some* system of recording your activities so you can remember all the details.

Galleries are not the only way to break into the marketplace. If you don't want to deal with galleries, or if you'd like to supplement your gallery business with other ventures, it's important to look into these other routes.

*Some of these file ideas come from Susan Lynne Berger's article, "For a Well-Organized Artist: Think Professional," *Artworkers News* (November 1979), 9(3):18.

There are, for example, slide registries all across the nation and these registries can produce a lot of action for you. Most local museums, art commissions, and various other arts organizations maintain slide registries: these registries are "banks" of slides that the organization uses when mounting a group show or purchasing art for public spaces. These organizations with slides files are also approached by corporations or individuals who need access for one reason or another to artwork. So call up the various arts organizations in your town and find out if they maintain slide registries: if they do, send them a set of your slides. (See Chapter 4 for how to photograph your work.) For a state-by-state listing of slide registries, consult the *Directory of Artists Slide Registries,* compiled by Suzy Ticho and published by the American Council for the Arts (570 Seventh Avenue, New York, New York 10018).

When calling your local art commission, find out how they purchase art for government-owned buildings and other public spaces. Many municipalities now require new public buildings to allocate a certain percentage of construction costs for art purchases. If your city is one of those municipalities, find out how that public art is purchased. Quite often, the arts commission is indeed interested in local talent.*

Also check into cafés, coffeehouses, bookstores, frame shops, theater lobbies, furniture stores, churches, and libraries. Many

*For more information, see: Joyce Newman, *One Percent for Art: Action Kit No. 2.* (Washington, DC: Artists Equity Association, Inc., 1975). Dennis Green, *% for Art: New Legislation Can Integrate Art and Architecture.* (Western States Art Foundation, 1976). For a listing of more than 80 art-in-public-places programs in the United States, send $2 to Inter-Arts of Marin, 1000 Sir Francis Drake Boulevard, #18, San Anselmo, CA, 94960. For public art in New York, consult the Public Fund, Inc., 25 Central Park West, Suite 25R, New York, NY 10023, 212 541-8423. On a national level, contact the Public Art Trust, 1050 Potomac Street, NW, Washington, DC 20007, 202 965-6066. Although many percent-for-art programs are limited to artists who reside in that city or state, some programs will consider nonresidents as well (see Appendix 1 for details).

of them hang shows on a regular basis. Some even hold receptions and print invitations. Such places are a great way to get some exposure, especially if the gallery scene in your town is particularly tight or if you don't feel quite ready to deal with galleries.

Go to the art schools in your town and look at their bulletin boards, as they can provide an enormous number of hints about jobs and grants and arts organizations. Get on the mailing lists of both your city and state arts councils, because very often such groups publish useful newsletters and booklets. Start subscribing to art business periodicals, and look through the standard art-marketing guides (see Appendix 1). Find out if there are any legal-aid-to-artists groups in your area: they, too, can give you many, many useful business hints through their various services and publications. Contact your local museums to see if they maintain rental galleries. Many museums around the country rent artworks to their members, and most museums offering this service allow local artists to submit work for possible inclusion in the gallery.

If you have the inclination and the time, you might even try volunteering your help to a local arts organization—an arts commission, some other nonprofit agency, or a gallery. Perhaps you could offer to write art reviews for a local publication. You can make connections, establish contacts, and get some working knowledge of the ins and outs of your art community.

Don't forget about corporations. Many firms are interested in buying artwork, both to enhance their headquarters and as an "investment." Some corporations even have "galleries" in their lobbies. *The Directory of Corporate Art Collectors* lists over 130 corporations that are active art collectors. The route to corporate money is not always easy or direct (most corporations that regularly purchase art employ special curators or art consultants), but you may want to give it a try. So call up some of your local corporations and inquire about these possibilities.

While checking out your local corporations, contact architectural firms and interior design groups, because both architects

and designers buy art for their clients on a regular basis. Just consult the Yellow Pages and make some initial inquiries.*

Another way to get some action and gain exposure is to enter juried competitions. Many art magazines and newsletters—the Bulletin Board section of *American Artist,* for example—regularly list information on juried shows, and there are several book-length directories of such exhibitions (see Appendix 1). If you have sold work at a juried show or have been selected by such-and-such juror, that experience can be valuable. It can "beef up" your résumé, add names to your collectors' list, bolster your recognition, and so on. Unfortunately, there are some problems with juried competitions. Some shows are "phony," without real jurors, for example; there are entrance fees for most juried shows; and there is the additional problem of transporting your work to shows outside your local community. But despite such problems, competitive exhibitions remain one way to circumvent or supplement the gallery scene.

In the past few years, art fairs and trade shows have also become a popular alternative for those artists who publish prints and other multiples. (Work is frequently purchased in large quantities at trade shows and art fairs; hence you have to have a fairly large stock.) Again, this route of marketing your artwork can be expensive: there are booths to rent, transportation costs, lodging, and so on. Check out the situation before making a commitment of time and money.†

In short, there are many, many possibilities and you yourself must go out there and dig them up. Be thorough, be creative. Really *think* about the various possibilities of breaking into the marketplace. Ask yourself: what in the world is out there that I might connect to?

One of my friends, for example, thought his work would be

*For an overview of how to market artwork to interior designers, see "Markets: Interior Designers," *American Artist Business Letter* (May 1982), 9(2): 1–3.

†For an overview of marketing artwork at trade shows and art fairs, see *American Artist Business Letter* (September-October 1980), 7(4–5):1–2.

good for record album covers, and he found out that many of the top record companies do indeed have art departments that regularly look at new artists' portfolios. Another friend, who happened to paint lots of cats, investigated kennel shows, vet offices, pet organizations, and so on, and she got results.

Figure out your own formula for breaking into the marketplace. If you think your work would sell well at street fairs or sidewalk exhibitions, check out *The Artist's Guide to Sidewalk Exhibiting* by Claire V. Dorst (Watson-Guptill Publications). If you think your images would work on greeting cards, check out the latest edition of *Artists' Market* or explore the possibility of publishing your own cards.*

If you want to enter the art business world, if you want to start showing and selling your work, concentrate some of your own creativity on that business. Where there's a will, there's a way: find your way.

*For a brief introduction to the greeting card market, see "Markets: Greeting Cards and Other Paper Products," in *American Artist Business Letter* (May 1981), 8(2):1–4.

In 1976, I decided to publish my own suite of postcards. I chose 21 images of my work and printed 1,000 postcards of each image in black and white. The printing costs were $630—approximately 3¢ a postcard. (Printing costs, of course, have risen since then.) The series has been popular enough that I have had to reprint several of the images. In fact, I've sold more than 42,000 postcards to date. The cards have been invaluable to me—as publicity tools, as gifts, as résumé handouts, and so on. If you have a gallery, check into the possibility of their "co-publishing" the postcards with you. If, for example, the gallery paid one-half the printing costs, you could include the gallery's name on the cards as publicity for the gallery, although you would still own all the cards. If, on the other hand, the gallery paid the *entire* costs of printing, you could, in addition to including the gallery's name on the cards, give them one-half of the cards to sell, keeping the other half for yourself.

3

WHAT TO BRING TO A VIEWING: YOUR RÉSUMÉ

When you go to a gallery for a viewing, don't forget to bring a copy of your résumé (sometimes called a "vitae" or a "bio"). Many artists hate to write their résumés, and I must admit it's not my favorite task, either.

But it's important to remember how useful a good résumé can be, how it can work to your advantage. After all, a résumé allows you to show yourself in the best possible light. At its best, a résumé is a historical document: it gives the rest of the world some sense of who you are. And it gives the gallery such vital information as your address and phone number.

Some galleries don't pay much attention to résumés. They're understandably more interested in your work itself. But other galleries do want to know about your professional background—your training, shows, collectors, and the like—and such galleries will read your résumé thoroughly before deciding whether to handle your work or give you a show.

Collectors, critics, arts administrators—any number of people you'll encounter when marketing your work—may also want to see your resumé. A good résumé can help make a sale, get a grant, or win a commission. If a writer is doing a piece on you,

he or she may find your résumé useful as "research." If a collector comes to your studio, loves your work but wants to know "more" about you, wants something to take home to show his wife, a résumé can come in handy. If you're being considered for a grant, a teaching position, a seat on the board of an arts organization or whatever, you'll need a résumé.

Résumés come in all shapes and sizes. There's no single "must-use" format. Some résumés are relatively simple and straightforward. Other résumés (especially those of artists who use graphic designers and public relations specialists) can look more like elaborate press packets, with "top-quality" graphics, slick paper, and expensive illustrations. The format I describe below is easy to use and flexible: it can be adapted to fit your own needs.

Remember that although your résumé should be rich with details, it's not a full-fledged autobiography: it's not a story or a tale or a novel. Rather, its a *list* of items neatly divided into *categories* such as Education or Prizes or Exhibitions.

Also keep in mind that an artist's résumé is slightly different from a standard business résumé. Unlike a standard business résumé, an artist's vitae does not usually include such items as Foreign Languages, Hobbies and Interests, Goals and Objectives, References, or license number or teaching credential number.

First and foremost, your résumé should be clear, concise, and clean: very businesslike and as easy on the eye as possible.

(1) Start your résumé with your name—the name you go by professionally. To give it the appropriate emphasis, center your name, near the top of the page. After your name, skip several lines and put the first general category of information: Personal Information. This includes your current address and telephone number and—if you wish— your date and place of birth (see Appendix 8). Some

people prefer to place this information at the very end of the résumé because they want to begin with the "meatier" items. It's up to you where you place it, at the beginning or the end. But this Personal Information section should never come in the middle of your résumé.

(2) A second standard résumé category is Education. Do not include your elementary or high school here. List only college degrees and other post-high school education (including degrees in progress). Each entry here should list the name of the school, the location (city and state), the type of degree (B.A., M.A., Ph.D., and so on), and the date the degree was conferred.

If you were an art major, mention it. If your major was in a field unrelated to art, perhaps you might simply leave your major unstated. If you graduated with honors, that would also be appropriate to mention. (Again, see Appendix 8 for details.) Even if you did not finish your degree, you might want to mention the training you received at that school. And if you have variously attended many art seminars, lectures, and symposia, you might want to include these as Continuing Education.

Some people have had extensive educations, so they have several "impressive" entries under this category. But if you have one degree and do not feel you want to make a whole category for just one item, you might want to place your education in the Personal Information section.

(3) A third standard category in artists' résumés is Exhibitions. Here you list every place that has shown or handled your work, be it a gallery, a frame shop, a bookstore, or whatever. Even if the gallery or bookstore has closed, you should include that entry in your résumé: it's part of your hard work and professional history.

Again, each individual entry here should include: the year of the exhibition; the name of the gallery; its location (city and state); the nature of the exhibition (whether

it was a one-person show or a group exhibition); and the type of work shown (watercolors, sculpture, paintings, and so on). If the show had a title—such as Contemporary American Women Printmakers—you might want to include it.

In listing your shows, you can start with the most recent and work backwards, or you can begin with your earliest exhibition and work toward the present. Whichever chronology you choose, use it in all the other categories as well. Be consistent.

If you've already had several shows, don't list them all under the single heading "Exhibitions." A list of thirty or forty items is almost impossible to read—it's simply "too much" for the eye to hold. So divide your shows into subcategories if you've had many of them.The subcategories could include:

- Major One-Person Exhibitions
- Major Group Exhibitions
- Major Invitational Shows
- Major Juried Shows

Such a subdivided format is much easier to read and will greatly enhance the appearance of your résumé. (In fact, any category that has more than twenty items should be similarly subdivided. Think of appropriate and professional-sounding titles for the subdivisions.)

(4) Other standard categories for artists' résumés include:

- Awards and Prizes
- Teaching and Lecturing
- Commissions
- Special Projects (mural participation, for example)
- Professional Affiliations (the names of any arts organizations you belong to)

- Collections (the names of major collectors and the cities in which they live; don't, however, include the name of the work they own)
- Community Activity (any activity in your local arts scene)
- Notices and Reviews (a list of reviews of your work with the name of the publication, the date of the review, the critic's name, and the page number on which the review appeared).

These categories are by no means all-inclusive. Your own experience might call for a whole new category: the histories of no two artists are exactly alike. If you've had experience that you want to include but that does not easily fall into any of the aforementioned categories, find a good name for a new category and include it. If, for example, your town sought your advice when it was considering some art-related legislation, you could place that experience under Consulting or Special Projects.

Anything you've done—jury a show, organize a committee, sit on a board of directors of a local arts group—that reflects your seriousness as an artist or that might be of interest to someone regarding your artistic development should be included in your résumé. You've heard people say, *Of course I'll do it—it'll look good on my résumé.* Well, that may not be the best reason to do something, but many people (including curators, critics, and collectors) are interested in such information: they'll read *everything* in your résumé. Collectors especially like the details: they *enjoy* sharing your success.

So generally speaking, include any information that makes you look good or interesting. If you studied with Picasso when you were three years old, begin your résumé when you were three years old. If your "second job" is somehow art-related, mention it; if it isn't, forget about it if that suits you.

Include whatever is *you,* whatever you feel best about. On the other hand, if you wish to leave something out, leave it out. Remember, don't lie in your résumé, but how much of the

"truth" you tell depends on you. If you don't want to mention something, don't.

What you put in depends on you; what you leave out depends on you. Again, the résumé is *your* chance to show yourself in the light *you* wish to be seen in.

If you wish you can attach several "handouts" to your résumé: copies of favorable reviews, attractively designed announcements of your various shows whatever you think makes you look good. If you are including any reviews, include only the favorable ones. Don't be so ridiculously honest that you include "bad" notices.

Remember, each review should list the name of the newspaper or magazine, the writer's name, and the date of publication. If this information did not appear in the review as it was originally published, type it in at the top or the bottom of the page. And if the review as it originally appeared in the newspaper or magazine was very large—larger than standard $8\frac{1}{2}'' \times 11''$ paper—have that review reduced at a good photocopy shop. It's not very expensive to reduce reviews (it usually costs less than one dollar), and having all the pages in your résumé the same size makes your résumé much easier to handle and more professional-looking.

If you don't wish to include several pages of full reviews, you may excerpt your reviews so they all fit onto a single page. Select the best part of each review (delete the unfavorable remarks) and type them as a list. Your Review page could then look something like this:

What the critics say about:
JOHN DOE

". . . *superb . . . masterful . . . Doe's style is simplicity itself . . .*"

—Mark Evans, *Los Angeles Times* (8/12/79)

"The total effect of Doe's work is a wonderful kind of cross between Leger and the underground comic book, with a very special sense of humor overall."
—Rose Taylor, *San Francisco Chronicle* (6/15/80)

". . . enchanting . . . Doe has discovered something Picasso also discovered: it takes five years to learn to paint like an adult, and twenty years to forget it and paint like a child."
—Clara Simon, *Sacramento Bee* (6/18/80)

"In his new series, Doe has been able to communicate the sensation of color more directly and nakedly perhaps than has been done before."
—Caleb Williams, *Boston Globe* (3/15/82)

Many young artists are afraid their résumés are too short and skimpy. There are many legitimate ways to "beef up" a résumé without resorting to tricks and gimmicks. Sit down and really *think* about things. If, for example, you have traveled throughout Europe looking at galleries and museums, you could include such invaluable experience under a Research and Development entry in your Education section. Or if you don't have many collectors yet, you could consider trading your work to friends or other artists who then could be legitimately listed in your Collections section. (Remember, a collector is not someone who has necessarily *purchased* your work; a collector is anyone who *owns* a piece of your work.) In short, there are many, many ways to fill out your résumé if you want to.

One of the best ways to "beef up" a résumé is to include an artist's statement. (Actually, even long résumés may include an artist's statement.) Unlike the rest of your résumé which consists of lists, the statement is a mini-essay of between 250 and 500 words. The statement can be an explanation of your aesthetics, if you're into talking about your work in such terms. Or

it can be a more factual description of the materials you use for your work and your processes and procedures.

Anything you want to talk about—materials, content, philosophy—can be discussed in your statement. (Try not to refer to specific works, however, as the person reading the statement probably won't have seen the work you're referring to.)

Many galleries appreciate reading something about your work. And once a gallery accepts you for a show, your statement may help the gallery sell your work. Often, if there are some questions from a prospective collector, the gallery can refer to your statement. It can provide "ammunition" for the curator. Many collectors don't know much about our work habits and work tools, so they're curious and interested. The statement makes you that much more prepared should someone (critic or collector) be interested in your work.

If you hate to write or if you think you're not a particularly gifted writer, you might consider having someone else write your statement. I know I hate to write: I feel more comfortable at my easel than sitting behind a typewriter. So I asked my roommate (who teaches literature) to help me with my statement. If you have a friend who's a writer, ask her or him to help: you can write a rough draft, and your friend might agree to polish it. You can even offer to trade work for the services and then your writer-friend could be added to your Collections list.

Once you have your résumé compiled, your statement composed, and your handouts selected, take them to a good photocopy shop. Remember, the original copy you bring to the photocopier must be cleanly typed. If you're not a great typist, consider having your résumé professionally typed or typeset. It's not prohibitively expensive, and most professional typists/typesetters know lots of tricks to make a résumé look better. If you are a fine typist but do not own a typewriter, many libraries and most photocopy shops have typewriters you can use for a small fee.

Ask your photocopier about papers. Standard photocopying paper is not of particularly high quality, so you may want your résumé reproduced on finer stock. It doesn't always cost that much more and the improvement is noticeable. In fact, with a good photocopying machine and good paper, you often can't tell the copies from the original.

Don't make the mistake of making only a few copies at a time. If you run off only ten or fifteen copies of your résumé, you'll find yourself returning to the copy store again and again. Résumés are needed quite often, so you should have plenty on hand. It makes more sense to have fifty or even seventy-five copies run off at a time.

Once your résumé has been copied, you have to decide how to bind it. You can staple it, if you're into "basics," or you can put it in a ready-made folder, or you can even have it professionally bound by your photocopier. It all depends on your own tastes and on your pocketbook. Keep in mind, however, that even an inexpensive color file folder might allow your résumé to "stand out."

Your résumé should be revised from time to time, perhaps once or twice a year depending upon your activities. These revisions can go much more smoothly if you keep a file or box in your office for all such revisions. Everytime you have something you'll want to include in a future version of your résumé, throw it in that file or box.

That way, when it comes time to revise your résumé, you won't have to stop and think, *Now what have I done lately that I want to include as updates?* You'll be amazed how much can happen to you and how easy it is to forget even your own accomplishments. Start a special file for résumé updates and revisions now.

4

WHAT TO BRING TO A VIEWING: SLIDES AND PHOTOS OF YOUR WORK

You should bring good slides and photographs of your work when you have a gallery viewing. The slides and photos can be invaluable, because even if your work is small and quite portable, you're still limited as to how many pieces of work you can gracefully bring to a viewing. With photos and slides, you can show many more examples of your work; you'll have on hand a much fuller range of your work.

Besides, once you decide to enter the marketplace, you'll need good photos of your work for many, many other occasions. For example:

. . . You have a wonderful new major painting. You want to register its copyright with the Copyright Office in Washington. The Office needs to know what the painting looks like, and of course you can't send them the original for their files. So what do you do? You send them a good slide or photo of the work.

. . . One of your most enthusiastic collectors has moved and now lives 2,000 miles away from you. A few years pass and the collector writes to tell you he or she is interested in buying another one of your works. *What is your recent work like?* the collector asks. What are you going to do—mail the collector ten or

twenty works across the country just for her to take a look? No, you simply send a dozen or two photos and slides of your new work to see if she is interested in any of them. It's certainly easier, cheaper, safer (many works are quite fragile), and often very effective.

. . . You've just finished a watercolor. A collector wants to buy it and you feel you could in fact part with it, so you make the sale. Two years later, you realize you would *love* to see that watercolor again. You might even be thinking of making a print or a poster of that watercolor, or you might have a new idea in a similar vein and just want to reuse the image or part of the-image in a new work. Now, for one reason or another, you can't locate the watercolor collector (you will indeed be surprised how easy it is to lose track of your collectors).

So you're stymied: you don't even have the chance to *see* the watercolor let alone reproduce it as a print. Right? Not if you had photographed the piece before selling it. Almost any kind of subsequent reproduction—posters, prints, postcards—can be handled from a good photograph or slide. Had you photographed the watercolor before selling it, you would not only have a record of that work for your own enjoyment (and it *is* often wonderful to look at old work), you would also be able accurately to make any kind of reproduction from that photo.

. . . A local art critic approaches you and tells you he is crazy about your work and would like to write an article about you. The article, the critic thinks, should have several illustrations, and to meet the publication's deadlines, the photographs are needed right away. What are you going to do? Tell the critic to wait until you (1) arrange to have some of your work photographed, (2) have the film developed, (3) select a few shots from the proof sheets, and (4) have those shots printed up? That will obviously take too much time: you'll miss the chance to have your work reproduced in a publication that may have thousands of readers.

You can see just how handy—even necessary at times—photos and slides can be. Whether you're applying for a grant, reg-

istering a copyright, submitting work to a slide bank, sending off a press packet to a newspaper or magazine, showing a long-distance collector some new work, choosing pieces for a retrospective, substantiating an insurance claim, or simply maintaining a record of your work for your own files, you are going to need several sets of high-quality slides and photographs.*

Many artists, understandably wanting to save money, think they can photograph their own work. *Why not just take Polaroids?* they ask. *After all, don't I know my own work best?*

You should not photograph your own artwork, unless, of course, you are in fact an accomplished photographer yourself. After all, photography is an art in its own right—a very complicated, *technical* art. You should no more expect to turn out a good photo if you are inexperienced than a good painting.

A professional photographer will bring lots of skill and know-how to the job: he or she will know about light, contrast, tonal qualities, and a hundred and one other technical details you've never even heard about.† It's more expensive to hire a pro than to shoot the photos yourself, but it is a worthwhile expense. You're investing in your own work, your own talent.‡

Here are a few hints about having your work photographed:

*If you are just maintaining a record of your work for your own files, not all of that work has to be photographed professionally. Many black-and-white drawings and sketches, for example, can be nicely documented by a good photocopy machine. I have hundreds and hundreds of drawings that would be much too expensive to photograph individually. So I photocopy them instead.

† Did you know that *no* color film is permanent? Or did you know that if you're photographing a work under glass and using a silver tripod for your camera, that the tripod may be reflected in the glass? In short, there are many, many technical details that you've probably never considered.

‡ If you do photograph your own artwork, please consult a good photography book: many such books have chapters on how to shoot artwork. Reliable texts include: John C. Barsness, *Photographing Crafts* (New York: American Craft Council, 1974). Claus-Peter Schmid, *Photography for Artists and Craftsmen* (New York: Van Nostrand Reinhold Co., 1975). William H. Titus, *Photographing Works of Art.* (New York: Watson-Guptill Publishers, 1981). "Photographing One's Work," in *The Business of Art,* ed. Lee E. Caplin (Englewood Cliffs, NJ: Prentice-Hall, 1983).

(1) When searching for the right photographer, don't be afraid to approach a fine-art photographer. Many art photographers do some commercial work on the side to earn extra money, and they often enjoy photographing artwork they admire and respect. If the photographer you hire does indeed love your work, you might even suggest that some of the fees could be paid in trade. I've worked out such arrangements with several of my photographers.

(2) Always discuss the fees *before* the shooting, not after. Some photographers charge a flat fee; others will bill by the hour; and still others will charge an hourly fee *plus* printing costs. Don't hesitate to tell your photographer you don't have lots and lots of money if that is the case. Many photographers know ways to cut costs without cutting quality.

(3) Always make sure that you—and not the photographer—own the negatives. You'll want to use those negatives in the future, and you don't want to have to ask the photographer's permission to do so. (You also don't want to have to track down a photographer you may have used five years ago.) So have the photographer sign a simple letter of agreement that gives *you* the negatives.*

(4) If possible, photograph your work *before* it's been framed under glass: glass and plexiglass can create color

*Simply draft a letter stating:

I _____ am employing _____
 (artist's name) (photographer's name)
to photograph my artwork. Since this is a work-for-hire arrangement, it is understood that (1) I, the employer, own the photographic negatives taken of my artwork and that (2) those negatives shall be given to me by the photographer/employee.

DATE: _____ SIGNED: _____ _____
 (Artist's Signature) (Photographer's Signature)

changes for the camera, making it difficult if not impossible to obtain good color fidelity.

(5) If you sign and copyright your work on the front of your work (see Chapter 10), then photograph your work *after* you have signed it. It's always a good idea to have the signature and copyright notice appear in the photograph.

(6) If your work is especially large, you may want to have some photographs that include a person standing beside the work to convey a sense of scale. Remember, whatever the size of your work—whether it's $8' \times 8'$ or just $1' \times 2'$—it's going to be reduced to a 35mm slide, which is approximately 1 *inch* \times 1½ inch. So you may want, in one way or another, to indicate scale.

(7) If your work is especially detailed or quite large, or if your work involves a particular texture such as thick brush strokes, you might want to photograph some of your pieces both in their entirety and various sections in close-up. A close-up can show wonderful details that remain invisible in a full-view photo.

(8) If your work is three-dimensional, photograph it from more than one angle: make sure you have several different "views" of it. Three-dimensional work can seldom (if ever) be captured completely from one angle. So you might try walking around your three-dimensional work to see which angles are likely to produce the best shots. Don't hesitate to discuss the various possibilities with your photographer: he or she may have several good suggestions you've never considered.

(9) Try to photograph your work against as plain and uncluttered a background as possible. You don't want anything "extraneous" in your slides: you don't want the kitchen sink or the living room fireplace showing. Nearby color floors and walls can sometimes create color changes for the camera, so you and your photographer should consider these issues.

If you have a large neutral wall in your studio, you

might use that as your background. Or you might consider buying photographic "sweeps," which are huge rolls of paper that can be dropped from the ceiling to create a wonderfully clean background. The sweeps have several advantages besides the obvious: they're relatively inexpensive; they can be easily rolled-up when not in use; and they come in white and black and a variety of solid colors.

(10) Tell your photographer you want *both* color slides *and* black-and-white photos of your work. Many artists don't understand why they need black-and-white photographs when the original artwork is in color. The reason: most reproductions of artwork (whether in newspapers, magazines, show announcements, or whatever) are in black and white.

Many artists at first hate to see their work in black-and-white photos, but it's something we all have to get used to. Sometimes, we even grow intrigued by how our work looks in black and white: the photos can produce an interesting view of our images.

Besides, since most black-and-white photos are printed in 8″ × 10″ format, whereas color slides are only 35mm, your black-and-white photos provide a good chance for someone to see your images in a larger scale. They're easy to flip though and don't require a slide viewer or any other apparatus.

(11) Tell your photographer you want *large* quantities of your color slides. There's really no sense in having just a few sets shot when you can use up a few sets so quickly. It's easier in the long run to click off twenty or more shots of each slide at the initial shooting. That way you won't have to call your photographer back to reshoot your work, and you won't be forced to reprint one slide from another (color slides that are reproduced from an original slide are often blurred and poor in color quality.)

Yes, it *is* expensive to have twenty or more sets shot

at once, but in the long run it saves both time and money: do you really want to go through all the hassle of arranging another photo session? No. If you're photographing a major work—a work you plan to show a lot, a work you're very attached to—shoot at least thirty slides of that work in the initial photo session. You'll be surprised how often you'll need good color slides, so why not have them on hand?

You don't, on the other hand, need to print up large quantities of black-and-white glossies right away. Black-and-white photos, unlike color slides, can be first printed on proof or contact sheets: usually there are thirty-six shots to a single sheet. You can look over the proof sheet, decide which shots you like best, and then have only those "best" shots printed. If you need more printed later, you can always have them reproduced from the original negative. There's no substantial loss in quality in successive generations of black-and-white photos. And any photo lab can make up your prints as long as you have the original negative. The prints do *not* have to be made by your photographer. (Just give your photo lab special instructions as to how you want the negatives printed.)

(12) Photograph your work regularly—once every six to twelve months depending upon your productivity. Although you certainly don't have to call your photographer the minute you finish every new piece of work, don't let years and years go by without photographing your work. Photographing that much work at once would be both a major hassle and a major expense.

(13) If you are a conceptual artist or an artist who makes work that is in any way impermanent, make sure you photo document your work. Have a photographer or videomaker shoot your work during its creation, its installation, and so on. (Christo's running fence may have stayed up only a short time, but there are still stunning

photographs that show what it looked like in progress and while it was up.) A photo record of your impermanent work can allow an interested investor/dealer to see what your work looks like. You might even want to make a book from the photos. So please, plan ahead: arrange to have such work documented.

(14) Be satisfied with your photos and slides: if you don't like them, have them redone. There are any number of occasions when curators will see your slides first, and *only* if they like the slides will they ask to see the real work. If your slides don't make it, unfortunately, neither will your work.

Once you have your photos and slides in hand, you must label them. Don't write directly on the back of a photograph: the pen impression will come through the front and destroy the photo. Rather, type the information onto a white label and attach the label to the back of the photograph. (The labels, available at any stationery store, are inexpensive.) If you want to be especially cautious, you can spray the label with a fixative, so there's no smudging when you attach the label to the photo.

The label should contain the following information for each work:

- your name
- the title of the work
- the medium of the work
- the size (or weight) of the work (height precedes width and depth in archival catalogues)
- your copyright notice ©, that is, the letter "C" inside a circle, or the word "Copyright," or the abbreviation "Copr."
- the year the work was completed
- the photo credit, that is, the name of the photographer
- and an arrow (↑) to indicate the top of the photo.

Thus, a photo label would look something like this:

Clara Simon, "Two Women at Sunset." Acrylic on
canvas, 6' × 4'. © 1970. All rights reserved.
Photo: John Doe (↑)

Labels can—and should—include other kinds of information
depending upon how you use the photograph. If, for example,
you are sending the photo to a newspaper or magazine, you might
want to add a second label with the following information: "The
artist gives permission for a one-time reproduction of this image
for publicity purposes." And if the photo is being used in con-
junction with an exhibition, you should include the gallery's name,
location, and the dates of the show.

Wherever you're sending the photo, it's not a bad idea to in-
clude a second label with your address and a "Please Return
Photo When Finished To———." On the other hand, it's never
a good idea to mention a price on the label: your prices can
change, so you don't want one of your photographs floating
around with prices that are now several years old. And when-
ever you send out photos and slides of your work, don't forget
to include a cover letter briefly explaining *why* you are including
the photos and slides. If you want the photos/slides returned, al-
ways include a self-addressed, "padded" envelope or appro-
priate mailer with the correct postage.

Unlike photos, color slides can be labeled on the white card-
board mount of the slide. You can write directly on the card-
board, but I advise typing the information onto a white label which
you can then cut up and attach to the cardboard mount.

Each slide label should include the information mentioned
above for the photo labels: that is, your name; your ©; the year
the work was completed; the title of the work; the medium of
the work; the dimensions of the work (that is, height, width, and
depth); the photo credit; and the arrow indicating the top of the
slide. You might also want to include the word "FRONT" to
facilitate positioning the slide in a projector or slide viewer.

On the back of the cardboard slide mount, put your address

and telephone number in case the slide gets lost or is separated from the other slides in the set. If you're planning to use your slides frequently, you might want to have a rubber stamp made up for this back-of-the-slides information.

Sometimes you cannot fit all this information on the cardboard mount. The mount is, after all, very small. In this case, simply put your name, address, the arrow, and © notice on the mount along with a number. You then put all the other information, by the corresponding number of the slide, on a Slide Information Sheet.

If you're submitting a *set* of slides, it's a good idea to include a "credit slide" as the set's first slide. A credit slide should say something like: "The following slides show works by San Francisco artist Clara Simon and are all copyrighted by the artist." Simply write or type whatever information you want included in the credit slide on a piece of paper and have your photographer take a slide of that paper.

Before you take your slides to a viewing, be sure to project them at home to see if they are of good quality : (1) be satisfied with the color fidelity; and (2) be certain that there's nothing extraneous showing in the slide. The slide should show only the work itself; as mentioned, the background should be plain.

If you do indeed need to "crop" something out of the slide, buy masking tape (leitz silver) from a photography shop. It's possible to mask the slide without removing it from its cardboard mount. If you're not sure how to mask a slide, ask your photographer or a salesperson at a photo supplies shop, so that you do indeed do a good job of masking.

When handling your slides, touch only the cardboard mounts, not the celluloid itself. Chemical reactions can occur when your fingers and celluloid meet—reactions that could eventually change the color quality of the slide.

Don't keep your slides out on a table or desk. Slides easily collect dust. (If your slides do get dirty, clean them with a lens

tissue paper that's available at most photo shops.) Slides should never be subjected to excessive light, moisture, humidity, heat, or physical pressure. Store your slides in a dark, dry, and cool place—either in the small box they came in, or in those handy (and very inexpensive) plastic slide sleeves.

Slide sleeves are loose-leaf pages of clear acetate. Each sheet has individual pockets for twenty or so slides. The sheets are not only an ideal way to store slides, they're also a wonderful way (1) to mail slides, (2) to bring slides to a viewing, and (3) to include slides with a résumé.

Remember, when mailing slides, you should include a stamped, self-addressed envelope if you want the slides returned. And when you bring your slides to a viewing, you might also want to bring a slide viewer or a slide "light wall" just in case the gallery doesn't have any slide-viewing equipment on hand.

5

WHAT TO BRING TO A VIEWING: SEVERAL GOOD PIECES OF WORK

Of course you'll want to bring several actual pieces of your work when you go to a viewing: after all, no matter how good your slides and photographs are, there's nothing like the real work itself.

But bringing work to a gallery viewing can raise a multitude of problems, ranging from the physical (if your work is unwieldy, it's difficult to transport) to the psychological (since you can't bring *all* your work with you, *which* pieces should you indeed choose?).

Most artists work in more than one medium or in more than one style, and we all start tearing our hair out when trying to figure out which pieces to take to a viewing. *Should I bring old work, new work, my different types of media? Should I bring paintings, watercolors, or prints? All of one thing or a mixture? What if they hate my paintings but would love my watercolors but I'm not even planning to bring any watercolors?*

Of course, *we* know that there's nothing wrong with having many different bodies of work. Style is developed by going through many changes, and that's often what the bodies of work are: the changes. But we know that other people—curators and critics and the like—often think such variety "inconsistent." So,

when selecting works for a viewing, should we try to present a "consistent" image, or should we opt for variety and range? Are we willing to stand by *all* our bodies of work, or do we in fact believe that some of our various styles are "minor" bodies of work and are better left in the studio?

Of course, there are no easy answers to these questions. But before you even make an appointment for a viewing, you should consider the issues. Sit down and ask yourself: What *is* the product you want to present to a gallery? What *is* your vision? Sit in your studio and identify what you have, what your assets are. Scrutinize your work, hone it down. Be your own best—and toughest—critic, because getting ready for a viewing means knowing your own work, knowing which pieces and what styles you want to present.

If, for example, you both paint and sculpt, do you envision a show with seven paintings and seven pieces of sculpture? Do you, in fact, have a vision of how your work could look in a gallery: do you see your paintings down one wall, your watercolors down another wall, and your sculpture in the center of the room? What *is* your goal, your vision? Have some idea *before* your viewing: know which bodies of work you believe in and want to show.

If, for example, you did certain works several years ago that represent that past time in your life, you might be tired of that body of work and not want to include it in your viewing. But if there are many examples left of that period of work, it might be a good idea to include a sampling. In short, if you indeed believe in several of your bodies of work, bring samples of each. If you want to show the gallery that you're very hard-working and dedicated, that you have several different "trips" going, by all means bring in a representative sampling of the different styles. Of course, the curator might think you're just fooling around with only two or three pieces in each style. But if you tell him or her that you have thirty or forty more of each style at home, that you just brought in a sampling of each style to give some idea of your range, the curator might realize that you are indeed serious.

In case the curator is interested in one particular style, you might want to have more samples of each style on hand: slides can easily back up each of your bodies of work. You might even consider having a second portfolio of actual work leaning against one of the walls or outside in a car.* You don't even have to mention you have more works on hand until—and unless—the curator expresses interest.

If you do bring several styles of your work, you have a better chance that the gallery will like one of them. But, on the other hand, you run the risk of the curator thinking you haven't found your "vision" yet. You can't tell, you never know.

And remember, the work you bring to a viewing—whether it's all in one style or in twenty—must be ready to handle. All your work must be as clean and as presentable as possible. Don't bring wet work or unfinished work or pastels and charcoals that haven't been sprayed or are uncovered. If your works on paper are rather large, try either to mat them first (so they don't roll up and flap in your face), or to cover them with acetate with mat board behind them. And be sure your artwork is wrapped to keep it clean during the trip from your studio to the gallery; be especially careful if the weather is bad the day of your viewing.†

*If you don't have a car, try to borrow one from a friend or take a taxi: a car/taxi can make the ordeal of gallery viewings much less difficult. And while you're borrowing a friend's car, you might also want to borrow the friend. Don't forget, you want to be comfortable during a viewing. The last thing you need is to be flustered by making five or six trips out to your car while the dealer waits. Keep your psychological strength up during your viewings. The friend can simply help carry bulky work in, put it down, and go back to the car and wait for you.

† An easy and inexpensive way to protect your work is to "shrink wrap" it. Shrink wrapping is a process whereby a thin, translucent piece of plastic is wrapped around a piece of work and then "shrunk" for a perfect contour fit. (The process resembles the way record albums are wrapped.) Check with your local framer to see if he or she offers shrink-wrapping services. If the process particularly appeals to you, check into buying your own shrink-wrapping machine. They're not unreasonably expensive.

6

WHAT TO BRING TO
A VIEWING: RECEIPTS

When you go to a viewing, you should be prepared to leave some of your work with the gallery. Sometimes, for example, the dealer doesn't want to give you a definite *Yes* or *No* on the spot, but would first like to look at your work for a few days. Or perhaps the curator needs to hold on to your work to show it to a partner who's out of town that day. Or perhaps a dealer might want to keep a few pieces to see how the public responds to them before deciding whether to give you a show or not. Of course, there's the possibility that your work so impresses the dealer that he or she wants to start handling it right away—that very day.

But you shouldn't leave any work—or any sets of slides and photos for that matter—without first getting a signed and dated receipt. The receipt gives you the protection you need: it's your proof of exactly what you've left with the gallery.

Suppose you leave a set of slides with a gallery and return to pick them up a month later. On the day you return, you learn that the curator who gave you the viewing is no longer with the gallery, and the new person knows nothing about your set of slides. If you have a signed receipt from the previous curator,

at least you have proof that you did indeed leave a set of slides. The gallery would be legally obliged to look for your slides.

Receipts are not difficult to write, so as soon as you start to market your work (or, for that matter, as soon as you start to let work/slides out of your studio for any reason), you should familiarize yourself with the mechanics of writing receipts.

If, for example, you were leaving a set of slides with a gallery, just write up a receipt on a piece of paper (one original and one carbon copy) that states in plain English:

- the date you are leaving the slides
- the number of slides
- approximately how long you expect the slides to be out of your hands
- your name, address, and phone number
- the gallery's name, address, and phone number
- and both your signature and that of an authorized gallery representative.

If, for any reason, you have to leave actual work with a gallery, the receipt has to be more specific. Receipts for artwork must mention all the information listed above plus (among other things):

- the title, size, and medium of each work
- whether the work comes with any installation apparatus, such as a frame, base, box, rods, or other hanging devices
- the condition of the work and of its installation apparatus, that is, the fact that the work is in perfect condition when you leave it with the gallery
- the retail price of each work, and whether that price includes any installation apparatus
- the commission percentage, that is, the dealer's cut should he sell the work

- and, perhaps most important, the fact that the work has been left "on consignment." (See Appendix 6 for a sample receipt.)

It is absolutely essential that the receipt include the words "on consignment." "Consignment" means that you are merely leaving the work in the gallery's "trust," that you—and not the gallery—still own the work.

Consignment laws have been enacted in several states: California, Colorado, Connecticut, Massachusetts, Michigan, New Mexico, New York, Texas, Washington, and Wisconsin. Artists exhibiting with galleries in these states are protected in many important ways. For example, under the California Artist-Dealer Relations Law, consignment means that the *gallery* is responsible for the work while it is in its care. Should there be a fire or theft, for example, the gallery would have to reimburse you for any damage or loss. Or should the gallery go bankrupt, it would have to return the consigned work to you or pay you your money: the work could not merely be included among the gallery's assets to pay off its debts. This is a nonwaivable law in California. As long as your receipt specifies "consignment," there is no way the gallery can wriggle out of its responsibility: should your work be damaged in any way while it's in the gallery's care, the gallery must reimburse you for the damage. This money is a bona fide legal debt owed to you.*

*The gallery would reimburse you not for the full retail price of the work, but for the wholesale price of the work, that is, the retail price minus the sales commission. This is why your consignment receipt must in fact make mention of both the retail price and the gallery's commission.

If you exhibit in a gallery in one of the ten states listed above, obtain a copy of that particular state's consignment law, because the law varies from state to state. The California Artist-Dealer Law, for example, covers only "fine art," which means a "painting, sculpture, drawing, work of graphic art (including an etching, lithograph, offset print, silk screen, or a work of graphic art), a work of calligraphy, or a work in mixed media (including a collage, assemblage, or any combinations of the foregoing art media)." Not covered are photography and crafts. And the California law applies only to art dealers, that

It should come as no surprise that some galleries will be "slippery" about consignment. If, for example, a gallery tells you that you don't have to worry about specifying "consignment" on a receipt because the gallery is fully insured for all fire and theft and other damages, don't listen to the gallery: you must *still* specify "consignment" on your receipt. Because even if the gallery is insured, you have no guarantee that *you* will be reimbursed for any damages: after all, the insurance company would pay the money directly to the gallery owner, *not* to you. Without a "consignment" receipt, the dealer has no legal obligation to reimburse you. (We won't mention, however, his *moral* obligation. . . .)

In short, whenever a piece of work leaves your studio temporarily for *any* reason, get a signed and dated receipt for it. If you're leaving work at a framer's, get a signed and dated receipt. If you're putting a piece in an art festival, get a signed and dated receipt. If you're allowing one of your collectors to keep a work for a few days to "live with it," get a signed and dated receipt. Even when sending your work through the mail, send it registered or certified, so that you have a receipt. Whatever the occasion, get a signed and dated receipt. If you don't, the results could be unpleasant, if not downright disastrous.

An acquaintance of mine, for example, was asked to submit one of his works to a show. The show was being organized by a conceptual artist who was then going to do "something" to each of the submitted works. My acquaintance did, in fact, agree to submit a work to this show, but he never asked for a receipt for it.

The show was successful enough that it traveled to several other cities. My acquaintance gave verbal permission for his piece to be included in the traveling show, but again, he never asked for a written receipt.

is, to people engaged in the business of selling fine artworks. If, for example, your work were damaged while it was being shown at a coffeehouse or bookstore, then you—and not the owner of the coffeehouse or bookstore—would be responsible for that damage.

As it turned out, my acquaintance then had a great deal of trouble getting his piece back. The conceptual artist who organized the show held on to the pieces in the hope both of having the show travel to still other cities and of documenting the show in a published book. My acquaintance made phone calls, wrote letters, even visited the conceptual artist in person—all to no avail. He simply could not get his work back.

Finally, my acquaintance sought legal advice, and, of course, the first thing the lawyer wanted to know was whether or not he had a signed receipt or contract. The lawyer told my acquaintance that much trouble could have been avoided had he simply used his standard consignment receipt and attached a second signed and dated receipt which simply stated in plain English: *John Jones, artist, has lent so-and-so an original piece of work titled so-and-so and measuring such-and-such, in such-and-such a medium, with such-and-such frame. The piece will be included in such-and-such a show, in such-and-such gallery, which will exhibit the show from such-and-such a date to such-and-such a date, whereupon the work will be delivered back to John Jones, artist.* Signed and dated by both the artist and the person to whom the artist was lending the piece.

Had my acquaintance simply taken the time to do this, his case would have been simple and direct: practically foolproof.

Receipts are among the most important papers in your files. Unlike conversations and verbal agreements which are incredibly easy to forget and subject to debate, receipts are written, legal documents. Receipts provide a great amount of protection and control of your most precious possession: your work.

7

GETTING READY:
PRICING YOUR WORK

Another essential item to bring to a viewing is a price
list. Pricing your work is seldom easy. Money *is* complicated,
the importance of your work *is* a mystery, and the significance
of your work to the world *is* unknown. So it's not surprising
that artists often find pricing difficult or impossible.

The very notion of attaching a price to an artwork can raise
a bundle of prickly questions: *If I price my work rather low, will
it "belittle" my work? Does inexpensive work sell more quickly
than expensive work? And just how much is my work "worth"
anyway? Should I give some of my work away to friends or is it
foolish not to charge for my work? Is a "young" artist unwor-
thy of asking high prices?*

There are no simple answers to these questions. No compre-
hensive rules exist, no rational principles apply. What works for
one artist may not work for another . . . what's true on the East
Coast may not be true on the West Coast . . . and what applies
at this stage of your career may not even apply one year down
the road.

It is, however, important to remember one thing: *you* own the
work and *you* are the only one entitled to price it. A gallery can

advise you—the people there can tell you what price range they think your work should fall in or what price range other works similar to yours are selling for. A gallery may even refuse to sell your artwork if they don't agree with your prices. But remember, *you* made the work, it belongs to you, and you, and only you, are in charge of pricing it.

That said, here are a few pricing guidelines:

(1) Don't price your work *solely* by superficial standards such as size, color, or "complexity" of image. Try not to get caught in the stupidity of the "smaller" one necessarily costing less than the "larger" one . . . or the black-and-white works being cheaper than the color ones . . . or the works with five colors necessarily being more expensive than the pieces with only three colors.

Use your own judgment. Some of the smallest pieces in my studio are much more expensive than my very large pieces. As a matter of fact, some of the small ones are not even for sale—*that's* how expensive they are.

And although some people will advise you that a painting with only three flowers should be priced lower than a painting with six flowers, I find such advice silly. "Simplicity" and "complexity" have little to do with value or worth. Don't you treasure a Brancusi sculpture or a Matisse drawing—works that appear to be simple and not complicated—as much as a visually dense painting by Botticelli?

One day a student brought two paintings to my class. One was a full-figure painting, the other a bust, or waist-high work. The student thought the full-figure should be automatically priced higher than the waist-high simply because the collector would be getting "more" with the full-figure work. I disagreed. I do paintings with half a figure and I do paintings with full figures, and I never think, *Well, the collector didn't get the girl with the legs this time, so I'm going to charge less.*

A whole wall costs more than half a wall when you're selling wallpaper, not art. So price your work piece by piece, according to its own merits, not by size, color, or "complexity" of image. Of course, there are exceptions to every rule: If I were commissioned to paint a mural of an image in monumental scale, I would charge more because the sheer size of the project would be much more difficult to execute—harder to transport and install, more expensive for materials and supplies, and so on. Similarly, some prints that are multicolor with many overlays are much harder to execute and take much longer than those prints with fewer overlays, so I might charge more for the multicolor prints.

(2) Don't be fooled into thinking you can price a work simply by adding up the number of hours it took you to do the work and by then multiplying that number by some "hourly rate."

For one thing, I don't think you can truly calculate exactly how long it takes to make a piece of art. Let's say you were to try to compute the time. What would you include in the computation: would you include only the time the brush is in your hands? the time it took you to stretch the canvas? the time it took you to buy the canvas? the time you spent "thinking" about the piece? And if you were calculating the number of hours it took to make that one great drawing, would you also include the hours it took to make the 200 so-so drawings to get to that one great one? (Only the artist knows how much "bad" work it takes to make one or two "great" pieces—that an artist's most important tool is often the wastebasket.)

As an artist you may be "working" even when you don't realize it—when you're simply talking to friends, looking through a magazine, or even watching television. You never know how something might inspire your work. A friend of mine once went to New Zealand on vacation and her subsequent work was strongly

influenced by the colors in the island's landscape. If she were pricing one of the paintings she did after the vacation by some "hourly rate," should she include the time she spent in New Zealand? Some of my own work has been influenced by Cocteau's movies or Billie Holiday's music—should I include the time I spend with their work when calculating my "hourly rate"? In other words, it would take a computer to figure it all out, and even then the statistics would have little legitimacy.

A student once told me that since a particular still life only took her one hour to paint she wasn't going to charge much for it. I told her, *Right, it took you one hour to paint it and ten years to get your head "straight" enough to have that one hour!*

I simply don't think an artist's productivity can be measured by a punchclock. When someone asks me, *How long did it take you to do that?* I now answer: *My whole life.*

(3) Don't assume that a beginner's work must automatically be priced low. How many years and where you have studied should hardly be the main determinants of price. I realize that this isn't the standard rule of thumb, that most people will tell you only the work of mature, "proven" artists should be priced high. Forget the norms so you can find out how *you* really feel. When you price your work, take pride in what you've done.

Some of my painter friends thought I was crazy to charge $1,900 for some of my paintings when I had my first one-person show in 1971, while their paintings were going for $500. But I was 36 years old at the time, loved those paintings, and simply was not willing to give them up so easily. I didn't care if it was only my first major show or not.

Don't be afraid to price your early work "high" if you think it merits the price. Remember, it's all right if no one buys the work: you'll be happy to keep it.

(4) You may want to visit several galleries to see how much "your" kind of work is going for, but I don't think such comparisons are particularly effective in pricing your art.

Let's say, for example, you go around to forty galleries in New York or Los Angeles to figure out how much medium-size watercolors are selling for, and you see that one artist's medium-size watercolors are priced at $1,000. But watercolors may be that artist's main body of work, whereas they are only a "sideline" for you, so why should you compare prices?

Why use an outside source to determine your prices? Pricing should be done artist by artist, one piece of work (or one body of work) at a time.

(5) Don't be afraid of having some inexpensive work for sale. There's nothing shameful about low prices. Try to forget our culture's mistaken notion that something costly is necessarily better, that the more expensive your paintings are, the better an artist you must be. Have a range of prices to make your work more accessible.

If you make both unique (one-of-a-kind) works *and* multiples such as etchings or woodcuts, the multiples could obviously be priced lower than the unique pieces. Or if you have a particularly large body of work, you could divide it up into a "favorites" pile, a "seconds" pile, and a "thirds" pile. Each of these divisions could be priced differently, giving your work a range of prices. (Of course, sometimes the piles switch in six months, and you should remember that even works in the "thirds" pile should be works you're proud of: never sell anything you're not proud of.)

I think it's unwise for an artist to charge a lot for *all* of his or her work because then a lot of people won't be able to afford it. It's important for artists not only to protect their own finances when pricing, but also to think democratically in terms of the audience. You want to make your work accessible to the public. You want

to have some quite inexpensive works along with your more expensive ones. (After I made postcards of some of my works, I loved the idea of having work that sold for 25 cents.)

When you price some of your work inexpensively, don't assume that the inexpensive art necessarily sells faster than the expensive art. It's not always the case.

I've had expensive work sell and the inexpensive work not move at all. Two or three galleries actually refused to handle a suite of my serigraphs until my prices at least tripled: the galleries thought the suite wasn't expensive enough!

It's difficult to "psych out" galleries with regard to prices. If you hand a gallery inexpensive work, you can imagine the curator saying to himself, *These are so cheap, it'll be really easy to sell them.* But it's just as easy to imagine the curator thinking, *No, I really don't want to hang around with a collector for an hour or two, just to make a measly $50 commission.*

In short, there's no way of knowing who will buy what.

(6) Price each piece of work according to what it is worth to *you.* Of course, this is easier said than done, but here are a few ways I determine "worth" in terms of money:

(a) *Attachment to work.* Generally speaking, the more attached I am to a work, the higher its price. If a piece is really close to your heart, don't charge too little; there's nothing worse than pricing a treasured work very low, selling it, and feeling cheated.

And if you are very, very attached to a particular piece, don't put it up for sale at all: don't sell anything you can't psychologically "afford" to sell. When Picasso died, he had several castles worth of work he hadn't wanted to

sell: they were *his* private collection. Of course, few of us have that kind of storage space, but still . . . don't be afraid of keeping some of your favorites. (Keeping earlier work also makes good business sense should your prices later rise dramatically.)

A man once purchased one of my paintings, but later returned it because when he took it home his wife wasn't crazy about it. A year or so later, a woman bought the same painting, but again, later asked to return it because (yes, you guessed it) her husband wasn't in love with it. Each time that painting came back, I grew more attached to it—I felt "sorry" for its having been rejected, and each time I raised its price.

A curator would say that such a pricing principle is absolutely crazy, but I say that in the mumbo jumbo world of the art marketplace, it's exactly this kind of craziness that keeps me sane.

(b) *Rarity of work.* How many pieces of that type of work do you have? If very few, the price of each could be higher than if there were very many. The fewer pieces you have of a style of work that's very dear to you, the more you should charge for each work in that style.

(c) *Age of work.* I often charge less for new work than for old work. I figure I have a lot of the new pieces, and I'm still producing that kind of work. But with the older pieces, many of them have already been sold, and as I'm probably not going to work in that style again, I want to hold on to more of them—they're worth more to me.

(d) *Commitment to a particular medium.* Some

people say that a work on paper should never cost as much as one on canvas. I say it depends. If you have been really concentrating on a particular medium—let's say, prints—then those works could be priced higher than if the prints were merely a sideline to your major work. In this case, your prints *are* your major work and thus *are* worthy of higher prices. They're worth more to you because you've been concentrating on them and are committed to them.

(e) *Financial needs.* How much money do you need? Would a $50 sale make a great difference to you? a $200 sale? a $500 sale?

Perhaps one way to begin pricing work would be to think: *if my ten new paintings were gone for all time, what would be a fair trade in terms of money for that loss? What am I going to get back in return? What could that money buy me?*

Ask yourself: *Which one of my paintings would I trade for a month's rent? for a year's rent? for one roll of canvas? for one year off from my other job?*

I'm currently working on a new series of paintings that I haven't yet priced. I've thought—just played with the idea—of charging $1,000 each. But then I've said to myself, *Well, that's not really enough. That $1,000 would only give me one month off from teaching, and I think each work is worth more time than that.* I'm trying to think what I'd like to have—an etching press or a photocopying machine—and whether that item would be a "fair trade" for the proposed price of the painting.

You have to think how much money you need to strengthen and prolong your work life.

Money per se doesn't mean anything. Protecting your work life—that should always be the real "bottom line" in pricing your work.

(7) When pricing your artwork, take the gallery's commission into account. Remember, galleries often charge a 50 percent commission, so if you want to make $100 from a particular work, the work must sell (retail price to the collector, that is) for $200 in a gallery. And once your work is shown in a gallery, you must charge the same price for that particular work wherever it is sold—whether it is sold by a gallery that takes a 50 percent commission, or by a gallery that takes only a 30 percent commission, or even by yourself out of your own studio. Once you enter a business relationship with a gallery or curator, you must be honorable. You cannot charge different prices for the same work just because one gallery's cut or commission is higher than another's. Such inconsistent pricing is not professional or ethical, and it will get you into trouble.

Let's say, for example, that you want to take in $100 from the sale of a particular print. You then ask a 50 percent commission gallery to charge $200 for that print, and you ask a 33 percent commission gallery to charge $150 for another copy of the same print. You think your request in each case is fine, because in each case you'll see $100 income from the sale. But you're wrong! Obviously, a collector would rather pay $150 for the same print than $200, so of course the collector will buy from the "33 percent" gallery. When the "50 percent" gallery finds out what's happening, the curator will be so angry he'll drop you right away.

In short, you *must* have a consistent retail—or "top"—price for each piece of work once you start showing. Once established, your prices should be firm. It is unprofessional to lower your prices. A collector

who buys from you, buys with the understanding that your price range is firm. You are entitled to give your best friend a discount on a unique (one-of-a-kind) painting that you sell directly out of your studio, but it's not professional to give a studio discount to anyone on a print/multiple. Why should a gallery continue to handle your prints when a collector can get a "better deal" by buying directly from you in your studio?

Your retail is *not* what *you* will always take in on the work. If you sell a print out of your studio which retails for $200, you will make $200. But if that same print sells in a gallery that takes a 30 percent commission, you will take in only $140. And then, if that same print sells in a gallery that takes a 50 percent commission, you will only see $100 income.

Of course, all this commission business complicates pricing tremendously, but it's absolutely essential to understand the business and act accordingly. If you're not showing in any galleries, your prices don't have to be so consistent. But once your work is being handled by one or more galleries, you must establish a consistent "top" or retail price.*

(8) When pricing your *framed* artwork for a gallery, take into account the cost of the frame. Otherwise, you can lose your shirt.

Here's an example:

You have a print which retails for $100. You spend $100 to frame the work. So when you send that framed print to a gallery, you tell the gallery to charge $200: $100 for the print, and $100 for the frame. Right?

No.

*Similarly, if an agent asks to represent your work, be sure you know the agent's exact commission. Generally speaking, agents charge a lower commission fee (10 to 15 percent) than galleries (30 to 50 percent), since agents seldom have a gallery's "overhead" expenses. In any case, always make sure an agent's commission is known and agreed upon.

Because when the gallery (which, let's say, takes a 50 percent commission cut) sells that print, the gallery is going to send you a check for only $100, or 50 percent of the total sale. You then have to use that $100 to pay the framer, which means you've made nothing—absolutely nothing—on the print!

The solution?

First, you could ask the gallery to reimburse you for the frame and take its 50 percent cut *only* on the print. That way, you won't lose any money. Most galleries, however, are not willing to do this. Most galleries want their cut on the *total* selling price—frame and all.

Alternatively, find a framer who will sell you the frames wholesale, for 50 percent of the retail price. (Many framers are indeed willing to charge wholesale prices to artists, especially if the artist uses the framer regularly.) If the frame retails for $100, you pay only $50. The framed work mentioned above would still retail for $200: $100 for the print and $100 for the frame.

Thus, after the gallery does in fact sell the framed work, they'll deduct their 50 percent commission (that is, $100) and send you a check for the remaining $100. You then pay the framer his $50 and keep the remaining $50 as your legitimate share of the print profit. This way, you don't lose any money on the frame. Of course, you don't *make* any money on the frame either, whereas the gallery in fact enjoys a $50 profit on your frame! So, it's not an ideal solution.

A third solution would be to buy the frame wholesale and ask the gallery to (1) reimburse you for the frame's *wholesale* price, and then (2) split the remaining profit with you. In other words, you have a print that retails for $100, and you frame it with a $100 frame that you've bought wholesale for $50. The collector still buys the framed print from the gallery for $200. But the gallery first reimburses you for the wholesale price

of the frame ($50), and then takes its commission on the remaining $150. Thus, the gallery would keep $75 and send you $75. You both make some money on the frame.

(9) When pricing a series of works, try to be consistent within that series. I'm currently working, for example, on a new group of paintings called *Women in Love*. I'm not exactly sure how much I want to charge for each painting in the series, but when a collector recently asked me the price of the first painting in the series, I said, "I'm not sure yet, but I think when I'm done with the series, I'll ask $5,000 each."

He agreed to that price.

Now, let's say, when I have in fact completed the series, I sit back and say, *Well, here are 20 paintings and it will be a lot easier selling each for $2,000 than for $5,000, and I think $2,000 is indeed a fair price.*

So I charge $2,000 for each painting.

But one of my collectors has already purchased one of these paintings for $5,000. You can be sure he's going to be very angry—and rightfully so—when he visits the gallery and sees the paintings are selling for $2,000, not $5,000.

Before you take money for a work in a series, make sure you know how much that whole series is going to cost. What you charge the first collector is what you charge the rest of the collectors, with a few exceptions. If, for example, you truly believed that the first work in the series was a much "better" work, you could legitimately charge a higher price. Or if once you had sold a few pieces in the series, you decided to raise the prices for the remaining pieces, that, too, would be fine. Collectors never object when you go *over* their prices with the other pieces in a series: it's going *under* the price that gets you in trouble.

(10) Remember, it is indeed legitimate to raise your prices in certain instances, for example, when:

- almost half of a body of work is gone or sold, and the rarity of the remaining pieces increases their value
- you decide that a piece of work you didn't care about is quite an important piece
- your reviews have been quite good and various publications have started giving you exposure
- your work has been selling very quickly
- your gallery suggests you raise your prices and, after careful consideration, you agree with its suggestions
- the price-of-living index goes up
- a certain percentage of the edition of your prints (multiples) are gone/sold, etc.

I don't think you should raise the price of a work in the middle of a show. Nor do I think it's legitimate to raise your prices when you know a wealthy collector "who can afford it" is going to visit your studio.

Be ethical!

If you do raise your print prices and are already showing at several galleries, you *must* notify *all* those galleries at the same time. If you notify the galleries by telephone, follow up the call with a letter, so you have a record of the notification.

(11) Whenever possible, know the price of your work even while it is still in your studio. This not only makes it easier should the work later be shown in a gallery; it also makes a studio sale that much more likely.

Many studio sales have fallen through, in fact, due to an artist's confusion when asked, *How much is that?* Remember, a blushing artist is inexcusable: embarrassment is the best way to lose a sale.

I don't suggest that you should crank out your work and slap a price tag on it before you've even enjoyed it yourself. But when you create a piece of work, and when you are thinking you could show it to the public,

that it's not so precious that you couldn't possibly sell it for a year . . . then I suggest you give yourself some kind of idea of what you want to charge. Make some time for private thoughts on pricing the work: don't be forced to price the work under pressure.

Because you are going to be caught off guard at times; you are going to be surprised. You'll find that no sooner have you finished a work—a work whose price is the furthest thing from your mind—when someone will visit your studio and ask, *By the way, how much is that one?*

And keep in mind, people who buy your artwork are often embarrassed themselves. Buying art is not a familiar experience for many people: it's not the same thing as buying a Chevrolet or a freezer or a TV set. Many collectors find the whole notion of buying art extremely delicate and sensitive. So you have to make it easy for them—you have to be the business person and tell them the relevant details: the work's price, the fact that the price does *not* include sales tax, and any other pertinent information you might want to convey about copyright and resale contracts.

(12) Since pricing can be such a complicated business, try to simplify your prices whenever possible. If, for example, oil paintings are your major body of work but you also do many watercolors as a sideline, you could give all the watercolors the same price. You could say, *Well, I don't want to have to price each one of these 200 watercolors individually, so I'll charge $100 for each of them and forget about it.*

If such a pricing principle for your minor—or major—works appeals to you, it could save you a lot of time and a lot of decisions.

(13) When pricing your work, don't forget to consider your costs and overhead whenever such expenses are relevant. If, for example, you've been charging $15 for each of your drawings and you switch to using handmade

paper, you should raise the price of those drawings: handmade paper can be expensive. Or, if every time you sell a $25 print, you first roll the print with a piece of plain paper and then put that print into a protective mailing tube, you should figure those costs into the price of the print.

I hope you'll find these guidelines useful, because it is important that you price any works you bring to a viewing.

But no matter how complicated or important pricing might be, the union between art and money remains—when all is said and done—an absurd one. When told that his "Three Flags" had been sold to the Whitney Museum for a million dollars, Jasper Johns commented, "I was brought up in the Depression, and one million dollars is a very important figure to one who grew up at that time. It has a rather neat sound, but it has nothing to do with painting."

8

GETTING READY: SIGNING YOUR WORK

Signing your work is essential. The signature is the mark of the creator of the piece. It is the sign of authenticity of the work—your credit in the work and your moral right to the work. So whenever work leaves your studio—be it to a gallery, an art festival, a collector's home, or whatever—the work should be signed. The signature allows the work to "travel" in the outside world.

Let's say, for example, you're at a gallery for a viewing of your work. The curator tells you, *Yes, I'm definitely interested in these. I'd like to keep a few to start handling them.* You can't stand there stuttering, *Oh, let me take them home and bring them back. They're not signed yet.*

You must be ready to do business when you go for a viewing. And no reputable dealer in the world will handle your artwork if it isn't signed or in some way authenticated. The more you show and sell, the more you'll realize just how much an artist's signature can mean: quite simply, many collectors won't even buy a work without a signature.

But signing is not always an easy matter. Here are the most frequently asked questions about how to sign artwork:

Where Should I Sign?

When signing two-dimensional works such as drawings and paintings, I generally try to sign the *front* of the work, so the signature is always visible. This doesn't mean the signature should be excessively large or vulgar. No, the signature certainly doesn't have to be the first thing you see when you look at the work! You don't have to make the signature a "big announcement" and thus disturb the size and scale of your imagery.

Nor should you sign your name with a cheap "flourish"—at a large scrawled angle or in an "intense" place in the work, such as on the top of one of the objects in a still life or across the chest in a portrait. Be careful where you sign: don't let the signature interfere with the work; don't let a cheap signature spoil your piece.

But remember, even a subtle, inconspicuous signature on the front of a two-dimensional work insures that your credit is inseparable from the work itself: it allows an interested viewer to see (and possibly remember) your name.

Let's say, for example, you've sold a drawing—which you signed on the *back* and then had framed—to a collector. The collector is at home entertaining friends one day, when one of those friends, obviously taken by your piece, asks *Who did this wonderful drawing?* The collector—as is much more common than you would ever think possible—can't even remember your name! Do you really think that the collector is going to unscrew, unwire, and unframe the drawing just to see your signature on the back? No. So, because you didn't sign your work on the *front*, you may have just lost another sale.

Many artists are reluctant to sign their works on the front. They think it's too "pushy"—too egotistical. But at least a "front" signature gives you some chance of repeat business—it keeps your name before the public.

Many artists—especially those who work in an abstract vein— have quite a hard time signing the front of their work: there's simply no obvious place for the signature that wouldn't "disturb" or destroy the integrity of the piece.

Many such artists *do* find a way to sign the face of their work because they want to be sure their credit for the work is evident. If you, too, are having trouble finding a place to sign the front of your two-dimensional work but do indeed want to keep your credit for the work visible, I suggest you really *think* of the various possibilities: be ingenious without being gimmicky. Look through illustrated art books and see how other artists have signed their work: you'll be amazed how often an artist has found a wonderful way to sign the front of a work that you would have thought defied "front" signature.

There are many, many ways to keep your name visible if that's what you want. If, for example, you work on stretched canvas, you might consider signing on the *edge* of the work, that is, on the side which has the front canvas wrapped around it. Because in many cases, no frame is needed around the canvas (the canvas is virtually framed the way it is stretched), so a signature on the "edge" is fine. Such a signature would always be "visible," and it would not interfere with the face of the work.

But, if after careful consideration and research, you still can't find a way to sign the front of a two-dimensional piece, sign on the back—"on verso." Signing the backs of work on paper is relatively easy, but if you need to sign on the back of a canvas, remember to sign the canvas itself and not the stretcher bars. The bars could be removed in the future and hence the signature would no longer accompany the work.

Other kinds of artists—especially sculptors, fiber artists, and conceptual artists—have an even harder time signing their work. I have a friend, for example, who does the most gorgeous conceptual sculpture—all wire and mesh—and she was completely stymied about where to sign. There was no front, back, *or* side that had a good place to sign! Fortunately, the new copyright law allows an artist to sign and copyright work on the label of that work, as long as the label accompanies the work in the normal course of business. So this was what my friend eventually did.

What Do I Include with the Signature?

Because I want to copyright each of my works, I begin the signature with the copyright symbol: ©. Then I put my name, always including my last name. One of my friends, on the other hand, used only his initials. He had turned these initials into a clever "fish-head" monogram, and used this "fish signature" instead of his name to sign all his works, including a wonderful poster he had designed for a dance company. The signature was quite charming, but rather limited: how would anyone who liked this poster know who the artist was? That's why I always include my full last name.

After the name, I put the date the painting was finished. Always be sure to include the year—not just the day and month. One day a student showed me a work which included a "1/25" after her signature. I assumed the work was a multiple, that it was the first of a limited edition of 25. But I was wrong. The work was, in fact, a one-of-a-kind piece that had been created on January 25 or "1/25." The year didn't appear anywhere: hence the confusion. When dating your work, *always* include the year. Whether you include the day and the month is up to you, but the year is absolutely essential.

And since the signature should include the year the work was completed, I think it's a good idea to sign your work shortly after you finish. If you wait too long you may forget, exactly when you created the piece, you may no longer have access to the same tools, to the same emotions: you may no longer be in "sync" with the piece and the signature could suffer.

If, for one reason or another, you haven't signed a piece you did years ago but have now decided to sign it, use the date you originally *completed* the piece. And if you are now reworking a piece you've already signed, don't feel you have to obliterate the first signature. Just add, if you want, a second signature on the back of the work, saying "reworked, 1981." There's nothing wrong with having two such signatures: generally speaking, the more you "document" a piece, the better.

The copyright notice, your name, the work's date: these are basic to unique one-of-a-kind works. Sometimes an artist will add more information on the back of a work. If I'm so so inclined, for example, I occasionally add a little "story" on the back for my collector and for myself that in some way describes the "provenance" of the piece: *I was here when I did the painting, and the original drawing this painting comes from was done at such-and-such a place on such-and-such a date, and I used such-and-such materials, etc.*

When signing a handmade, limited edition of prints, printmakers also include in the signature information concerning the number of that particular print and the number of prints in that particular limited edition. Thus, a print could be signed: "19/40 © Clara Simon, 1982," which would indicate that the print was the 19th of a limited edition of 40.

A printmaker friend of mine also includes the following information on the back of her print frames: *This is the 19th of the limited edition of 40 original prints created, printed, and signed by the artist, Clara Simon, in 1975. With the addition of 5 proofs, the total size of the edition is 45. The plate has not been destroyed, effaced, altered, or cancelled. There are no other authorized prints of this original other than the limited edition. The print is an etching printed on Rives paper, matted with acid-free paper to ensure the longevity of the print.*

What Do I Sign with:
a Pen, a Pencil, a Crayon, or what?

The instrument you use for the signature depends upon *what* and *where* you're signing:

(1) If you're signing the *front* of a painting, you should use the paint of that painting. That is, if the painting is in acrylic, sign in acrylic. If you've used oil-based paint for the work, sign in oil-based paint. Remember, you can't use acrylic over oil paint: the acrylic won't hold and will eventually peel off.

(2) If you're signing the *back* of a painting, you could paint your name in acrylic. Acrylic is fine on raw canvas or raw linen, not only because acrylic dries fast, but also because acrylic does not eat into the canvas. Oil-based paint, on the other hand, could eventually rot your cloth, unless the cloth had been primed first. And since many conservators say you should never prime the back of your canvas (if both the front and back of your cloth are primed, the cloth cannot "breathe"), perhaps it's not a good idea to use oil to sign the backs of works on canvas or linen. Thus, if you indeed frequently sign the *backs* of your paintings, why not have a little jar of acrylic on hand just for that purpose?

I have been asked about the use of crayons for signing the backs of works on canvas or linen. Crayon is not permanent, and besides, with a crayon you would have to bear down on the cloth, possibly damaging the front of the work. (In fact, *any* pointed tool could possibly poke a hole in your work.) Even permanent or indelible markers—contrary to their name—can eventually fade, especially under sunlight. Even though the back of a canvas is usually against the wall and away from sunlight, I don't think it's a good idea to sign the back of a canvas with an indelible marker.

And when you are, in fact, signing the back of a canvas or linen, please remember to sign the cloth itself. Never glue a label or anything else onto the back of the cloth: glue can ruin the cloth. If you need to attach an exhibition or an address label, then glue or staple the label to the stretcher bar. (Sometimes the stretcher bars will have several such labels on them, providing a "history" of the piece.)

(3) With the exception of pen and ink drawings which are traditionally signed in pen and ink, most works on paper are signed in pencil. Signing a work with pencil presents no problems if that work has a margin or border: you can simply sign in the unmarked margin.

But if, for example, a watercolor or pastel has no margin, if the work covers the entire piece of paper and you therefore have to sign *directly* on the face of the work, an ordinary drawing pencil could present some difficulties: either the pencil signature won't show up clearly enough, or the pencil signature is too "shiny." Sign such a work with one of two pencils: the Stabilo #8008 or the Stabilo #8046, both of which are much darker than many ordinary drawing pencils. (If you do use one of these two pencils, make sure, however, that you don't get the piece near anything wet right after you've signed it, because water "feathers" the signatures made with these Stabilo pencils. In other words, don't sign a pastel with one of these pencils and then spray it.)

If you go to a museum or browse through art books, don't expect most artworks to conform to the signing guidelines outlined here. Methods of signing artwork are hardly standardized today, let alone in the past: many painters (Oskar Kokoschka among them) used only their initials when signing their works . . . several artists never included dates in their signatures . . . and copyright notices in artwork have become common only in recent years.

In this chapter, I have tried to include signing suggestions that make good sense: good business sense *and* good aesthetic sense.

Of course, some artists think all this fuss about signing your work is ridiculous—that it's just vanity to be so concerned about your signature. ("If you are vain it is vain to sign your pictures and vain not to sign them," Fairfield Porter once said. "If you are not vain it is not vain to sign them and not vain not to sign them.")* Other

Fairfield Porter: Art in Its Own Terms, ed. Rackstraw Downes (New York: Taplinger, 1979).

artists argue that ultimately the work itself *is* the signature: *You don't need Van Gogh's signature,* they say, *to know it's a Van Gogh.* But how can you go outside your studio with unsigned work? You're taking a tremendous risk if you do. I will never let a work out of my studio without signing it. For one thing, I'm proud of my work—I *want* my name on it. For another, if one of my works is outside my studio and a viewer sees and likes it, I want to be sure that viewer knows where to get another one.

9

GETTING READY:
TITLING YOUR WORK

In business, a title is useful for identifying and describing a particular piece of work. If you have delivered twenty watercolors to a gallery (done the same year, the same size), and the gallery calls to tell you one has just sold, how will you know which one was indeed sold if all the pieces are untitled? You can't expect a curator to sit there, phone in hand, muttering, *Well, it's the one, you know, the one with the small orange mark in the top right-hand corner, you know, the one with the yellow drip across it.*

So anytime you bring work to a gallery, you should attach a title or a descriptive phrase to each piece (at least on your price list and packing sheet, if not on the work itself). Quite simply, titles make business transactions easier: they're practical.

But titles can be more than practical. A title can be extra information for the viewer: it can be further communication by the artist, steering the viewer in a certain direction. I once did a painting, for example, of two very funny-looking birds staring at each other with great glee. Each bird was actually the mirror image of the other. I called the work *Self Love*. That title "framed" the image—it allowed the viewer to "step" into the

painting the way I intended. Without that title, much of the "meaning" of the work would have been lost. So a title can be quite important. If (to give another example) you had done a work based on a famous artwork and you wanted the viewer to know that, you could title the work something like, *Sunflowers, after Van Gogh.*

Not every work, however, *has* to be titled. Some artists call a work *Untitled* when they want no other words attached to it. And some artists give a series of works a single title or descriptive phrase, and then merely *number* the individual pieces in the series.

Titles do not have to appear on the work itself. It's up to you. Sometimes I write the title on the front of a piece, along with my signature and copyright notice. But other times, I only put the title on the price list or information sheet which accompanies the work whenever it leaves my studio to go to a gallery, museum, festival, or whatever.

Sometimes a title will come to an artist while he's still working on a piece. Sometimes the title will come to you only after the piece is completed. And sometimes—on very rare occasions—a title will come to you before you've even *started* a piece. But whatever the sequence, don't get caught having to title all your work at once. It can be a difficult task to honor a work with a title, and you should give yourself enough time to make your individual decisions slowly.

I know when I do a piece of work, I need some "room," some time to think it over, to be with it, to enjoy it, and to know if it's "enough" or whether I might want to relate to this theme again in a different way. To have a gallery owner drop by the day after I finish a painting and ask—*What's it called?*—is quite a pressure.

10

GETTING READY: COPYRIGHTING YOUR WORK

Copyrighting is not my favorite subject. In fact, it's one of my least favorite subjects. Copyrighting can be tricky and messy—thick with legal complexities. There are lawyers who specialize in nothing but copyright cases, so you can imagine just how complicated this copyrighting business can be!

Be we, as artists, shouldn't let such complexities scare us off, because copyrighting *is* important. In fact, at times I think it is *the* single most important thing an artist should consider whenever his or her work is about to travel in the outside world: copyrighting is essential, and the basic instructions are extremely easy. If you let work outside your studio which has not been copyrighted, you are courting trouble.

Every artist owes it to himself or herself to understand copyrighting—to remember that the federal government devised the copyright laws to protect us, the creators (or "authors" as the Copyright Office likes to say) of original works. Copyrighting in all its basics is not difficult to understand.

Why Should I Copyright My Work?

Perhaps the best way to understand why you should copyright your artwork is to realize that every work of art has two very

different "parts": it has a "body" (that is, the tangible object itself) and it has an image.

A painting, for example, has a canvas, frame, stretcher bar, paint, and so on. They are the painting's "body." Now, if you take a photograph of that painting, you are not actually reproducing the *body* of that painting. After all, the photograph (unlike the painting) does not have a canvas, stretcher bar, frame, or paint. No, the photograph reproduces the *image* of the painting.

Many artists don't realize that the soul and guts of any work of art—its real heart—is the *image* of the work and not the work itself. It is the *image* that can be reproduced so easily, it is the *image* that can be duplicated in so many different and valuable ways. A painting's "body," for example, can hang on a wall, but its image can "fly" almost anywhere: it can end up as a print, a poster, a note card, a postcard. At the right time and in the right place, an image can become extraordinarily valuable. Do you remember several years ago when Robert Indiana's

LO
VE

was popping up everywhere?

When you sell a piece of your work, you may no longer own the work itself, but you can be sure you still own the *rights* to that image. This is where copyrighting comes in, because the copyright is the source of all reproduction rights to original works of art. Copyright allows you to make the work "public"—to let it out of your studio—without losing your interest in that work. If you copyright a piece of yours, you still own the rights to the image of that work, even after you sell the piece of work itself. The copyright notice gives an artist protection—it prevents other people from using your images, from making money from those images, and from damaging the quality of those images.

The copyright law specifically gives you, as the creator of the work, the *exclusive* right to:

- reproduce the copyrighted work in copies
- prepare derivative works based upon the copyrighted work

- distribute copies of the copyrighted work to the public by sale or other transfer of ownership, or by rental, lease, or lending
- perform the copyrighted work publicly (in the case of literary, musical, dramatic, and choreographic works, pantomimes, and motion pictures and other audiovisual works)
- and display the copyrighted work publicly (in the case of literary, musical, dramatic, choreographic, or sculptural works, including the individual images of a motion picture or other audiovisual work).

These rights, known as "exclusive" rights, give us a good amount of protection. Just think what could happen if we didn't take advantage of our ability to retain such rights:

. . . You sell a painting to a gallery for $1,000, but don't retain the copyright to the painting. The gallery then publishes an edition of 300 prints of that painting and sells each print, let's say, for $100. You've made only $1,000 from that painting; the gallery, on the other hand, makes $30,000 from the prints *plus* whatever it sells the original painting for!

. . . Or, let's say a collector buys a drawing from you, and, again, you haven't retained the copyright to that drawing. Well, you visit that collector's home a few months later and find that he has plastered your drawing's image all over his sheets, towels, shower curtains, tote bags, T-shirts, matchbook covers, or whatever. Even if the collector isn't marketing such copies of your work, do you really want someone else fooling around with your images in that way?

. . . Or, let's say an uncopyrighted painting of yours is hanging in a group show. A few months later you're walking down the street when you see a poster advertising a new pizza parlor, and the poster has your painting on it! Imagine your sense of outrage and loss!

These examples may sound extreme and unlikely, but they're not. I have heard horror story upon horror story of injustices suffered by artists who were not familiar with copyright protection and hence who did not take advantage of the copyright laws. For example, in 1938 two young men—one a writer, the other an artist—sold a 13-page comic strip story for $10 a page, that is, for $130. Obviously unfamiliar with copyright laws, the two men (they were barely out of their teens) signed a release form giving the publisher all rights to the story. The comic strip those two "kids" sold just happened to be *Superman.*

Superman is now published in 38 countries and 15 languages. The comic strip has been made into: a radio serial; an animated cartoon series; a novel; a fifteen-episode movie serial; a television series; and three blockbuster films, the first one of which has grossed $275 million worldwide, and the second one of which notched a spectacular $24,009,272 in its first seven days of release—then the highest weekly earnings for any film in motion picture history. According to Licensing Corp. of America, which has held the rights since 1960, in the last decade alone the Superman property has grossed over $1 *billion* in goods and services.

The two creators of Superman—Jerry Siegel and Joe Shuster—have seen none of that money because one day back in 1938, they forgot to do one thing: copyright their work in their own names.*

This story should make clear why you should copyright your work. Copyright gives you the right to your own material, your own creations. When you secure your copyright, no one can infringe upon your rights to your work.

*When the plight of Siegel and Shuster reached the public's notice in the mid-1970s, the publicity embarrassed Warner Communications Inc. (which controls the rights to the Superman character), so the corporation decided to give the two men a pension of $20,000 each a year, later raised to $30,000. See Aljean Harmetz's article, "The Life and Exceedingly Hard Times of Superman," *New York Times* (June 14, 1981), Arts and Leisure Section, pp. 1, 17.

How do I copyright my work?

Under the new law—which took effect January 1, 1978, the first major revision in American copyright law since 1909—your copyright is secured the moment you finish a piece. When your work becomes "fixed in a tangible form of expression" (to use the legalese so favored by the Copyright Office), the copyright *immediately* becomes your property and it lasts throughout your life plus fifty years. No registration or any other involvement with the Copyright Office is required to secure copyright under the new law. It's yours as soon as you finish a piece!*

You should, however, put notice of the copyright on each of your works as soon after you complete it as is possible. And you certainly should never let works outside your studio if the notice does not appear on the work. The notice simply tells the public that the work is, in fact, copyrighted and subject to all such protection under the law. The notice, in short, is a warning sign: Hands Off!

Placing such a notice on your work is quite simple:

- First put the copyright symbol ©, that is, the letter "C" inside a circle, or the word "Copyright," or the abbreviation "Copr."
- Then place your name after the copyright symbol. You can abbreviate your name, if you wish, or use "a generally known alternative designation," if you have one, although I suggest you use at least your full last name whenever possible.
- Last, put the year the work was completed.

*Under the old law, a work had to be either registered with the Copyright Office or published with the copyright notice before copyright protection was secured. The protection under the old law lasted for a first term of 28 years. During the last (28th) year of the first term, the copyright was eligible for renewal for another 28 years. (The new law extends that renewal period to 47 years.) Works copyrighted under the old law are subject to that law. Works which were created before the new law came into effect, but which had neither been published nor registered before January 1, 1978, are under the protection of the new law.

The year can be omitted if your artwork is reproduced on greeting cards, postcards, stationery, jewelry, dolls, toys, or any other "utilitarian" object.

Thus, a copyright notice might look like this:

© Clara Simon, 1981.

If you wish to be protected in some South American countries, add the words "All Rights Reserved" after the date. According to the law, these three items—the copyright symbol, your name, and the date—do not have to be in any special order, or do not even have to appear near each other. I think it's simpler, however, to put all three in one place.

Just put the notice in such a manner and location as to "give reasonable notice of the claim of copyright," which means (according to the Copyright Office's lenient interpretation), if someone were looking for it, he could find it.

Thus, the copyright notice can go on the front *or* back of your work. It can even be placed on any framing, mount, or any material "to which the work is permanently attached or in which its is permanently housed." In certain difficult cases where there is no way to sign the work itself, the copyright notice can be located on the work's label, as long as that label travels with the work in the normal course of business.

I recommend that the notice appear on the front of the work whenever possible—I just think it's safer that way—but government regulations don't require such placement. Be practical: if you have a 5,000-pound sculpture, don't put the copyright notice on the bottom. Do you really expect someone to lift that sculpture to see the notice?

That's it! That's all you have to do to protect your work. The use of the copyright notice does not require any permission form or registration with the Copyright Office. No formalities!

Can I "Officially" Copyright My Work?

Yes, you can register your copyright with the Copyright Office if you wish. There are certain advantages to official regis-

tration, and since it is not especially difficult, I suggest you register most of your major works with the Office.

All you have to do is send the Copyright Office a package containing the following three items:

- a properly completed application form. For most artists, this usually means Form VA ("Visual Artists"), which is a relatively straightforward, two-page form which can be obtained from the Copyright Office in Washington, D.C. These forms are free; you can ask for as many of them as you want.* But you must use the Office's actual form (which is on archival-quality paper) and not a photocopy
- a fee of $10 (no cash) for each application
- a deposit of the work.

The Copyright Office is actually very flexible when it comes to deposit requirements for visual artists. If your work has been published in an edition of more than 300 copies, you must send the Copyright Office two copies from that edition. But if your work is one-of-a-kind (such as a painting or a drawing), or if it has been published in an edition of no more than 300 numbered copies, or if the work is three-dimensional (such as sculpture), you send "alternate" identifying material.

The alternate materials can be photographs (including Polaroids), slides, photostats, drawings, or other similar two-dimensional renderings that can be looked at without the aid of a machine. If the original work is in color, the alternate material must reproduce the actual colors of that work. The alternate material (usually it's a photo or slide) must show the entire copyrightable content of the work for which the deposit is being made,

*If you need a registration form and know which type of form you need, you can call 202 287–9100 at any time, day or night, to leave your request as a recorded message on the Copyright Office's HOTLINE. If you do not know which form you need, call 202 287–8700 weekdays, during business hours (8:30–5:00 EST).

and it must show where the copyright notice is placed. (If the copyright notice does not show up on your photo or slide, you can include an accompanying diagram showing where the copyright notice can be found.) The material should have some identifying label listing the title of the work and an exact measurement of one or more dimensions of the work.

Slides must be 35mm in size and should be fixed in cardboard, plastic, or similar mounts. All other material (such as photos or photostats) must be no smaller than $3'' \times 3''$ and no larger than $9'' \times 12''$. The Copyright Office prefers such material to be $8'' \times 10''$.

Remember, these three items—the application form, the $10, and the deposit of identifying material—must be sent in the same package to the Office. Otherwise the application cannot be processed. The Copyright Office is part of The Library of Congress, and your deposit becomes part of the Library's permanent collection.

The law does allow you to group register your unpublished works or your published works if those works were all published on the same day. Group registering can save you lots of money and lots of time. For example, you could take all your paintings from one period of time and register them under one title—let's say "Collected Oil Paintings of Clara Simon, 1981." The Office has been known to accept group registrations containing 600 (!) different works.

To qualify for such registration (and it really is a wonderful way to save time and money), you simply have to make sure:

- the elements of the collections are assembled in an orderly fashion
- the combined elements bear a single title identifying the collection as a whole
- the copyright claimant (you, that is) in all the elements and in the collection as a whole is the same person
- and, all of the elements are by the same person, or, if they are by different people, at least one of the people has contributed copyrightable authorship to each element.

If you look over these requirements for official registration, you'll find, I think, that official registration is not as difficult as many people first think. And, as mentioned, there are definite advantages to such registration.

What Are the Advantages to Official Registration?

For one thing, official registration is ordinarily necessary before any infringement suits may be filed in court. If someone violated your copyright on an artwork that had not been officially registered, you would then have to register the work before the courts would hear your case. So, many people argue, *Why not be one step ahead and register when you first finish a work?*

Secondly, official registration establishes evidence in court of the validity of the copyright and of the facts stated in the certificate. In short, if you did have to go to court because someone had infringed your copyright, your case would be that much stronger if your copyright had been registered with the Copyright Office.

But most important, if registration is made *prior* to an infringement, you are eligible to be awarded more money from that infringement. For one thing, you can be awarded attorney's fees—that is, if you win your case, the infringer has to pay *your* attorney's fees as well as his attorney's fees. And you can also win "statutory damages," which is a sum of money between $250 and $10,000 for each infringement, as the court considers just.

If you have *not* registered your copyright before an infringement, you can only be awarded actual damages, that is, money damages you can actually prove you've suffered, which in many art infringement cases are practically nil. Let's say, for example, a theater company uses—without your permission—one of your images on a poster. But the company does not sell that poster; it's just putting the poster up all over town to advertise its current season.

Although the theater company has indeed infringed your copyright, you probably haven't suffered any financial losses and the theater company hasn't made any profits from that infringement. So the court could only tell the theater company to stop using your image—the court couldn't award you any damages (statutory or otherwise) if you hadn't registered your copyright *prior* to the infringement. In this particular case, you would have to pay your attorney's fees, which means you—the innocent party—would actually lose money to defend yourself.

Needless to say, in certain cases, it certainly does pay to register your copyright from the beginning!

What Can I Copyright?

Certain categories of materials are *not* eligible for copyright protection under the current law. You cannot, for example, copyright basic geometric forms such as circles, triangles, squares, stars, and so on. Such shapes—unless arranged in original and artistic combinations—are in the "public domain." Nor can ideas, processes, or procedures be copyrighted. If, for example, you have discovered a new way to execute a block print, you can only copyright the block print's image—not the process by which you made the block print.* And titles, names, and short phrases are similarly excluded from copyright protection.

But all original works of art in any form can—and should, I think—be copyrighted, even if that work was created by collaboration, that is, even if that work had more than one "author." If one of your images has been transferred to a T-shirt, copy-

*One of your concepts or processes could, however, be patented. Whereas copyright is based upon the notion of "originality," patents are based on the concept of "invention." "The requirements for utility patent protection are that the invention must be useful, new and 'unobvious' to those skilled in the art. The test for a design patent is that the item designed must be an article of manufacture and the design must be new, original, ornamental, and 'unobvious.' " Franklin Feldman and Stephen E. Weil, *Artworks: Law, Policy, Practice* (New York: Practicing Law Institute, 1974), p. 207.

right that T-shirt. If you turn one of your drawings into a doll, copyright that doll. If a Christmas ornament has been adorned with one of your designs, copyright it. Don't belittle your artwork: even if it has a "utilitarian" function, it's still art and can be copyrighted. (I copyright, for example, my needlepoint designs.) No piece of art if shown to the public is too small, too inconsequential, or too "useful" to be copyrighted. Protect yourself!

This means any reproduction of your work should also display the copyright notice. If you are bringing photos or slides of your work to a gallery viewing, those photos/slides must include the copyright notice. (The photos can be labeled on the back; the slides can be labeled on the mounts.) If you're sending out announcements for a show and the announcement displays one of your works, the announcement should show the copyright symbol. If your show is being publicized with a poster of one of your works, the poster should similarly include a copyright notice. Postcards, posters, note cards, announcements—any reproduction of your work should display the copyright notice.

And it's up to you to make sure they do!*

Does Copyrighting Give Me Complete and Total Control of My Work?

Not exactly. Copyright protection is not infinite: there are certain restrictions. For example, the law does provide for certain "fair use" practices whereby someone can use your images without your permission. If a newspaper, for example, were publishing a story about you, the paper could legally reproduce

*Because you may have to include the copyright notice on so much of your own paperwork, it's often a good idea to have a copyright symbol—©—placed on your typewriter. Most typewriters don't come with such a symbol, of course, but it's not outrageously expensive to have such a key put on: it usually costs between $40 and $50. You might also check into the possibility of having a rubber stamp made with your copyright notice; it, too, would come in quite handy.

images of your work to illustrate the article, and your permission would not have to be obtained in such a case. Or if a teacher at a nonprofit educational institution were giving a lecture on, let's say, contemporary American art, the teacher could, in some cases, show slides of your work without first getting your permission.

According to the law, the use of a copyrighted work for "purposes such as criticism, comment, news reporting, teaching (including multiple copies for classroom use), scholarship, or research, is not an infringement of copyright." Such uses are considered "fair use."

Of course, it's not always easy to determine whether a use is, in fact, "fair use"—each instance can have its own peculiarities. But the law considers four factors to determine fair use:

- the purpose and character of the use, including whether it is for profit
- the character of the copyrighted work
- how much of the total work is used in the course of the use
- and what effect the use will have on the market for or value of the copyrighted work.

Fair use doctrines not only determine how someone may use your work without your permission; fair use also determines how you, as an artist, may use other artists' work. Many artists, for example, when making a collage, use other artists' photos or drawings or paintings or whatever. The legality of such uses is determined by the "fair use" doctrine.

If I Have Omitted the Copyright Notice from One of My Works, Can I Now Correct the Omission?

If the work was published (that is, offered in multiple copies) before January 1, 1978, and the copyright notice was omitted or incorrect, all copyright protection for that work has been per-

manently lost. If the work has been created since January 1, 1978, and published without any or with an improper copyright notice, you can correct the situation by:

- making a reasonable effort to add the copyright notice to copies that don't have it
- and registering the copyright within five years of publication.

You can also correct an omitted notice if you can show that the notice was left off against your written instructions that such notice be included in the work.

If you have work which was created before January 1, 1978, but which has neither been published nor registered, that work is brought under the protection of the new law, and you may copyright it accordingly.

How Do I Give Someone Permission To Use My Copyrighted Work?

There may be times when you want to grant someone permission to reproduce your work. A collector who has purchased one of your paintings, for example, may ask you if it's all right to reproduce that painting on his Christmas cards. Or a dance company may love one of your images so much that it would like to use the image to advertise its next season. Or a filmmaker may want to include your works in his current movie. Or a gallery may want to buy one of your paintings *and* your copyright.

Under the right conditions, such uses of your work may, in fact, be acceptable or even beneficial to you, and you can then transfer any or all of your rights. Copyright rights are divisible—you can retain some for yourself and sell others. You just have to be careful, you have to be sure you know exactly which rights you are in fact transferring: there are (among others) first rights, one-time rights, serial rights, all rights, North American rights, and so on and so on.

The law stipulates that the transfer of *exclusive* rights must be made in writing, and that the transfer of *nonexclusive* rights can be transferred verbally. But I say *any* licensing of copyright rights—exclusive or otherwise—should be made by contract. Get it in writing!

If you want to grant someone permission to use one of your images, write up a contract or letter of agreement:

(1) First, stipulate exactly which rights you are granting. If you are licensing only a one-time use of the image, say so. Be specific. If, for example, that aforementioned dance company wanted to reproduce one of your images to advertise its next season, you should stipulate whether it can use that image only on its posters, or whether you're giving it permission to use the image also on T-shirts or in newspaper advertisements or whatever. Are you giving permission only for this season, or for next season as well, or for ten seasons down the road? And just how many posters will be printed? *You* have control, *you* own the copyright. So stipulate exactly what rights you wish to license. Don't grant more rights than you wish to grant.

(2) Remember, keep your credit in the work: stipulate that any reproduction of your work *must* include your name and copyright notice. Under current copyright laws, someone must, of course, get your permission before using one of your images, but once that permission is obtained, the law does *not* require that your name be included in any reproductions. So, it's up to you to require it.*

*Check to see if your state has some "moral rights" legislation. The California Preservation Act, for example, does contain a "paternity clause" which requires any reproduction of an artwork to include the artist's name. That law, however, applies only to "an original painting, sculpture, or drawing of recognized quality." Thus, prints, photographs, crafts, mixed-media works, and video art would not come within the protection of this law, unless of course, a court could be persuaded that a particular work did indeed fit the definition of "a painting, sculpture, or drawing."

(3) Make sure you retain the right to supervise the handling
and reproduction of your image. You don't want some-
one cropping your image in half or reproducing the wrong
colors. Remember, more people are probably going to
see the reproduced image than the original, so you should
care about *how* your work is copied. Maintain the integ-
rity of your work!

Because once someone has obtained permission to use
one of your images, the copyright law does *not* stipulate
that that person must use it in a way that's faithful to
the original.* And you would be amazed what some
people want to do with your work!

A magazine once asked to use a painting and told me,
*Well, to make it fit on this page, we're going to cut it
right here. Is that all right?* It was not all right: they
wanted to crop below the chest line and not use the rest
of the painting. Such a use, I thought, would deface my
work. The magazine was interested in designing a "cute"
page, but I was interested in maintaining the integrity of
my work. So I said no to its requests.

If you care about the quality of any reproductions of
your work, retain the right to supervise.

*Again, check to see if your state has some "moral rights" laws. The Cali-
fornia Art Preservation Act, for example, does prohibit anyone (except an art-
ist who owns and possesses the artwork which that artist created) from
intentionally committing or authorizing "any physical defacement, mutilation,
alteration, or destruction of a work of fine art." The law, however, only ap-
plies to "an original painting, sculpture, or drawing of recognized quality."
There is legislation before Congress to make a "moral rights" law effective
throughout the nation. Congressman Robert F. Drinan's "Visual Artists Moral
Rights Amendment of 1979" would provide that "independently of the au-
thor's copyright in a pictorial, graphic, or sculptural work, the author or the
author's legal representative shall have the right, during the life of the author
and fifty years after the author's death, to claim authorship of such work and
to object to any distortion, mutilation, or other alteration thereof, and to en-
force any other limitation recorded in the Copyright Office that would prevent
prejudice to the author's honor and reputation."

(4) Include the exact fees involved in the transaction. If you are granting a one-time use of an image free of charge, say so. If you are charging $100, say so. And, if you are selling a work *and* all your copyright rights to that work, charge as much or more for the rights than for the work. Any artist is a fool who sells an original work along with any reproduction rights for the same price as the price of the original work. An additional (and arguably a much larger) fee should be paid to any artist for any auxiliary uses of an image.

If, by the way, you do transfer your rights, you should record that transfer with the Copyright Office.

(5) If you want copies of the reproduced images of your work, say so. If the dance company, for example, were making 1,000 copies of that poster, you could stipulate that you want 50 of these free of charge.

(6) If the person you are giving permission to is then going to *sell* the reproduced copies (if, for example, you are allowing someone to publish prints of one of your paintings), you and that person must agree upon several issues:

- What is the retail price of the prints?
- Who decides when the prices of those prints should be raised?
- Who benefits from the raise?
- Should you (the artist) receive royalties, and if so, how much, and on what payment schedule?
- Will you be given the names of those people who buy the reproductions, so you can have the names for future reference?
- Will you be informed in advance of publicity and distribution plans, so you can have some control over how your name and work are used?

These and many other issues (such as whether you are a partner in the publishing endeavor or not) must be ad-

dressed in the contract, *before* the transaction occurs, not after.

(7) If you are signing a contract for a commissioned work, make sure the contract stipulates that you, in fact, own the copyright to that work. If the contract says the work is a "work for hire," you are signing away your copyright protection. According to copyright law, it is the *employer* and not the employee who is considered the creator of works for hire! So never sign a contract that says "work for hire" unless you want to give away both your right to credit and your copyright protection.

This, I think, covers the basics of copyrighting visual artwork. It would be impossible to be completely thorough about copyrighting here, because each example can bring its own particularities, and because each day new precedents are being set.* This has been but an introduction to the subject. If you would like to know more, write the Copyright Office (The Library of Congress, Washington, DC 20059) and ask for a Copyright Information Kit. It's free. The kit contains copies of the new law, application forms for registration, and explanations of copyright regulations. If you have special questions, you can also phone (at your own expense, of course) the Copyright Public Information Office, at (202) 287–8700, weekdays between 8:30 A.M. and 5:00 P.M. (EST).

The Visual Artists and Galleries Association, Inc. (VAGA) offers protection against pirated reproductions,

*For example, several years ago artist Alan Sonfist created an environmental artwork on the side of a building in the Bronx. In 1980 that artwork showed up in the closing frames of Alain Resnais's movie, *Mon Oncle d'Amérique*. Sonfist claimed the piece was used without his consent. The film's producer settled out of court, paying Sonfist several thousand dollars and agreeing to give him credit on prints of the film. Sonfist said, "It's an important issue in that it established that using artwork in a film without permission can violate copyright." The film's attorneys, however, disagreed and said they settled because they wanted to clear up the dispute as quickly as possible.

not only in the United States, but also in Western Europe. If you would like to join VAGA, or learn more about its services, write to them at: One World Trade Center, New York, NY 10048. Should you need to consult a lawyer because of copyrighting problems, I suggest you contact your nearest legal rights for artists organization. And for useful additions to any artist's "copyright library," see Appendix 1.

Remember, it's *your* responsibility to understand the basics of copyrighting, because sooner or later you'll probably have to explain them to a collector or curator. (In fact, whenever a collector buys a piece of your work, it is a good idea to explain to that collector that he or she is buying *only* the work, and not the right to reproduce it.) Even if you've just started creating art, it's not too early to get acquainted with the principles of copyrighting artwork. And even if you are already along in your career, it's not too late to understand more about copyrighting.

Copyright laws were created by Congress to help artists protect the rights to their work. As a friend of mine once said, "Create the work, sell the work, but keep as much control of it as you can so you have the opportunity to earn as much as you can from the work in as many ways as you can."*

Copyrighting provides that control and allows for those opportunities. It's a form of respect for your own work: your way of saying you believe in your work and its value.

*Shirley Levy, "Viewpoint on Copyright," in *Are You Ready to Market Your Work?*, ed. Norma A. Fox (Boston: Boston Visual Artists Union, 1979), p. 29.

11

HOW TO SURVIVE
GALLERY VIEWINGS

When you go to a gallery viewing, keep in mind you're trying to start a business relationship—not a friendship, not a romance, but a business relationship. So treat the viewing like a business appointment and act accordingly: reconfirm your appointment the day before; show up on time; bring a professionally assembled portfolio; and leave your pain at home. In short, always be professional: don't let your emotions get in the way.

You should, in fact, show your own work as you would want someone else's work to be shown to you: easily, neatly, and in a simple, straightforward manner—a clean, clear viewing. Take your time making decisions—judge carefully what to bring and how to be most prepared.

Of course, viewings can make you nervous—we're all vulnerable when showing our work to dealers. But keep that nervousness, that vulnerability under control. You don't want to be so frazzled that you can barely speak during the viewing. Always try to keep your spirits up, to maintain a certain amount of "presence." Learn whatever tricks you can to keep your "cool" during viewings.

I'm talking about strength now, about confidence and faith,

about the ability to endure the ordeal of gallery viewings and come out feeling good.

Here are a few "survival" hints to do exactly that:

(1) Remember that viewings can—and should be—"two-way" affairs. The dealer may be viewing your work, but you should be "viewing" the dealer.

Artists often get so anxious during a gallery appointment that they think only the curator has the power to say *Yes* or *No*. But we, too, can accept or reject. After all, galleries and museums need *us*. Without artists, there would be no dealers, no curators, no museums, no arts administrators or National Endowment for the Arts (N.E.A.). It's important to remember that *we make* the goods *they're* interested in handling.

So you shouldn't get completely intimidated during a viewing. Keep in mind that as the curator is looking over your work, you should be looking over and "sizing up" the curator. Because should you indeed start to show with that gallery, you're going to have to talk to and interact with that dealer regularly. And, quite simply, if you can't get along with him or her, you're likely to have a dreadful time.

Many artists argue that it doesn't matter whether you do or do not get along with a dealer: the only thing that really counts is whether or not the dealers *sells* your work. I know I myself have stayed in many galleries where I couldn't stand the curator: I needed the money and/or the exposure. But I have also stopped dealing with galleries whose curators I could no longer tolerate, even though those curators were, in fact, selling a considerable amount of my work. Despite the money those curators generated for me, I got to the point where I couldn't stop thinking, *How much is it worth for me to have a bad day every time I have to talk to that dealer on the phone? One day she treats me like a baby, as if I didn't*

know the first thing about the business of art. But then the next day she's all fancy and sweet because she has a new idea about my career which she hopes I'll like.

So now, it is indeed important for me to "size up" a dealer before allowing that gallery to handle my work. I don't want to relate to curators who think they're doing *you* the world's biggest favor just by handling your work, who won't acknowledge that it's a partnership, that you're each doing something for the other.

(2) It's also useful to remember that viewings can only go one way or the other. Either the dealer is going to say *Yes* and be gracious about it, wanting to know *everything* about you: how long you've been working, where you grew up, what your grandfather did for a living— the whole bit—to get some historical "sense" of you.

Or, the minute the dealer sees the first piece, he just can't stand it. He doesn't like your work, he doesn't like you, and he's trying to figure out how to get rid of you as quickly as possible. And you hope he succeeds, because you already understand the situation.

Although viewings aren't always a mere matter of the dealer completely loving *or* hating your work, it's good to realize that, basically speaking, viewings are a *Yes* or *No* situation.

Keep in mind that, after all, it's only a viewing, that they can only say *Yes* or *No,* and that you will love your work just as much if they tell you *No* as if they tell you *Yes.* Your career is *not* on the line; your work life is *not* in jeopardy; and your love of your own work is *not* in danger. It's only one viewing, only one dealer's opinion—over the years, you will have many, many viewings that will be successful.

(3) Be prepared for criticism, because when some dealers tell you *No,* it can be a complicated *No.* Many dealers won't simply say, *I'm sorry, we already have as many artists as we can handle. Thank you anyway.* They go

into a full-blown discourse on why your work doesn't "make it."

- Be prepared for the gallery owner who's so rude he tells you, *Why are you wasting my time? Are you crazy? I can't handle your work. I would never handle this stuff!*
- Be prepared for the dealer who's had such an awful day looking at forty other sets of slides that by the time you arrive, she can only take one glance at your portfolio and snap, *Maybe you're in the wrong profession. Maybe you should try commercial art or just get a regular job and have a family.*
- Be prepared for the curator who's so weird that even though he seems thoroughly interested in your work, even though he spends time asking you a hundred questions, he nevertheless winds up the viewing by pointing his finger at your signature while asking, *But who's ever heard of you? Who are you? You're not famous—you'll never be famous. No one will ever know who you are! I only handle superstars!*

You have to learn how to withstand such crazy comments. You have to realize that such irresponsible and insensitive remarks are merely the dealer's ungracious and lazy way of getting rid of you, that the dealer does not have the respect and decency to tell you, *I'm sorry, I don't think we can handle your work right now.*

Don't let crazy, insensitive criticisms get to you. If a dealer tells you your work is *too small,* don't run home and start stretching bigger canvases, because invariably the gallery right next door will tell you your work is *too big!*

Remember (even if many curators forget it) that you're going to a viewing to do business—not to have a critique. If the dealer starts to give a critique when a cri-

tique is the last thing you want (most likely you want
money, not criticism), ignore the critique. Don't get an-
gry, don't cry, or slam your fist at the dealer, or tell him,
What a damned fool you are for not liking my work! Just
learn to bounce back.

(4) Don't let six or nine months pass between each rejec-
tion. Don't let some dealer's remarks depress you so
much that you don't go to another viewing for months
and months. You can't wait that long between rejects or
you'll be 90 before you see any action at all!

You can't afford to spend six months in bed trying to
figure out why that gallery dealer didn't like your work.
If one dealer is awful to you, forget about it and go to
another viewing. Go again . . . and again. Be strong
enough to have several viewings in a week or in a month.
Yes, you may not want to have another viewing the day
after a rejection. But don't get so depressed that you stop
trying. Prepare yourself for some rejects, so you can
handle them—so that you can "keep on keepin' on."

Remember, there's going to be a gallery that re-
spects, admires—perhaps even loves—your work.

(5) At a viewing, you should also be prepared to face any
number of problems besides rejection and criticism. Be-
fore I got my first major show, the curator had to say
Yes, the gallery owner had to say *Yes,* and the owner's
girl friend had to say *Yes.* That's a lot of yeses, and I
thought I'd have a nervous breakdown waiting for each
one of them. And then, just when I thought I had heard
the final *Yes,* I learned the gallery was hiring a new cu-
rator and out of respect to the new curator, he, too, would
have to say *Yes.*

At a viewing, you might, in fact, find yourself in many
other situations: the dealer could keep you waiting a whole
hour while he leisurely eats his lunch . . . your view-
ing could be going splendidly when all of a sudden the
curator takes half an hour out to chat with her husband

on the phone . . . you expect to have a viewing with only one person, but when you show up, just about everyone present in the gallery—the entire staff, the gallery's bookkeeper, another artist waiting for an appointment, even a few collectors there to see the present exhibition—is privy to the viewing because the gallery has no private office. Unfortunately, there's little you can do under such circumstances: keep calm, stay cool, and just remember how much you love that stuff in your portfolio.

12

PREPARING TO NEGOTIATE WITH DEALERS

You're having an appointment with a gallery to view your work: you walk in, sit down, and hand the curator your portfolio. The dealer first quietly reads your résumé . . . views your set of slides . . . and studies the portfolio of work. Then, looking up from the desk, he says: *I'm crazy about this stuff. I want to handle you.*

This would strike many artists as an easy viewing, indeed as a "dream" viewing. As soon as a dealer says those magic words—*I want to exhibit your work*—many artists sit back, relax, and give a great big smile of relief. They've been so nervous before their viewings—*Will the dealer hate my work? Will he reject me? What if I've brought the "wrong" pieces?*—that the minute they get accepted by a gallery, they think all their problems are solved: they can just go home to their studios and work.

I would be the last person to deny that getting accepted by a gallery is a relief. But it by no means solves all your problems. In fact, in many ways, it's just the beginning of a whole new set of issues—of problems and pressures and challenges and heartaches. Getting accepted by a gallery in no way means you can simply return to your studio to live happily ever after.

Because once a dealer says he's interested in your work, once he says he wants to start handling and showing your work, you have to start talking business. You have to start discussing the details: you have to begin to negotiate. Galleries have, in fact, many *different* things to offer an artist (a one-person show, a two-person show, a group exhibition, an exclusive, and so on), and you should know how you feel about these different possibilities ahead of time.

Quite often an artist will be so grateful when a gallery has agreed to handle his or her work that the artist is willing to agree to anything—and everything—the gallery wants. But always be careful, always realize that you have the right—and the obligation to yourself—to make *your* needs known. After all, the artist-dealer relationship is a *mutual* affair: if you have certain obligations to the gallery, the gallery similarly has certain obligations to you.

Many artists just beginning to deal with galleries think that they're not in a position to "negotiate" because they're not well-known, not "established." But this is not completely true.

Once the gallery says *Yes, we want to handle your work,* you're automatically on a completely new level with the gallery, and it's up to you (even though you may think you're just a beginner with no bargaining rights) to negotiate your business well.

Don't be difficult and overbearing the minute a gallery accepts you. It would not be such a great idea if you immediately told the curator of your first show, *Well, I want you to paint all your walls with a fresh coat of white paint and I don't want a show in either July or August because I've heard those are "bad" months and when you do give me a show I think you should make a four-color announcement and of course I want a poster made up for the show and yes, I want I want I want . . .*

You'd be a fool to make such demands: the gallery, finding you a ridiculous upstart, would probably not want to deal with you at all!

But if you handle these details in a businesslike manner, the gallery may respect you as a knowledgeable, professional busi-

ness person. (Of course, it may not want to handle *anyone* who makes *any* requests in *any* manner whatsoever, businesslike or otherwise. But in that case, you'd be better off with another gallery anyway.)

There's simply no way of knowing how a gallery will react when you start asking about details. You have to "proceed" slowly, choose which points you want to begin with, and see how the gallery responds.

Each detail should be approached carefully: often they can be handled socially. For example, if you're having the dealer over to your studio to look at your work a few weeks after he has accepted you, why not say: *Look, there are a few things I want to know about, a few things that concern me. What are your feelings about, let's say, resale contracts? I'm beginning to believe in them and I was wondering if you're willing to use them?*

You don't have to phrase it as a demand—you don't have to be offensive about it, bellowing: *Look, don't think you're ever gonna stop me from using resale contracts, because you're not.* No, you can simply say: *I'm just curious. I've haven't had many shows yet and I'd like to know your thoughts on a few issues.*

In other words, first find out about the gallery's policy on a particular issue and then decide: *Should I make a stink about this one, or can I live with it?*

Don't expect to get everything you want right away. Learn how to negotiate, how to compromise. Of course, continue *working* at getting the things you really believe in, but if maintaining business with a particular gallery is especially important to you, learn how to bend a little. If, on the other hand, you decide the gallery's unwillingness to bend at all is too humiliating for you to endure, don't be afraid to say, *No, I can't take this anymore.* What's the point of having a nervous breakdown? What's the point of endangering your work life? If your dealings with a gallery are going that poorly, you might as well wait another year and have your show somewhere else. Remember, if you look hard enough, there's always going to be a gallery that treats you correctly.

Generally speaking, the more experience you have, the more you can ask of a gallery. If, for example, you're having a third show with the same gallery that gave you your first two shows, you could reasonably expect it to do more for you this time around. The fact that it keeps you on that long suggests it's doing quite well (financially, aesthetically, critically, and so on) from your work, so you could, in fact, expect a few things such as some more promotion, a catalog for the show, a poster, a color announcement, a few big ads, or an out-of-town show.

Of course, no matter how many shows you have, you should still expect to negotiate and compromise. You're still always going to have to ask yourself, *How far can I push before they tell me to go show somewhere else, before they remind me, "You know, we've got 5,000 other artists dying to have a show here. We don't need any trouble from you."*

Unfortunately, there *are* many more artists than there are galleries, and gallery folk *are* just like other people: they can be pushed only so far before they say, *Enough! We don't want you around anymore. Stop bugging us with all your demands. Stop criticizing our business practices. We don't want to hear about copyright laws, about resale contracts, about delivery costs, and artists' rights. Enough already!*

So, don't always be pushy and demanding and uncompromising. Just remember that you *always* have the right to at least consider your own best interests, you always have the right to make *your* needs known, and you always have the right to know the gallery's intentions toward you. After all, you *do* have a stake in your business affairs. As artist Mark Wheeler has said, it's important to remember the fact that when you consign an artwork to a dealer for sale, "you are in fact loaning your money (in the form of time, materials, travel, and so on) to that gallery with the intention of realizing a profit. Since no one expects a loan from a financial institution without first answering some questions, why then should you, as an artist, be expected to loan anyone anything without your first asking—and getting solid answers to—a few questions? Take the attitude that *you are ap-*

pointing the gallery to represent *you as an artist,* and that it is *your decision* to appoint only those dealers who meet *your requirements.* Don't feel badly if the gallery throws you out. It is much better to find out now about potential problems, before effort and expenses become excessive. The chances are very good that any dealer not willing to work with you at this point is not worthy of further consideration. Galleries have generally required artists to meekly consign artworks to them without questioning their integrity. But you don't have to go along with this. The more artists who take a solid businesslike approach to their profession, the more rapidly will irresponsible galleries be eliminated. Remember, it is your money—not to mention your talent and artistic skills—that's on the line." *

* "Checking Out Galleries," *American Artist Business Letter* (April 1979), 6(1):2–3. Mark Wheeler lives in Ketchikan, Alaska.

13

QUESTIONS TO
ASK YOUR GALLERY

Before you even show up for a viewing, you should not only have some idea of what you want or don't want from a gallery; you should also know how to discuss and negotiate your desires within the context of the art business world. Establishing a relationship with a gallery is, quite simply, easier if you speak the gallery's language.

It *is* a good idea to have with you a checklist of the more important items you want discussed, defined, and agreed upon if the gallery accepts your work:

Here's a checklist I find useful.

(1) How will the gallery handle your work?

Will the gallery give you a one-person show? a two-person show? a group exhibition? Or does the gallery want to begin by taking a few pieces on consignment?

Each of these possibilities has its advantages and its disadvantages. Certainly a one-person show comes with a certain amount of prestige and honor, but such shows also entail an enormous amount of work and pressure. Getting ready for a ma-

jor exhibition takes time and herculean energy. First you have to endure the agonizing process of choosing which works will be in the show. (Or, in many cases, you have to sit back and endure the equally agonizing process of watching the curator choose the works.) Then you have to make sure all the pieces are properly framed, titled, signed, priced, and copyrighted. Announcements, mailing lists, press photos—all take time to discuss and prepare. And of course, with a one-person show you're incredibly vulnerable and exposed: it's *your* work filling up that gallery and *all* yours!

A two-person show also presents certain problems: are you willing to have that two-person show with *any* second artist the gallery chooses, or do you want to be able to refuse to show with someone whose work you really don't respect? Remember, sometimes a curator will get a strange notion of how to combine the work of two artists. You might be mortified by the combination; you might think your work is cheapened by the other artist's work. (Of course, the other artist might feel the same way about your work.)

Some artists think it's better to have a two-person show regardless of the quality of the second artist's work. But other artists feel it's better to wait than to have a two-person show (or a group show for that matter) with an artist (or artists) whose work you don't respect. Artist Clyfford Still, for example, refused to participate in *any* group exhibitions because he didn't feel that an artist's work was truly *seen* in a group show: he called such shows "minestrone—all jumbled" with no one particular impression seen or felt.

If the gallery doesn't want to give you a show right away, but instead would like to take a few pieces on consignment, you might want to discuss *where* the gallery is going to keep your work: Will it keep it:

- in its drawers, where a collector can't get to it without the aid of gallery personnel?
- in its bins, where the collector can get to it by leafing through?

- on its sliding panels, where it is at least "hanging," but where it is often not in full view?
- or will it keep some pieces on the wall, framed, where they are the most visible, the most accessible, and hence the most "saleable"?

Remember, if you don't want any unpleasant surprises about the way the gallery is going to handle your work, you should discuss all the possibilities listed above as soon as the gallery has agreed to handle you. Once, for instance, a friend of mine was booked for a one-person show at a good downtown gallery in San Francisco. He was very excited about the show; he liked the pieces the curator had chosen to exhibit; and the curator had even allowed my friend to design his own announcement. But when my friend arrived for the show's opening, he learned much to his dismay ("horror" might be a more appropriate word), that he, in fact, was having a two-person show, not a one-person show.

The curator had thought some "campy" sculpture might "liven up" my friend's paintings, which were very minimal and austere. Each artist's work ruined the other's, and my friend was disheartened and depressed. But it was too late to do anything about it: he had no written agreement stating he was to have a one-person show. And besides, the guests, of course, were already arriving, so all he could do was stand there with a glass of wine in his hand, trying to stay alive.

(2) What will the gallery handle?

One of your media? all of your media? some of your media? Are you willing to get into an "exclusive" arrangement with the gallery?

Many artists work in more than one medium, and you should know which media of yours the gallery wants to handle:

- If you're a painter *and* a printmaker, and the gallery is giving you a show of your prints, does the gallery also want to handle your paintings?

- If a gallery is handling your current paintings, does it want to handle your *new* paintings as well?
- If the gallery agrees to handle *only* your watercolors, does the gallery understand that you are then free to find another gallery in the same city to handle, let's say, your oil paintings?

Just because a gallery agrees to handle some of your work doesn't mean it necessarily has rights to handle *all* of it. Sometimes when a gallery wants to handle your work, it indeed wants to do so on an exclusive basis—that is, it wants to be the *only* gallery in, let's say, California to show your prints, or it wants to be the *only* gallery, let's say, in Los Angeles to handle your work.

This may sound wonderful to some artists: the word "exclusive" has a nice ring to it; and some artist might think, *Well, it's easier to do business with only one gallery than keep track of five or six, so why not agree to an exclusive?*

Exclusives, however, can be quite disadvantageous to an artist. You should be wary of signing any exclusive until you really think about the possible consequences or until you consult other artists or a lawyer. Certainly, exclusives can limit your sales potential.

For example, a friend of mine who was just beginning to market her work was asked by her first gallery to sign a contract giving the gallery an exclusive on her work throughout California. The dealer then took four pieces of her work on consignment: he didn't buy any of her work outright, nor did he offer to give her a show. Some time later, my friend's aunt (who worked for a large corporation outside San Francisco), introduced my friend to the corporation's vice-president, who liked my friend's work so much he bought a $1,200 painting from her studio.

Because of her exclusive contract which stipulated that the gallery would take its 50 percent commission on *all* works sold, my friend had to give the gallery $600 of that $1,200, even though

the gallery had never given her a show, had never sold a single piece of her work, had never included her name in any of the gallery's publicity. The gallery even insisted that the billing for the $1,200 go through it, which meant that the gallery got the $1,200 and, at the end of the month, sent my friend her $600.

I was once asked to sign an exclusive contract which stipulated that the gallery would receive its commission on any and every work that left my studio. Even if I were giving one of my works to a friend as a Christmas present, the gallery wanted either the right to give away a similar piece of my work or its commission for that piece, in *cash!* The exclusive, for all intents and purposes, gave the gallery a joint-ownership of my work.

Exclusives are particularly disadvantageous for artists who make prints and other multiples, especially if the edition of those multiples is very large. Why should, for example, one gallery tie up your prints and only sell perhaps ten prints a year when you can just as easily have six or seven galleries handling the prints simultaneously?

If you sign an exclusive with a gallery, the gallery should at least guarantee you some action: it could, for example, buy some of your work . . . or guarantee you a certain amount of sales per month . . . or advance you money against future sales. Don't tie up your work for a long time without getting something in return.*

If you are unsure about an exclusive, you might agree to an exclusive for a two or three month "trial" period: at the end of that time, if the gallery hasn't produced much action for you,

*If the gallery does advance you money, you must know what will happen if the gallery doesn't sell enough work to equal those advances: (1) Will you then be asked to pay back the advance? or (2) Will the gallery then take possession of your works equal in price—the retail price that is—to the sum you owe the gallery?, i.e., the gallery advances you $12,000 in one year and makes no sales. Will the gallery then take $24,000 worth of your work (if they were taking a sales commission of 50 percent)? and (3) If the gallery does indeed take possession of certain of your works, who chooses the works—you or the gallery? These possibilities must be discussed if the gallery advances you money.

you can then renegotiate. Renegotiating would not necessarily mean pulling out of the exclusive—it might mean that you would want certain guarantees on paper. You've proven your good intentions by agreeing to the trial period. Now let the gallery prove its good intentions by providing some guarantees.

(3) How long will the gallery handle your work?

Among the most basic variables of any agreement or contract is the duration of that agreement. When a gallery agrees to handle your work, you should know how long that agreement will last. If the gallery is giving you a show, will it continue to handle your work on an ongoing basis after the show? Is its continuing to handle your work contingent upon sales? Under what circumstances can the gallery terminate the agreement? Under what circumstances can you terminate the agreement? If the gallery undergoes a change of ownership, can you terminate the agreement if you so desire?

(4) Will the gallery buy some pieces of your work?

Many artists think galleries only *sell* work to collectors—they don't know galleries also *buy* work directly from their artists. Galleries won't usually *offer* to buy your art, but if you actually ask them to buy a few pieces (especially prints or other multiples) as an act of "good faith," many galleries will indeed purchase some of your work, allowing you to have money "up front."

So, once a gallery has agreed to handle and show your work, you may not want to offer to leave everything on consignment. Once you've given it everything on consignment, it's too late to say, *Well, how about buying a few pieces outright?* A gallery that buys a few pieces of your work is that much more likely to sell those works to a collector. Many galleries push harder for works they've bought than for works merely left on consignment.

When a gallery buys your work outright, it may want a large

discount. Let's say, for example, the gallery would normally get a 30 percent commission on consigned work—that is, on a consigned work that sold retail to a collector for $100, the gallery would keep $30 for its commission and give you the remaining $70. But that same gallery might ask for a 50 percent commission on prebought work. That is, the gallery would give you only $50 up front, so it would then make $50 when it later sold the work to a collector. I myself have gone as high as a 66 percent discount for a large (several thousand dollars) prebuy sale.

There are times when it's especially important for you to ask a gallery to buy works: when, for example, your work is particularly inexpensive. I have a series of soft sculpture dolls that are priced very, very reasonably—as low as $6. I would never leave those dolls on consignment because it would not be worth my time to send bills and do all that paperwork for a $6 sale. I want the money up front, and I believe the gallery should be willing to give me that money up front on such inexpensive items.

I also don't think it's a good idea to leave lots of prints on consignment. If, for example, you have an edition of fifty prints and the gallery asks you to leave more than five of them on consignment, you would be foolish to do so: you'd be taking too many of your prints out of circulation with no guarantee of sales. If the gallery wants more than five prints in a very limited edition, let it buy some up front, or let it take one or two on consignment, and call you when it needs more. That way you'll at least have the chance to sell those prints elsewhere.

Keep in mind that I'm not telling you to *demand* that a gallery buy some of your work up front. For one thing, many galleries simply can't afford to—many galleries are standing on shaky financial ground themselves. But suggest it to a gallery because a gallery will never suggest it to you. It's only a matter of getting that first sentence out—*How about buying some of my work?*— and you'll find that many galleries are indeed willing to buy your art.

Also keep in mind, the more you show, the harder you should try to get a gallery to buy your work. Because once you're

showing a lot, you should be getting something for all the time it takes to handle all those galleries. Why go through the aggravation of one more show—particularly if it's an out-of-state gallery—without any guarantee of money?

One last thing: although there are certain occasions when you want to make sure the galleries buy *some* of your work up front, there are other occasions when you want to be careful that the gallery doesn't buy *too much* of it. Some galleries, for example, will offer to buy virtually an artist's entire output of major work, planning to put those works away until they're worth much more. Let's say, for example, in 1975 you sold many major works to Gallery No. 1. In 1985, you are having a new show with Gallery No. 2. This second show is quite successful—great reviews, many sales, and so on. Because of your recent success, Gallery No. 1 decides to show your works, which it purchased in 1975: wanting to take advantage of all your recent success, Gallery No. 1 charges much higher prices for those earlier works than it paid you. You may not, to put it mildly, want a gallery to treat your work in such a manner. So, be careful about selling a gallery too much of your work. Remember, if you sell a considerable amount of your work to a gallery and you later come to bad terms with that gallery and leave it, you are then leaving your past production "in what may have become hostile hands." *

(5) What is the gallery's commission?

Although the gallery's commission is among the most basic issues to be settled between artist and dealer, many artists forget to discuss it at their viewings. Different galleries charge different commissions: some galleries take a 30 percent commission on any work they sell; others take 40 percent; and still others 50 percent.

You should know the gallery's commission before you leave any work. In fact, the commission should be listed on your

*Franklin Feldman and Stephen E. Weil, *Artworks: Law, Policy, Practice* (New York: Practicing Law Institute, 1974), p. 498.

Consignment Receipt (see Appendix 6). Only then can you have some idea of how much money you'll earn when the work sells. And only with a written agreement on commissions can you prevent a gallery from raising its commission in midstream without your permission.

Keep in mind that a gallery's commission can vary depending upon the price of the a work. You may, for example, get a gallery to agree to take a 50 percent commission on works under $3,000, but only a 40 percent commission on works in the $3,000 to $8,000 range, and a 30 percent commission on works over $8,000. Also remember that a gallery's commission may vary with the nature of the sale, so you should know what the gallery's commission is for all kinds of circumstances, including:

- arranged lectures
- prizes and purchase awards obtained for the artist
- "double" commissions, that is, when your gallery arranges for another gallery to show your work
- copyright use sales
- and any other commissioned work obtained for the artist.

(6) When will the gallery pay you for works sold?

Different galleries also have different payment schedules. If one particular gallery sells one of your works, you may, for example, expect to get paid right away. Other galleries pay only at the end of every month, or at the end of every other month.

I favor being paid as the work sells, especially if it's a major work. Let's say, for example, a gallery sells a $2,000 piece of your work on the third of January. The gallery's policy, however, stipulates that it pays its artists at the end of every other month. In this case, you might have to wait almost two months (to the end of February) to get your money!

If you discuss such matters at the very start of your relationship, you might, for example, get the gallery to agree that on major sales of over (let's say) $750, the gallery will pay you as soon as the collector's check clears.

(7) Does the gallery want to rent your work to a collector?

It is common practice for some galleries to rent the work they exhibit. A collector, for example, who is interested in a major piece, may rent that piece for three months to see how he "lives" with it before making his final decision to buy it. Or a corporation that likes to have artwork on its walls but wants to change that artwork every six months, may rent work regularly from a particular gallery.

Renting work can be advantageous to an artist, providing both added income and exposure. (During the six months that a corporation rents one of your works, it could be seen by hundreds if not thousands of people.) But you should specify from the onset of your relationship with a gallery whether you do, in fact, want your work rented. And you should similarly learn:

- the gallery's rental rates
- your share (percentage) of those rates
- when you are paid your share of those rates (you should generally be paid within 30 days of the gallery's receiving its rental fee)
- whether the gallery allows part of the rental fees to be applied to the purchase price, should the collector decide to buy the work
- and who is responsible for the work's care and protection while it is being rented: the gallery, the renter, or you (Don't agree to any rental policy that makes you responsible for the work's care and protection. The cost of insuring your work during the rental period would probably diminish your rental earnings so much as to make the rental not worth your while.)

(8) Does the gallery want to budget sales?

To make a sale easier for a collector, a gallery will sometimes allow the collector to budget the sale, that is, to buy "on time." There's nothing wrong with budget sales: in fact, you

yourself might want to budget sales you make directly out of your studio.

You and your gallery should discuss, however, the budgeting terms in detail, so that you both agree on the issues at stake:

- Must the gallery get your approval for extended budget plans?
- If one of your works is sold on time, when do you get paid?
- If the collector proves delinquent in his or her payments, who is responsible for such credit risks—you or the gallery?
- Does the gallery agree that until the last installment is paid, you are, in fact, still the legal owner of the work?*

(9) What is the gallery's policy on discounts?

Sometimes a gallery will ask if you will agree to a "discount." For example, if an interior decorator buys a painting for one of his clients, the interior decorator as a trades person will expect to get a discount on that painting—usually a 20 percent cut. In other words, the interior decorator is buying your painting wholesale, and he then sells it to his client retail. But who "pays" for the decorator's discount: does his 20 percent cut come

*The Sample Consignment Sheet included in this book (see Appendix 6) does in fact stipulate that you are the legal owner of the work until it is paid for in full. As mentioned in Chapter 6, ten states have passed consignment legislation, which in some cases addresses the various questions listed above. The Connecticut law, for example, requires that the consignment agreement include a written provision setting forth payment schedules. The California Artist-Dealer Relations Law stipulates that the artwork remain in the artist's name until the very last payment has been made. The California law also requires the dealer to pay the artist's share first, unless the parties agree otherwise in writing. For example, if the collector pays the art dealer $1,000 for the artist's work in $100 installments, and if the dealer's sales commission is 50 percent, then the dealer must pay the first five installments to the artist *before* receiving any of the $500 sales commission.

out of your part of the income, or the gallery's, or is it a shared expense? As a rule, the discount should come out of the gallery's commission.

(10) How does the gallery feel about studio sales once it starts handling your work?

Studio sales are often the cause of disputes between artists and galleries. After a gallery agrees to handle your work, you may, of course, wish to continuing selling to friends, relatives, and former collectors without the assistance of your gallery. In such cases, you may be understandably reluctant to pay the gallery a commission on a sale in which the gallery played no direct role. Unless you've signed an exclusive agreement with a gallery, you should indeed still have the right to make studio sales without commission to the gallery.*

If you do have an exclusive agreement with a gallery, you might still discuss special arrangements for those studio sales in which the gallery has played no role. You could, for example, arrange to have the commission for studio sales be set at a lower rate than for gallery sales—at 20 percent, let's say, instead of 40 percent. Or you might ask the gallery to permit you to make a specified number of studio sales each year without paying a commission. Once you had made the specified number of studio sales, the gallery would be entitled to its full commission on any additional studio sales. That way, you could still accommodate

*Of course, you should still never undersell your gallery. If, for example, a print of yours sells retail at the gallery for $200, it must also sell for $200 in your studio. You can't think, *Well, if I sold it through the gallery and they deducted their 50 percent commission, I would only get $100. Therefore, I should only charge $100 when I sell it directly from my studio.*

As mentioned earlier, if you did charge only $100 for the same print that sells for $200 at the gallery, obviously a collector will buy it from you and not the gallery. Therefore, you'll be underselling your own gallery; and the gallery, no longer having a financial incentive to handle your work, will drop you.

friends and relatives without paying any commission, while insuring that you do not compete with your gallery on a large scale.*

(11) Do you want the curator to visit your studio to see the full scope of your work?

If a dealer is going to handle your work well, he's going to have to *know* your work. He needs "ammunition" to answer collectors' questions, he needs to do his "homework" to know about your history as an artist—your past styles, your tools, your procedures, and so on.

The best way for a dealer to get such information is by visiting your studio at least once, if not regularly. So when a gallery agrees to handle your work, you may want to ask the dealer to pay you a studio visit. Some curators are only too happy to do so; others will oblige if you press the issue; and still others will refuse outright. But it is important to ask.

(12) Will the gallery permit you to use a resale contract if you so desire?

In 1958 Robert Rauschenberg sold one of his paintings to a collector for about $900. At an auction in 1973, the collector resold that same $900 work for $85,000! According to reports in *Time,* after the auction, Rauschenberg, obviously angry, went up to the collector and said, "I've been working my ass off for you to make all this profit." Later Rauschenberg told the press, "From now on, I want a royalty on the resales, and I am going to get it." What Rauschenberg was asking for has since become one of the hottest issues ever to hit the American arts scene: resale or residual rights.

In recent years, many artists—understandably upset that when their early works increase in value, only collectors and dealers enjoy the profits—have started to use "resale contracts" when-

*These two alternatives were suggested in a sample artist-gallery agreement drafted by the Lawyers for the Arts Committee of the Philadelphia Bar Association.

ever they sell a work to a collector. Such contracts are designed
to give an artist:

- 15 percent of any increase in the value of a work each time
 it is transferred
- a record of who owns each work at any given time
- the right to have the work unaltered by the owner
- the right to be notified if the work is to be exhibited
- the right to show the work for two months every five years
 (at no cost to the owner)
- the right to be consulted if restoration becomes necessary
- half of any rental income paid for the work, if there ever
 is any
- and, all reproduction rights.

A resale contract thus allows you to participate in the finan-
cial future of your work, but the benefits of such contracts go
beyond monetary matters: resale contracts allow you to "keep
in touch" with your artwork for the rest of your life. If, for ex-
ample, a collector later resells one of your works, the resale
contract requires that you be given the new collector's name and
address. As arts advocate Rubin Gorewitz has said, "For the first
time in 5,000 years, artists will have a way of knowing where
their works are. The umbilical cord between the artist's creation
and himself will not be severed." In many ways, a resales con-
tract "pays respect" to your artwork: the contract acknowledges
that purchasing artwork is different from buying a dishwasher or
a television or a Cuisinart. Such contracts, Rauschenberg says,
are "one of the first steps toward lawfully allowing the artist to
be a first-class citizen and a protected, self-employed business-
man."

For those artists interested in using a resale contract, I have
included a sample agreement with instructions for its use (see
Appendix 4). The contract was conceived by Seth Siegelaub and
drafted by Robert Projansky, a New York attorney. (Hence, the
reason why such contracts are often called "the Projansky.")

Remember that this is only a sample contract: you can adapt it to suit your own needs. You may, for example, decide that you don't really care to use such a contract for *all* your work, but only for your paintings, let's say, and not your prints. Or you may decide that one or two of the clauses don't really matter to you, and you can therefore delete them from your contract.

If you do decide to use these contracts, discuss the matter with your gallery. Many galleries are not great fans of such contracts. Be prepared: if you strongly care about these issues, familiarize yourself with the pros and cons, so you can fully explain your beliefs to dealers and prospective collectors. Have your "ammunition" ready. You might, for example, tell a collector who's hesitant to sign such a contract that the contract actually provides him, the collector, with certain protection and benefits, that the contract requires you, the artist, to provide the collector with a provenance of the work he's purchasing—that is, with a historical document that authenticates the work and details its history. Or you might inform a hesitant dealer or collector that many European countries have had resale laws (frequently called *droite de suite* laws) in effect for decades. Or you might point out the fact that United States copyright laws give other kinds of artists—authors, composers, playwrights—the right to receive royalties for commercial use of their works, and that the resale contract gives a similar right to visual artists. You might also agree to give your gallery a commission on the residual— that way, the dealer will have an economic incentive to use the Projansky. These contracts are controversial, so try to get to know the basic arguments.*

*On January 1, 1977, the Resale Royalties Act went into effect in California. Although the California law was designed as a prod to national legislation. a national law has not materialized. In fact, California remains the only state in the country to pass resale royalty legislation. Similar legislation has been introduced in other states, but it has never been approved in any state other than California.

Under the California Resale Royalties Act, living artists are entitled to a 5 percent royalty on the *gross* sale price when the artist's work is resold in Cal-

(13) Will the gallery help protect your copyright and right to credit?

If you copyright your work (and I think all artists should do so), you should inform the gallery that you want your copyright protected. If, for example, the gallery reproduces one of your images for publicity purposes—in an ad, an announcement, or in a duplicate set of slides, let's say—that reproduction *must* include your copyright notice. And if the gallery sells one of your works to a collector, the dealer should inform the collector that he or she has bought the work but *not*—unless expressly stated—the reproduction rights to that work. (The standard Projansky contract retains all reproduction rights to the artist.) Reproduction rights can be worth a fortune: reproductions of B. Kliban's cat drawings, for example, form the basis of a $50-million

ifornia or by a California resident, at an amount greater than $1,000, and greater than the seller's original purchase price. The act applies to work created before and after January 1, 1977. Unfortunately, only paintings, sculpture, and drawings are covered by the law, and not such artworks as photographs, prints, fiber art, and so on. Also, the law does not mention the artist's right to approve restoration, to borrow the work, or to be informed of the new owner's name and address—all three of which are features of the standard Projansky contract.

The California law was amended as of January 1, 1983, so as to extend coverage twenty years after the artist's death for the benefit of his/her estate. (Protection under the original law lasted only during the artist's lifetime.) Other amendments include provisions to allow artists to assign royalty collection to a third party or to an agency, such as Artists Equity; to provide attorneys' fees for the prevailing party, that is, if an artist wins a lawsuit against a violator of the Resale Royalty Act, then the violator will have to pay the artist's legal fees; and to exempt for up to a ten-year period sales of works purchased by dealers from artists and also sales of these works between dealers until after the first sale to a collector, so as not to discourage dealers from purchasing directly from artists.

Although the California Resale Royalties Act is certainly a landmark and a step in the right direction, it nevertheless offers limited benefits and protections when compared to the standard Projansky contract. So even though I am a California artist, I still use the Projansky.

worldwide industry. So, you should always be sure your gallery understands your copyrighting policies.

You should similarly make sure the gallery understands your "right to credit," that is, that the gallery knows your name must accompany your work on any reproductions thereof, and also on invoices that mention your artwork.

(14) Will the gallery provide you with the names and addresses of people who buy your work through the gallery?

An interested collector is a very, *very* important person in your life. Most collectors are extremely interested in your work—its progress, its new directions—and once a collector purchases a piece of your work, he or she is often interested in buying another; maybe not right away, maybe not even next year, but perhaps two or three years later, that collector will be back. So, the names and addresses of your collectors are like gold to you: they're a treasure—your investment in future sales.

But sometimes when a gallery sells one of your works to a collector, the gallery is very reluctant to give you the collector's name and address. A gallery will often tell you, *Well, if I give you the collector's name, you might invite him over to your studio and sell him some work directly, without giving me my commission. Besides, I'm not going to share the names with you, because that collector really didn't buy "your" work—he just bought whatever I recommended. He's in "my" pocket. When you're no longer in my gallery, I'll just sell that same collector another artist's work, because he's my collector, not yours.*

If a dealer gives you such a ridiculous argument, you owe it to yourself to:

- assure him that as long as he's handling your work, you will never sell a work to a collector the gallery's referred to you without giving the gallery its commission
- remind him that when you have a show at his gallery, you're going to give him—or send out—*your* confidential

mailing list, allowing hundreds of people to visit his
gallery and hence be added to his mailing list
• ask him what would happen if the gallery closed (and gal-
leries do indeed close at an alarming rate). How would
you have any idea who had bought your work from that
gallery? If you needed access to one of your sold paint-
ings—let's say for a retrospective—how would you ever
know who had that painting?

I feel quite strongly about the gallery's obligation to provide
you with your collectors' names and addresses. If you, too, feel
strongly about this issue, you should bring it up as soon as a
dealer tells you he wants to handle your work.*

(15) Do you have the right to remove stored artwork from the gallery during the year?

If you have left work with the gallery on consignment, you
may—for any number of reasons—want to take back that work
at a later date. What are the gallery's thoughts about this?

There are, of course, many situations in which you might want
a particular work returned from a gallery. Perhaps you want to
enter it in an art festival or a juried museum show, or perhaps
you merely want it back in your studio for your own pleasure.
You could, of course, offer to give the gallery another work in
place of the piece you wish returned. But you should know the
gallery's policy on taking works *out* of the gallery. Several gal-

*If your gallery agrees to use the Projansky contract, you will, of course, be
guaranteed of the collector's name and address: the contract takes care of this
issue. If you are not using the Projansky with your gallery, and the gallery is
reluctant to give you the names and addresses of people who buy your work
through that gallery, you might want to check into the consignment laws of
your state. According to the California Penal Code, for example, (section 536,
subparagraph a), every merchant who sells consigned work must, upon written
demand, provide the consignor (in this case, you the artist) with the names
and addresses of the purchaser, the quantity of works sold, and the prices ob-
tained.

leries make you sign contracts stipulating that they can return works to you for any reason whatsoever on 30 days' notice. (Some galleries even stipulate that if you don't pick up your work after a certain time, the gallery can actually *dispose* of the work!). But not all galleries will sign an agreement with you stipulating the reverse—that *you* can withdraw any work left on consignment on thirty days' notice. So discuss this issue with your dealer before you sign anything: find out how you can take some—or all—of your consigned work out of the gallery; know how each of you can terminate your agreement. Don't be surprised, and don't allow the dealer to have *all* the decision-making powers.*

(16) Will the gallery help with transporting artwork to and from the gallery?

Let's say a gallery wants to handle your paintings on consignment, and most of those paintings are very large. Who's going to pay for transporting those works to the gallery: you? the gallery? or will you take turns footing the bill?

Or, let's say, a gallery agrees to handle your prints, which start to sell very well indeed. Every few weeks the gallery is, in fact, calling you up to deliver another print. Who's responsible for the transportation and packing of the print? Should the gallery pick the print up at your studio? Or do you have to drop everything and deliver the work yourself?† Or do you and the gallery take turns? Is the work insured when the gallery is responsible for the transportation?

Or, let's say, the gallery sells one of your works to a collector. Does the gallery agree that it's standard practice for the gal-

*The sample consignment sheet included in this book (see Appendix 6) stipulates that you, the artist, may withdraw works on demand of one month's notice. So if your gallery signs this consignment form, you are covered with regard to this issue.

†If you are indeed responsible for delivering regularly to a gallery and you hate to leave your studio on such a frequent basis, don't forget to look into messenger services. Most cities have them listed in the Yellow Pages: they are usually quick, efficient, and not unreasonably priced.

lery to pay for the costs to take that piece to the collector? Or
does the gallery add transportation costs to the collector's in-
voice?

Transporting artworks can be both a major expense and a ma-
jor hassle. So you must know who is responsible for transport-
ing your works to and from the gallery. Make sure you discuss
this issue with your dealer.

(17) Will the gallery honor your price list?

Not surprisingly, pricing your artwork can be a messy matter:
money often complicates things. But no matter how messy pric-
ing your artwork can be—and it can indeed be a headache—one
thing should be kept in mind: *you* own the work and *you* are the
only one entitled to price it. Yes, a gallery can advise you—it
can tell you what price range it thinks your work should fall into.
And yes, a gallery can even refuse to handle your work if it
doesn't agree with your prices and you're unwilling to change
them. But you made the work, and if you want control over
pricing it, let the gallery know.*

(18) If your work needs to be framed, how will the framing costs be handled?

As mentioned in Chapter 7, framing your work can certainly
complicate your prices, and you should discuss these complica-
tions with your dealer: you must find out what she is willing to
do about the cost of frames. Who pays for frames? Will the gal-
lery pay ahead for the frames and deduct it from your share of
sales? If you are having a show and the gallery pays for frames,
how is ownership of the framed pieces at the end of the show
handled? If the gallery does indeed pay for framing, do you, the
artist, still retain aesthetic control—that is, over the choice of

*Again, if your gallery agrees to sign a consignment sheet, similar to the one
included in this book (see Appendix 6), then this issue of pricing is also cov-
ered: the consignment agreement stipulates that "the retail price of the above
works may not be changed without the written permisision of the artist."

frame, the color, the matting, and so on? If you pay for the frame, does the gallery get a commission on the frame and the work, or just on the work?

(19) How does the gallery handle returns and exchanges?

Let's say a collector buys one of your works from a gallery, and the gallery then pays you your share of the sale. Several months later, the collector wants to return it. Will the gallery refund the collector's money, and, if so, will the gallery ask *you* to return your share of that money? If the gallery doesn't refund the collector his money, but rather informs the collector that he can only *exchange* works, will the gallery tell the collector that he must select another one of your pieces, or is the collector free to choose any artist's work in the gallery? And if the collector does indeed exchange your work for another artist's work, will the gallery ask you to return your share of the money?

Obviously, you should discuss the gallery's policies on such matters with the dealer.

(20) Do you want to give the gallery any advice?

Do you want particular works of yours cleaned, stored, exhibited, and/or cared for in special ways?

Certain artworks require special care and you shouldn't always expect the gallery to know about that special care. If, for example, one of your works is transported in multiple parts, you should include detailed instructions as to how that work should be assembled. Or if certain of your works cannot be near sunlight, let the dealer know. If any of the works you leave with the gallery on consignment require particular maintenance or care, let the gallery know.

Don't forget that according to the consignment laws in several states (see Chapter 6), and according to the sample consignment agreement included in this book (see Appendix 6), it is the *gallery* that is fully responsible for "work lost, stolen, or damaged" while in the gallery's care. So, let the gallery know how

best to care for any works that may require special attention. Don't hesitate to check out the gallery's ability to prevent damage and theft and/or its ability to cover potential damage costs. Does the gallery, for example, have a burglar alarm system? a fire extinguisher? What is the average temperature in the gallery? Is any area of the gallery especially humid or damp? What is the gallery's insurance coverage? For what amount of market value will works be insured? Who decides value of damaged work and how? Who chooses the restorer if work is damaged? Who gets possession of damaged works if they cannot be repaired?

(21) If the gallery offers you a show, will it give you firm dates?

Who chooses the work to be included in the show and when? Who mounts the show? Which space in the gallery will you show in?

A show entails a thousand decisions, a thousand chores. If you're going to be as professional and efficient as possible in making these decisions and in accomplishing these chores on time, you must, first and foremost, know exactly *when* your show will be presented. When a gallery offers you a show, get written confirmation of the show's opening and closing dates, and of the gallery's hours during the show. Find out what day the work has to be ready to be delivered to the gallery, and what day after the show closes the work is to be returned. Learn if the show entails any other deadlines (résumés to be revised, photos to be submitted) or special requirements (restrictions as to size or weight of work—the gallery's doorways, for example, may not be as large as yours).

Also find out who decides which works will be included in your show. Of course, each instance is different (some curators are more flexible than others), but generally speaking, the selection of works should be a collaborative effort between you and your dealer. When I had my first one-person show, for example, most of the paintings included in the show were more or less self-portraits. I told my dealer that I strongly wanted one partic-

ular work (which was not a self-portrait) to be included in the show. I felt that this particular painting commented upon all the other works in the show, that it was, in some very important way, an "explanation" of the other works. Without this particular painting, my show, I felt, would not be complete. After discussing these matters with me, my dealer agreed: the particular painting would be included.

So talk over such issues with your dealer. Suppose your dealer agrees in January to give you a show the following December, and even chooses a few preliminary works. Many things can happen in the eleven months between January and December. What happens if one of the works selected for the show is sold in the meantime? Will the gallery allow you to exhibit a sold work? Do *you* want to exhibit a sold work? Should you not have sold the work? And what happens if during the intervening eleven months you begin to work in a "new" style? Will the gallery respect your artistic growth and ride with the changes, or will it only want to show your previous style?

Of course, you should at least listen to your dealer's comments and suggestions. Keep an open mind: be flexible—willing to compromise. But remember, when all is said and done, it's you—the artist—who has the final say. After all, it's your name, your work, and you shouldn't have to show work you don't want to show.

Also find out the dealer's feelings about mounting the show: will the gallery allow you some input? Will the gallery, for example, allow you to advise how high or low to the ground certain works should be hung if such information is critical to the aesthetic presentation of the works? Will the gallery hang certain works together if requested? And *where* is your show going to be hung? Galleries often have more than one room: you may think you're getting the main space, only to learn at a late date that you've been stuck with one of the middle gallery rooms. Of course, that might have been okay with you, had you known from the beginning. So, if you don't want any surprises, find out as much as possible in advance.

Will the gallery, for example, provide partitions, cases, stands, and other installation equipment at no expense to you? Will there be clean walls? no colored lighting? legible, accurate title cards? Will your name be on the wall of the gallery? on the window? on both? or just on the title cards? Does the gallery keep its lights on at night to allow passersby (that is, prospective collectors) to see your work? Will there be one price list floating around the gallery, or a stack of them, allowing collectors to keep one? During your show, will the gallery be willing to have unexhibited works stored on its premises? Will photos and slides of other works (not in the exhibition) be available in the gallery? Does the gallery have a slide viewer to present such slides? Who pays for these photos and slides? If the gallery does, does it agree you still own and control the negatives and transparencies? Will the gallery allow a statement by the artist or about the processes of the work to be visible during the exhibition? Will the gallery make copies of the artist's statement available to interested collectors during the show? Will the gallery keep a guest book during your show to maintain a list of prospective collectors and a notebook with your résumé and your photograph? Who pays for printing and revising the artist's résumé? During your show, will the gallery mention upcoming shows of your works—in, let's say, museums, cultural centers, or out-of-town galleries—to demonstrate the "demand" for your work? Will the gallery arrange and pay for an opening night reception or party for your show? If so, what will the gallery provide: flowers, food, wine, entertainment (music, performance artists, and so on), white tablecloths, extra security? And if you so desire, would the gallery permit you to have a private party in the gallery during your show—for example, a small cocktail party for ten to twenty special collectors? If so, how would it be handled? Would such a party, separate from the opening night reception, require any insurance changes?

Remember, when you are having a show and leaving your work on consignment, you are in fact providing the gallery with "goods." What, in turn, is the gallery providing you? You have the right to know.

(22) What kind of publicity does the gallery engage in, and do you have any control over your publicity?

If the gallery is simply handling your work on consignment but not offering you a major show, will the gallery include you in its general publicity throughout the year? Do you want it to? Will it be allowed to use your images in its general promotional efforts throughout the year? Do you want approval of all publicity using your name or images, so as to avoid the gallery's publicizing your work in some way that would embarrass you or somehow "cheapen" your work? Some artists ask their galleries for a "moral rights" agreement which states, for example, that the gallery "will not permit any use of the artist's name or misuse of the work which would reflect discredit of his or her reputation as an artist or which would violate the spirit of the work. The artist is to be consulted on all advertising of his or her work as well as on publicity releases, announcements, invitations to his or her showings, or on any other item which may show a reproduction of his or her work or processes."*

If the gallery is offering you a major show, how will it publicize the show? Will it send out printed announcements? If so, will the announcement include an image of one of your works? Who selects the image? the graphic designer? And who pays for the design, printing, and mailing of the announcements?

Although there are no hard and fast rules, the gallery usually pays for the announcements, and hence oversees their design. Some galleries will be quite nice: they will ask your advice. If you do have a particular idea or preference regarding your announcements, talk to the gallery as soon as possible, before it starts the wheels rolling with the graphic designer.

Let's say, for example, you are having a show of twenty works and would like at least some input concerning which of those twenty works is used for the announcement. Without being too pushy, you might approach your dealer and say, *Here are photographs of three of the works in the show, and I'd be happy to*

*See Chapter 10 for information concerning moral rights legislation.

have any of these three used for the announcement. These three
works are especially important to me—I consider them "major"
pieces. In this situation, the final choice would probably be the
dealer's, but at least you would have narrowed the possibilities.

It's clearly a good idea to have some say if possible. Other-
wise, you can be unpleasantly surprised. For example, when one
of my friends had her first major show, the gallery chose one of
her black-and-white paintings for her announcement. Unfortu-
nately, the curator, wanting to make the announcement "chic"
and fancy, actually had the audacity (not to mention the bad taste)
to print the announcement in black and yellow. The curator was
in fact quite proud of the change—the use of the yellow ink was
of course more expensive than printing it in black and white.
My friend, however, was understandably mortified and demor-
alized. After all, had she wanted the work in black and yellow,
she would have painted it in black and yellow in the first place.
She felt the announcement betrayed her work, but there was lit-
tle she could do about it: there was not enough time to have the
announcements reprinted even if she could have convinced the
curator to do so.

So even though the gallery generally controls the design of
the announcement, make sure that things are right, that the an-
nouncement doesn't include anything you're ashamed of. Make
sure all the pertinent information is there: your correct name,
your copyright notice, accurate information about any image used
on the announcement (title of work, dimensions, medium, date,
and so on), the name of the photographer who shot the image,
the designer's name if the designer desires credit, the dates of
the show (including the year, not just the days of the months).
You should even ask the gallery if it's possible to see proofs of
the announcements.

And make sure you have enough announcements. If, for ex-
ample, your gallery were printing 200 announcements for you,
but you felt you needed 500, you could offer to pay the gallery
to have an extra 300 announcements printed. (Printers do not
usually charge outrageous prices for a bigger print run. In fact,

an extra few hundred copies can be surprisingly inexpensive.) Attractive announcements can come in quite handy long after your show: they can be used in résumés, as handouts to prospective collectors, as publicity tools. In fact, I'm still giving out announcements from my first print show—I even had the announcement reprinted about three years after the show, because it had been so useful as a selling tool. Many collectors love to have such items—it keeps them in touch with your work.

Sometimes a gallery will pay to send announcements to the people both on its own mailing list and on your mailing list. In other cases, however, the gallery pays only for its mailing. Ask your gallery if it has a bulk mailing rate—that is, if it has an arrangement with the Post Office to send mail via a special reduced bulk rate. If the gallery does indeed use a rate, and if you are responsible for mailing out your own announcements, you might ask the gallery if you could use its bulk rate and reimburse it: this could save you some money.

To publicize a current show, a gallery will sometimes publish a poster as well as print announcements. Posters can be wonderful public relations tools—vibrant, beautiful works of art. But again, many of the same problems arise with posters as with announcements: will the artist have control over the image, design, and execution of the poster? Will the gallery publish fine arts prints in small editions, or offset litho posters in large editions? Who pays for the publishing of the poster? How many are printed? Will some posters be signed and sold? How will the posters be signed—will the signature be in the plate only, or a true signature? Who determines the price of the posters if they are sold? And how will the ownership and the storage of posters be handled?

If a gallery offers to publish a poster for your show, or if *you* have requested a poster and the gallery has agreed, the above questions must be addressed. (Occasionally, an artist will publish his or her own poster to have complete control of these issues and avoid any entanglements with the gallery.) Let's say, for example, a gallery agrees to publish an edition of 200 pos-

ters for your show. Fifty of these posters are used for publicity (in shop windows, bulletin boards, and so on), and fifty of them are signed and purchased for $20 each during the show's run. Now, who gets the $1,000 generated from the sales of those fifty posters, and who owns the remaining one hundred posters? The gallery could argue that since it provided the money for publishing costs, it has the right to any income and any unsold posters. You could reply, however, that since you provided the image for the poster, you are entitled to, let's say, half the income and half the remaining posters. Obviously, these issues have to be discussed and negotiated ahead of time.

Press packets are a third standard way to publicize a show. Usually, a press packet will include a press release about you and your show, as well as some supplementary material such as press photos of your work. Will the gallery compile and pay for such press packets? How extensive is the gallery's press list? If the gallery pays for your press photos and slides, who owns and controls the negatives and transparencies? Will the photos and slides be completely and correctly captioned? Will the gallery send out press photos in advance or only upon a critic's request? What other kinds of publicity will the gallery provide and/or pay for—advertisements in newspapers and magazines?

(23) Does the gallery need any more information to help sell your work?

You might provide the gallery with your business cards for studio referrals. Or you might give the gallery people extra copies of your résumé, so that they can, in turn, give them to interested collectors. Or if the gallery is taking only a few works on consignment because of limited space, you might offer to give the gallery several slides and/or photographs of works not in the gallery, so that a prospective collector can get a better sense of your work—sales are often made, in fact, on the basis of slides and photos.

In short, there are any number of things you can do to make it easier for the gallery to sell your work. And, of course, one

of the things you should definitely do to make things easier on everyone concerned is this: make sure the gallery knows *exactly* what name you use professionally—whether you use your full name or just initials and a surname, or whatever.

Remember this checklist contains items to be discussed and negotiated: it is by no means a list of *demands*. Also keep in mind that these issues should be discussed *after* a gallery agrees to handle your work; there's no sense in raising these questions at the beginning of a viewing, when the curator has just started examining your portfolio.

Some of these questions on this checklist will be important in certain circumstances but not in others. Your medium itself may dictate certain particulars, and each situation is different. If, for example, a gallery approaches *you* to handle your work, you may be able to ask for more than if you had approached the gallery. Or if you're a painter who makes small canvases and you live near your gallery, the question of shipping cost may not be foremost in your mind. If, however, you're a sculptor in Los Angeles, making 2-ton constructions and dealing with a New York gallery, the question of shipping costs to and from the gallery may be, economically, one of the more important items to be negotiated.* In fact, when dealing with out-of-state galleries, you often have a whole new set of questions to address: for example, will the out-of-town gallery pay for transportation and hotel accommodations if it wants you to attend the opening reception, and will such accommodations allow you to bring a second person? (Some artists say that since out-of-state shows are more difficult and time-consuming, that the artist should bargain for some guaranteed compensation, such as the gallery's buying some work.) Again, each artist-gallery relationship presents its own

*I have borrowed this example from *Artworks: Law, Policy, Practice* by Franklin Feldman and Stephen E. Weil (New York: Practicing Law Institute, 1974), p. 498.

particular set of issues. The important thing is to be ready, to be prepared, to be able to speak the gallery's language in order to communicate your needs.

After you've discussed your checklist with a dealer, go home and write the dealer a letter saying, *This is a correct statement of our oral agreement.* And then list *everything* the two of you did, in fact, agree upon. Send the dealer two signed copies of the letter, and ask him to return one signed copy to you for your files. The signature should include the date the agreement is signed by the respective parties. This letter of agreement is then a legal document and could, in fact, act as your contract with the gallery. (For those interested in a sample artist-dealer contract, see Appendix 2.) Although verbal agreements are binding, written documents are always safer. So get it in writing. And remember, if a dealer asks *you* to sign an agreement or contract, make sure you know exactly what you are signing. Don't sign there on the spot; take the document home and read it carefully. If you have any questions whatsoever, consult a lawyer. Be safe, not sorry.

14

HOW TO
SURVIVE YOUR SHOW

Artists exhibit not merely to sell their work, but to share it. A show allows you to disperse your "wealth," so to speak, to enrich your community by making a private part of yourself—your work—accessible to the public. Shows can be like weddings: a way to "marry" the world, a strange, marvelous act of celebration, confession, and communion.

But like weddings in general, shows are seldom easy or problem free. There are dozens of questions, doubts, and fears: Will the "marriage" succeed? What *is* the relationship between an artist and those who see and collect his work? How *do* you make a public statement about what is essentially a very private, very personal endeavor—your artwork? And there are also dozens of arrangements to make—a slew of discussions and decisions and details to attend to. Of course, no two shows are exactly alike, but here are a few general survival tips.

Use Your Time Wisely.

Discuss details with your curator and find out *all* possible deadlines, including:

- when the works will be selected for the show
- when photos and slides of the work will be shot for possible use in press packets and/or announcements
- when announcements will be designed, proofed, printed, and mailed
- when your work will be transported to the gallery
- when price lists, artist's statement, revised résumés, and any other documents (provenance for each of the works in the show, instructions for the works' care and maintenance, and so on) will be needed at the gallery
- when the show will be hung
- when the gallery will hold a reception for your show
- when the show will open to the public, when it will close, and when any unsold works will be returned to your studio.

Then, make up a list of *all* the things you have to do to meet those deadlines, including which works for the show have yet to be framed, priced, titled, signed, and copyrighted. As mentioned in previous chapters, having to title, frame, and price twenty or thirty works can be quite difficult. If they're left to the last minute, you'll often regret your decisions—you won't like some of the titles you used or some of the frames you chose. So give yourself plenty of time. Chart a timetable of events, working from the show's opening, so that you know exactly *what* is expected of you and *when* it is expected. Allow for unexpected—and time-consuming—problems. Clear your agenda of as many extraneous, non-show-related responsibilities as possible. Remember, getting ready for a show takes time, plenty of time, so make sure you have it.

Make Sure Your Mailing List Is in Order.

You want as many people as possible to see your show, especially those people who have already shown an interest in your work—that is, the people on your mailing list. Your mailing list—which is, I think, next to receipts the single most important doc-

ument in your studio or office—should contain the names of all your collectors and all interested parties. Collectors are not merely those people who have *purchased* your work: collectors also include people who have been *given* your work and those people with whom you have *traded* work for services. Friends, relatives, business associates—anyone who has expressed an interest in your work should be included in your mailing list. Every time you sell a piece of your work or meet someone who likes your work—a neighbor, a friend of a friend, a designer, critic, or architect, your grocer, lawyer, doctor, dentist, or accountant—these people should be added to your mailing list. Anyone who has respect for your work life, who has admiration for your survival as an artist, who has "enthusiasm for your enthusiasm," so to speak—these people must be included in your mailing list.

Just put each new name on a 3 × 5 index card with the person's residence, office address, telephone numbers, and any other information you think is pertinent. Some artists, for example, annotate their 3 × 5 cards with:

- the date of the initial contact
- which works the collector owns
- which shows the collectors have been invited to
- when the collector has visited your studio
- when the collector has been sent, let's say, a Christmas card, or some news of your work, such as clippings of your reviews or articles that have appeared about you, etc.*

Some artists put various color clips on certain of the index cards so that their mailing list can be easily "divided" into sev-

*Remember, when you mail anything to someone on your mailing list, periodically put Address Correction Requested on the envelope, so that if one of your collectors has moved, you will be notified of the new address. To save time, you may want to buy a stamper with the words Address Correction Requested.

eral different mailing lists—one color clip for "major" collectors, another for out-of-town collectors, and so on.

Over the years, the names will really add up, and your mailing list will become an invaluable document—a treasure trove of information for all your marketing endeavors. Several months before your show, you might, in fact, want to make a concerted effort to expand your mailing list. You could, for example, call your major collectors and ask them for the names and addresses of some of their friends who have seen and admired your work in their homes. (When you send your printed announcements to these new people, it's always a good idea to write a note by hand mentioning the name of the collector who referred the new person to you. In fact, you should write notes on your printed announcements to any number of people to "personalize" the announcements. You could, for example, remind collectors "to bring a friend" to the reception.)

A mailing list of at least 1,000 names should be your objective. Yes, that may sound difficult to compile, but remember, most mailings, such as announcements and invitations, usually draw little more than a 10 percent response. So if you wanted 100 or so people to attend your reception, you might have to send out 1,000 invitations.*

Keep Any Disagreements with Your Curator in Perspective.

While getting ready for your show, you will, of course, have any number of occasions to confer with your dealer: there will be works to hang, announcements to design, deadlines to discuss, receptions to plan. Most likely, you won't always see eye

*There is some debate about whether mailing lists should be shared or not. Some artists think a good way to get new names is by exchanging lists with other artists. I, however, tend to disagree: I think the mailing list is, as a general rule, the one thing artists should *not* share. After all, most collectors have a limited amount of money to spend on artwork.

to eye with your dealer on all these and other matters. Although you certainly have the right to make your needs known, don't disagree too vehemently with your dealer during your show's preparations. Remember, the dealer is the person who, during your show, will be talking to the critics, negotiating deals with collectors, drinking wine with your guests at the reception, and so on. You don't want to jeopardize your show by completely alienating your curator. Dealers are, after all, just human, and like the rest of us, they usually find it easier to help people they get along with than people who give them nothing but trouble.

I've known one artist who gave his dealer so much trouble (the artist told the dealer he was insensitive, stupid, bereft of organizational ability, and devoid of taste) that the dealer did little to sell the artist's work. When prospective collectors came to the show, the dealer actually told some of them, *You know, I like this work, but the artist is such a pain in the neck that I wouldn't show his work again as long as I live. The day this show closes, I'm going to tell the artist to "walk," that I don't want ever to have anything to do with him again.* Now, during your show, would you really want one of your friends or collectors to come to the gallery and be greeted by such a harangue?

Use your common sense. If your dealer does something so absolutely horrible that you can't live with it, then, yes, you might have to make a big fuss: it *is* important not to take bad advice from gallery personnel. But if the disagreement concerns something of a smaller nature, be reasonable and keep your cool. It's important to ''service'' your dealer—to provide him, for example, with knowledge about your work so that he can answer questions collectors might ask. Of course, I like to think that ultimately it's the work itself that sells, and not just a dealer's pitch. But collectors do often ask questions or want biographical information about you, and a dealer who knows a lot about your work can really make a difference.

So use your common sense and try to get along with your dealer. Invite him to your studio. Tell him about your materials and processes. Fill him in on your background (without, of course,

taking up too much of his time). It's up to you to make sure the dealer has any information he needs to sell your work.* If you keep some regular contact with your gallery, you have a better chance of that gallery working hard for you.

Learn How Your Work Can Best Be Transported to and from the Gallery.

Even if your studio is relatively close to your gallery, your work can still be easily damaged in transit if it is not carefully packed. It's essential that work be wrapped and kept clean when taken out of your studio, so as to protect it from possible spills, tears, punctures, dirt, grease, and so on. Of course, it's not always easy to pack your work properly, especially if you work in certain media or on an especially large scale. But it's up to you to find out how best to prepare your work for transit.

Start to read the basic texts on the care and preservation of artwork for general tips and hints (see Appendix 1). Visit packaging stores in your area to check out various packing supplies and materials. Ask your framer and curator questions—they often have knowledge and experience about these matters. You might even consult the conservators of your local museum—they're occasionally willing to give advice.

Think about all the variables. If you work on a large scale, find out exactly what size van you need. If you're transporting unframed prints, find out exactly *how* you're going to move them—will the prints be flat between two hard surfaces? in special drawers? Learn about different plastic wrappings, masking tapes, crating supplies, and so on. These are important matters. You wouldn't want someone accidentally knocking over a gallon of water on unwrapped paintings and thereby ruining two

*And remember, it's also important to service your dealer *after* your show closes. You might, for example, want to stop by the gallery once in a while to talk with the dealer or to see the gallery's current show. Or you could invite your dealer to your studio to see your new work, if some time has elapsed since his last visit.

years worth of your work. So, please, keep this transportation issue in mind.*

Be Prepared to Handle Reactions to Your Show.

To an extent not true of most people's work, an artist's creativity takes on a crazy, vulnerable life of its own: an artist's work faces the public, ready to be loved and hated, praised and condemned, or perhaps—worst of all—simply ignored. In other words, if there are many difficulties creating a work of art, there are other difficulties once the piece is finally finished: you must watch people *react* to your work. During a show, these reactions are frequent, often unavoidable: there are comments from curators, comments from critics, comments from collectors, friends, relatives, and other artists. Perhaps at no other time is your work so exposed, so vulnerable as from "showtime" on.

Listening to people's reaction to your show can amuse, surprise, and shock you. Even when someone's response is wonderfully favorable, his notion of what your work is "about" may differ wildly from your own—occasionally the comments will indeed boggle your mind. Some viewers love to pick through your show to give you a very detailed explanation of what they think it "means"—it's their way of giving you "constructive" criticism. Other people merely spit out their immediate, uncensored—and often unthinking—responses. Critics and collectors can, in fact, say such disgusting things to you during your show that sooner or later you'll just want to shove a paintbrush in their hand and tell them, *Why don't you try this for a few years and then I'll come by to tell you what I think!*

The more shows you have, the more your work "travels" in

*Useful texts include: *Packaging Marketplace,* ed. Joseph F. Hanlon (Detroit: Gale Research Company, 1978); Caroline Keck, *Packing/Shipping Crafts* (New York: American Craft Council, 1977); Caroline Keck, *Safeguarding Your Collection in Travel* (New York: American Association for State and Local History, 1970); United States Postal Service, *How To Pack and Wrap Parcels for Mailing* (Washington, DC: United States Postal Service, 1970).

the outside world, the more you find yourself faced with questions and comments that range from the ridiculous to the cruel to the unanswerable:

- I really like the *top* half of this one.
- Why do you draw noses like that?
- How come all your work looks the same? Are you in a rut? Don't you want to change your style?
- Why are your paintings so large? I don't have a wall that large!
- Why are your paintings so small?
- I think your works look better from a distance than close up.
- I saw a picture *exactly* like this just a few months ago.
- How many of these can you turn out in a month?
- What's the most expensive piece you've ever sold?
- Why do you do so much black-and-white work? Don't you *like* color?
- This design would look great on a bedspread!
- How come it's so expensive when it only took you a few weeks to do?*

Prepare yourself to handle the reactions of one particular group of people: the critics. Although it's been said that a "bad" review is better than no review at all, "bad" reviews can still be difficult, disheartening, and depressing. Some artists claim they don't read their reviews for this reason—they don't want to be miserable, they don't want to give critics that much power. Other artists say they don't really mind getting a bad review—after all, it's only one person's opinion. But I think anytime someone publicly states that he or she dislikes your work, it *is* difficult. Of course, part of being a "pro" is rising above this difficulty,

*Variations on this question have been prevalent for years. Recall, for example, the attorney general's famous question to Whistler—"The labor of two days then is that for which you ask two hundred guineas?"

but it's not always an ability that comes easily or quickly. Some artists want to retaliate—to write long, vehement letters to the critic, correcting him on his mistaken assumptions, requesting a retraction, and so on. (In 1981, artist Lee Waisler dumped five tons of fresh horse manure at the front door of the *Los Angeles Times,* saying he was protesting art critics "dumping" on artists, and, in particular, an unfavorable *Times* review of his work. "When one medium fails to communicate, then another will succeed," the artist said, climbing to the top of the manure pile to the cheers of about 200 spectators. "I object to the power that critics have over artists.")

When dealing with this whole question of reviews and critics' power, it's important to remember that critics are fallible, not to mention unpredictable. I've seen critics hate one particular piece of work one week and love it when they see it in a different show a few months later. I've seen critics ardently support an artist, give him a slew of wonderful, glowing reviews, and then— all of a sudden—attack the artist, claiming him to be "overexposed."

Even good reviews can occasionally present problems. When one friend received several favorable notices, more and more people came to her show; more and more people bought her work; and more and more people mentioned the reviews when making the purchases. Although my friend was obviously pleased by her success, she nevertheless had several twinges of doubt: *Are these people buying my work because they really like it or because of a few "silly" favorable reviews? What happens if I don't get great reviews next time? Will the collectors and curator think I've fizzled out, that I was a "one-shot" artist?*

If good reviews can cause certain problems and bad reviews other problems, there's also the problem caused by no reviews at all. Sometimes an artist attends the opening of his show, goes home, and each day anxiously awaits the arrival of the newspaper, only to find no reviews of his exhibit. Friends repeatedly ask him, *Had any reviews yet?* And he begins to worry nervously why no critic has commented upon his show.

Keep in mind that critics cannot review every show in town, especially in a city with an active arts scene. Sometimes your show just happens to have opened simultaneously with a major museum extravaganza like the Tut show, and the editors in your town have requested their critics to devote all allocated art space to the museum show. Or sometimes a critic hasn't reviewed your show because—for one reason or another—he hasn't ever reviewed *any* shows at that particular gallery.

Trying to get your show reviewed can be tricky. You can't nag the critics and beg them to review you, but there are a few things you might do. Although most galleries are quite knowledgeable about gallery-critic relations, it doesn't hurt to make sure your gallery has done everything possible: have they sent out press releases and press packets? have they called a few critics, especially those they know? have they sent the critics some advance photos of your work? (Some galleries, for example, are stingy with press photos and give a critic a photo *only* upon request. The curator of my first major show, however, sent several photos to the critics in advance of my show. One critic was sufficiently intrigued by the photos that he called my gallery to ask if he could come to see the show after hours, allowing him to look at my work at leisure, quietly. My gallery obliged. The critic gave me a wonderful review, one I'll cherish for the rest of my career. Of course, sending out photos in advance is much more expensive than giving photos only on request, but in this case, the additional expense was worth it.)

Like the comments of critics, the reactions of colleagues to your show can also surprise and shock you. Although the public likes to see artists as sensitive, poetic souls, we can often display incredible jealousy: when it comes to marketing our work, we often turn treacherous, nasty, and corrosively competitive. I've known several artists who lost good friends during their shows: their "friends" grew jealous and envious of the show's success, claiming the gallery really wasn't "top-notch," that the show really hadn't been reviewed by the "major" critics, that such success didn't really prove anything at all, that such suc-

cess could, in fact, "ruin" an artist (see Chapter 17). So be prepared to handle pressures from other artists during your show.

And remember, *all* comments—good or bad, intelligent or crazy as hell—are limited in value. Sure, feedback is interesting. Sure, some people's responses are particularly perceptive and useful. Sure, good reviews can help your résumé, your sales, not to mention your ego. And sure, certain ways of talking about your work do intrigue you. But in the long run, most comments are not worth very much.

The only opinion that *truly* counts is your own: only you know when one of your pieces is bad, good, or great. If you're your own toughest critic (and every artist should be), who needs other people to tear apart your work?

Besides, what's the alternative to "ignoring" most comments? Whenever you start a new piece, are you really going to try first to "psych out" the public's response? If someone tells you your work needs more yellow, are you really going to run home to the tube of yellow paint?

Don't let other people's reactions to your show overwhelm you. Don't get angry (unless, of course, you know how to turn anger into a creative resource, which, in fact, many artists know how to do). Don't get so depressed by a review, or by lack of reviews, that your work begins to suffer. Let anyone put his or her two cents in, but remember, that's exactly what most comments are worth: two cents.

The important thing, the very most important thing, as one of my dear friends always says, is to "keep on keeping on."

Be Prepared to Handle Your Own Reactions to Your Show.

Although self-doubt is a problem many artists face throughout their careers, you can be especially vulnerable to such doubts around showtime. Many, many questions come up:

- Do I have anything to contribute to the art world?
- What do I have to contribute?

- Do I fit in "historically"?
- Where do I fit in?
- Who are my major influences?
- Is my work too "derivative"?
- Is my work "original"?
- Are these questions ridiculous, like asking, What is art? What is life? What is love?

These questions can indeed be intense, painful, not to mention contradictory. (As Gauguin once complained in a letter to Emmanuel Bibesco, "the curious and mad public demands of the painter the greatest possible originality and yet only accepts him when he calls to mind other painters.") Yes, you are vulnerable during your show, but remember: vulnerability can be one of your greatest assets. Artists must be able to understand their vulnerability, to surmount their worries and insecurities. Keep things in perspective. Remember, it's not unusual for artists to have these doubts during shows, to feel depressed and exhausted one moment, and proud and excited the next.

Don't Judge the Success of Your Show by the Amount of Sales.

When one of my students was having a show, she came to my Artists Survival Seminar and told us she was having a major problem. "The show's been open for two weeks," she said, "and *everybody* I know has asked me whether I've sold anything yet. I haven't, and I'm getting increasingly upset, frustrated, aggravated, angry, ashamed, and humiliated every time I have to answer that question. I'm beginning to think the show's a failure, a mistake."

It's important to remember that collectors don't always buy during a show. What happens *after* the show is often as important as the show itself. Having a show is like sowing seeds— the results become evident later. The people who didn't buy during your show still saw the work: some of them loved it and

will buy a piece the next time they see it or the time after. Perhaps, they didn't have the money during the month of your show—five or six months later, their finances may change.* Similarly, a critic who saw but didn't review your show, may review your next show and have that much more knowledge of your work. Your show may, in fact, generate so many various connections and contacts *after* it has closed, that an important new aspect of your life will be a strong, vital business life.

It's also important to keep in mind that your gallery may not gauge the success of your show by the amount of sales either. When I had my first major show, for example, none of my major paintings sold. I was, at first, shocked, and I also thought the gallery would be shocked. But my show had received a lot of attention—lots of press, favorable reviews—and my dealer thought the show a great success. He really didn't care as much about the money as I thought he would, or, in fact, as much as I did back then. So, again, don't judge the success of your show strictly by the amount of sales.

Much of the above advice is primarily meant for those artists having their first show. But your second, third, and fourth exhibit can also present certain problems. Some critics, for example, might argue that the work you're showing this year hasn't really changed from the work you exhibited five years ago, that you're in a rut, overexposed—having too many shows. Other people will complain about the exact opposite—that your work has changed too much, and for the worse. Only your old work is any good, they'll say, your new pieces don't make it at all.

This response is indeed so common that once you start changing techniques and working in new styles, you'd better learn how to deal with people preferring earlier to current work. Of

*That's one reason why it's to your advantage to have your dealer keep some pieces on hand after your show—so that when people return and ask for your work, the gallery will be able to sell them some.

course you should be happy when people like *any* of your work, early or current. But don't let people's reactions to current work spoil your new directions. Don't listen when a dealer tells you, *You can't change your style because I won't be able to sell it— no one will recognize you did it.* Or when a collector complains, *Oh God, I can't stand this new stuff! Why aren't you doing those nice older works anymore?*

I think it's best to ignore such reactions. Why let someone's remarks hinder your explorations? If you do, how will you ever know where those experiments might have taken you? Besides, in five or ten years, your "new" work will have become your "old" work, and people will then be asking you, *How come you don't do pieces like you did ten years ago?*

15

ALTERNATIVES TO GALLERY EXHIBITS: STUDIO VIEWINGS, STUDIO SHOWS, COOPERATIVE GALLERIES, COMMISSIONS, GRANTS, PRINTMAKING AND MULTIPLES

STUDIO VIEWINGS

There will be times when you will want to show your work not in a gallery but in your own studio. A collector, for example, who's heard about you through a mutual friend, may ask to visit your studio to see if she would like to buy a piece of your work. Or a curator who has already seen some of your work may arrange a studio viewing with the possibility in mind of giving you a show or handling your work in some way.

Studio viewings do have several advantages over gallery viewings. For one thing, when a viewing is in your own studio, you don't have to undergo the agonizing process of *choosing* which works to bring to the gallery: everything is right there where you need it—in your studio. Similarly, you don't have to endure the difficulty of deciding how to pack and transport your works to the gallery.

But most important, studio viewings give a curator or collector a comprehensive look at your work. Not only do studio viewings afford a full view of your work's *range*—your differ-

ent bodies of work, your stylistic changes over the years—studio viewings also show the *way* you work—your tools, your materials, your procedures. It's good for a curator or collector to see how you work, how much goes into it. And since you never know which particular work or which particular body of work is going to hit a curator's or collector's fancy, studio viewings give you that much better a chance of "connecting" with a curator or collector. Studio visits are the best possible way to have a viewing.

But studio viewings do have their drawbacks. In their own way, they're as time-consuming as any gallery appointment: it takes time to clean up the studio, to hide all the "bad" work, to make sure you have everything on hand from résumés to refreshments. Because the studio viewing takes place on *your* turf, you have to play "host."

Here are a few suggestions to accentuate the advantages and soften the disadvantages:

(1) Be sure to reconfirm the date and time of your studio viewing, so there is no misunderstanding.

(2) Make sure your office is "geared up." During a studio viewing, you may need any or all of the following:

- copies of your current résumé and your résumé handouts, such as copies of favorable reviews, articles about you that appeared in newspapers and magazines, attractive announcements from previous shows, and so on
- invoice forms, plus carbon paper for duplicates, should you sell a work during the viewing (see Appendix 7)
- price lists, so you can easily remember the prices of various works when you are asked
- consignment and receipts forms, in case a dealer wants to take a few pieces on consignment, or in case a collector wants to take a work on approval (see Appendix 6)

- rental agreement forms, should a collector want to rent, not buy, one of your works
- budget agreement forms, should a collector want to make time payments (see Appendix 5)
- copies of the resale contract you use, if you ask collectors to sign such contracts (see Appendix 4)
- any wrapping and packaging supplies you might need should a collector or curator want to take works with them that day.

(3) Put away any unfinished works or "experiments" in progress: the last thing you need is a curator's or collector's comments on a piece you're still working on. (What someone says about finished work is generally easier to hear: the work's already completed.)

(4) Be careful how many people are present at a studio viewing. If you basically like to conduct business in private, then do so. If you share your studio with another artist, make sure you make the appointment for a time when you can have the most privacy. If your studio is in your home, don't hesitate to ask your spouse/roommate to "vanish" during the viewing.

Even at their best, viewings can be nerve-racking, and many artists only get more self-conscious when friends and family are around. If you're one of these artists, why add to your suffering? Why not simply make sure your studio viewing will be conducted in as much privacy as possible?

Remember, friends and family *can* interrupt—not to mention interfere—at a studio viewing. Once, for example, an acquaintance happened to be present inadvertently at one of my studio viewings. Although I'm sure his intentions were good, he continued to make one embarrassing comment after another to the collector: *Oh, you're here to buy lots of Toby's paintings? Aren't they wonderful! I know if I had money, I would*

certainly buy a whole houseful of them. Don't you think
that one there is particularly splendid? Toby's work,
you know, is a great investment—it's going to be worth
a fortune one of these days.

Needless to say, I wanted to crawl into the wood-
work.

If, on the other hand, you think a spouse or friend
could lend support during a studio visit, by all means
have him or her casually present. For one thing, it can
be quite wonderful to have someone there to keep the
your visitor occupied while you're taking care of some
of the "mechanics" of studio viewings—unwrapping
paintings, digging up a few old works that suddenly
someone wants to see, going into the next room either
to get a copy of your résumé or to take care of a
phone call.

And sometimes a friend or member of the family can
act as a great "buffering" agent. Once, for instance, a
gallery owner came to my studio to discuss the possi-
bility of her handling my work on an exclusive basis.
She was a very high-power, wheeling-dealing curator
with (1) lots of fancy words, (2) plenty of big prom-
ises, (3) a personal secretary in tow, and (4) a five-page
contract in her briefcase ready for me to sign, seal, and
deliver!

I happened also to have invited to that viewing one
of my friends—a writer who had himself signed lots of
contracts with several publishers and movie studios. The
friend's help was invaluable: in a subtle, diplomatic way,
he let me know that the contract was not advantageous
for me, that I should not sign it right there on the spot
or even make any verbal agreement. (When I later took
the contract to a lawyer, he pronounced it "one of the
most high-handed, low-down attempts to legally rob
someone" he had ever come across). If it had not been
for my friend's support, I—very inexperienced at the

time—might not have been able to resist the gallery
owner's pressures. My friend gave me the strength to
laugh at the dealer's "pressure cooker" tactics.

So there are no hard-and-fast rules about the "pri-
vacy" of studio viewings (or about any kind of busi-
ness meeting for that matter). You simply have to plan
the situation for yourself: if you think the viewing would
go much more smoothly were only you and the cura-
tor/collector present, make sure you "clear the decks."
If, on the other hand, you work better with another
person around, arrange for someone to be there. But
do consider the possibilities. It's up to you to pull off
the viewing as best you can.

(5) Don't hesitate to have a studio visit just because you
think your studio isn't "nice enough." Some artists think
that unless they have a fully stocked, fifty-foot-long
studio with lots of "elegant" skylights, they're not really
ready to have a studio viewing.

I don't agree at all! No studio space makes—or un-
makes—an artist. After all, you don't have a studio to
"impress" other people; you have a studio to make your
work the way you want to make it. If you do the most
gorgeous pieces of work on an old kitchen table or in
your basement, most curators and collectors will still
be happy to come there and see how you do make those
gorgeous works!

I know I myself would give anything to have visited
Giacometti's studio, even though it was, by some peo-
ple's standards, just a hole in the wall. To judge from
photographs, there was hardly any light in Giacomet-
ti's studio, and plaster was dripping everywhere: it
looked like the Ice Age. Giacometti didn't pretty it up.
When his dealers came to visit him, he didn't, I'm sure,
follow the usual suggestions in all those artists hand-
books: he didn't "decorate" it into a "clean, clear"
space with lots of "properly displayed" works.

Don't get me wrong. I'm not telling you to *mess up* your studio so it fits some stereotyped notion of an artist's "colorful" garret. I'm not telling you to change your tastes if you do indeed like a meticulously clean studio. And I'm certainly not denying that work looks wonderful on clean walls where the work isn't "interrupted" by other things.

I'm just saying that when you're having a studio viewing, you're having someone over to visit the *source* of the work, and that respect is *always* due that source, no matter how large or how small, or how clean or how messy it may be. If someone is indeed interested enough in your work to make a studio visit, he or she should be respectful enough of its source. And besides, an artist's studio is the artist's factory, not a "gallery."

(6) Really *think* how you could make your studio viewing easier for the curator and/or collector. Several years ago, I had quite a few problems arranging a studio visit with one particular dealer. It took me months to get him over to my house: he would make an appointment, then break it . . . then make another date . . . only to break that one. I was going through hell, making appointments, breaking appointments, changing appointments. I could never figure out what the problem was: did he not really like my work as much as he said? Was he changing his mind about handling my work? What was I doing wrong?

Finally, I found out what the problem was: my studio was not in a convenient location and the curator simply did not have a car. If I had only asked him if he needed a ride, I could have saved myself three months of aggravation. But I was so preoccupied with my own doubts and problems, that I never stopped to think: what are *his* problems? how could I make it easier for him to get here?

This may sound like an isolated example, but the

principle behind it is, I think, sound: do everything possible (within reason) to make things easier for a curator or collector during a studio visit.

In fact, you should have the same kind of concern for a curator or collector that you would for any guest in your home. If you were having a vegetarian over for dinner, would you serve a pot roast? So, just because you're into organic food, don't think every curator in town should be served carrot juice while visiting your studio.

When my curator without a car, for instance, finally made it over to my studio, I thought I was being incredibly polite: I offered him coffee, tea, or hot chocolate. He wanted a martini! I didn't even know what went into a martini! (I do now, though.)

All this may sound like Emily-Post-Book-of-Etiquette silliness, but it's not: it's actually just good business sense: all businesses consider their clients' tastes and comforts to make business go smoother.

After all, I *had* talked to that curator at least five times on the telephone before he finally made it to my studio. Why, during one of those many conversations, hadn't I asked: "Will some coffee or tea be all right, or do you have something favorite you particularly like to drink?" That single, simple question could have saved me a lot of embarrassment.

(7) When having a new collector over for a studio visit, don't always expect the collector to be a "soulmate." You're going to be frequently surprised by who buys your work. People you have nothing in common with, people who don't seem to "understand" your work at all, and people you don't even like often love and buy your work.

So be prepared for some "unusual" situations. Be ready, for example, for the new collector who first shows up with an interior decorator and who then goes all

around your studio holding up a swatch of fabric to see which paintings "match."

Or be prepared for the collector who comes over, is incredibly enthusiastic about your work, asks you a thousand questions, a thousand prices, asks you if it's all right to bring back her husband next week or her aunt, and who then—when it finally comes down to it— only wants to rent one of your works for a few months!

Again, don't misunderstand me. Most collectors who come to your studio are gracious and polite. Some of my collectors have, in fact, helped me to continue my work: they've offered to co-sign loans or invest in my next suite of prints. They've even been wonderful about bringing other collectors to my studio.

But a few collectors will surprise you: throw you off-balance. So be ready for everything—and anything— to happen when you open your studio door to new collectors.

(8) Give the curator or collector some "space" during a studio visit—give him some time to himself. Don't think you have to follow the curator/collector around. After you've given your visitor a general tour of your studio, you might, for example, say, *I'm going to the kitchen to make some coffee for us. If you have any questions, just ask.*

Collectors especially like some time to think things over. Often a husband and wife will need to discuss their feelings with each other, and it's easier for them to do so if the artist isn't present for a few minutes.

(9) Always be "up front" with a collector, especially about financial matters. Be sure to let a collector know:

- that you charge sales tax, so that he's not surprised later by the additional cost
- that the collector pays for transportation and shipping costs in most artist-collector transactions

- that you ask collectors to sign a resale contract (if that indeed is your policy)
- that the collector is buying a particular work, but not, unless expressly stated, the reproduction rights to that work, that is, you, the artist, will retain the copyright
- that the price you've quoted includes the frame, base, or box (if that indeed is the case)
- that the collector can use a national credit card such as Visa or Mastercard to purchase your work (if you have such an arrangement with your bank)*
- that the collector can budget sales (if that is indeed your policy)
- that the collector can buy one of your works, donate it to a nonprofit organization such as a museum, and then use the purchase as a tax deduction.

If you do decide to allow a collector to budget payments, you should be as explicit as possible about the terms. Specify the down payment, the number of subsequent payments, the amount of each payment, their due dates, and any other pertinent information, such as whether you will charge interest on late payments; whether you will give refunds or exchanges;† or whether

*To learn if you are eligible for such an arrangement, call the merchants' accounts department of your local bank.

†Let's say, for example, a collector buys one of your works for $1,000. He puts $100 down, makes three consecutive monthly payments of $100, and then loses his job. He tells you that unfortunately he can no longer make his payments to you. You might give the collector an extension until he finds employment. Or if that doesn't work out and the collector wants to return the work and get his money back, you might tell him that you don't make refunds, but that you do allow exchanges—that is, you will allow the collector to return the $1,000 for a work or works priced at $400, the total of his down payment plus his three monthly payments.

Of course, budget sales are not the only occasion when you might have to consider your policy on refunds and exchanges. One of my collectors, for ex-

you will send the collector monthly bills, or whether
you expect the collector to send payments on his own
initiative so as to save you the paperwork. You must
also decide when the collector will be allowed to take
the work: some artists don't let the budgeted work out
of their studio until the collector has made the last pay-
ment; other artists, myself included, allow the collec-
tor to take the work once they've made the down
payment and signed the budget agreement. (So far, I've
never been cheated on any of my budget sales—the
collectors have always honored their agreements.) And
you should also know if you will allow budget sales
only on large purchases: some artists, for example, make
budget sales only on purchases larger than $500, but I
myself have permitted collectors to make payments on
works as inexpensive as $50. (I'm delighted to have
people who don't have much money own my work.)

 To facilitate studio sales, you should know your
feelings on as many of these financial matters as pos-
sible. If you want collectors to respect your work and
your business, you should return the respect by being
clear and direct in all your interactions.

(10) Although there are definite advantages to studio view-
ings over gallery viewings, don't be unreasonably op-
timistic. I know many artists who figure, *Well, when
one of my collectors goes to my gallery, he then sees
the work of forty-nine other artists. But when he comes*

ample, once purchased one of my paintings in full. Three years later, I found
out the collector's wife did not really like the work: for some reason, the painting
"scared" her. I talked with the collector and told him he would be welcome
to exchange the work for another of equal price. I could have gotten "tech-
nical" with him and said, *Listen, I won't allow refunds or exchanges. After
all, you've had that painting for three years, and the price you paid for it
wouldn't even cover rental fees for three years. So you're just stuck with it!*
But I chose not to do that because I liked the painting and was glad to have
it back.

here, to my studio, he sees only my work. Therefore, there's a better chance of his buying something at a studio viewing.

That kind of thinking may sound logical, but don't expect every studio viewing to produce a sale or a show. To get one sale or one more gallery to handle your work, you might have to go through ten or fifteen viewings, viewings that may be more unpleasant than not. (In fact, studio viewings with a collector certainly show you how hard galleries work.) I say this not to depress you, but to warn you: marketing your work *is* work.

STUDIO SHOWS

There may be times when you decide to have an exhibit in your home or studio—as a way to avoid or supplement the gallery system. As mentioned, collectors are usually interested in seeing *where* you work, so studio exhibits (or "open studio shows" as they are often called) can be especially appealing. The variables that should be considered when having a studio viewing also apply to studio shows, but here are additional hints to keep in mind:

(1) Plan your studio show well in advance. Studio shows take much more time to arrange than studio viewings—you can't produce a studio show overnight or in a week. There are mailing lists to check; announcements to design, reproduce, and mail; friends' help to solicit, and so on. So give yourself plenty of time—a minimum of three months.

(2) Choose the date of your studio show carefully. Generally speaking, the best days for a studio show are the weekend—on Friday night or Saturday and Sunday afternoons. Weekdays may be better if you live in a city where people go away for weekends. Similarly, certain months are usually considered better than others. Janu-

ary is said to be a poor choice because people are usually still paying Christmas bills. The summer months are also thought ineffective since many people are away on vacation. Some artists prefer November and early December to capitalize on the Christmas market. Others say late spring, when people are receiving tax refunds, is a good time, but of course, other people will have just *paid* their taxes.

(3) Make sure you invite enough people to your studio show. As mentioned in Chapter 14, if you would like 100 people to show up at your reception, you should send announcements to approximately 1,000 people, since the usual response to such solicitations as exhibition announcements is approximately 10 percent. (Also see Chapter 14 for how to compile, maintain, and expand your mailing list.)

Make sure your announcement or invitation includes any information you deem pertinent, such as:

- your name
- the exact date, time, and place of your show
- what kind of work will be sold at the show, (sculpture, paintings, watercolors)
- a quotation from a favorite review
- an image of at least one of your works with its necessary identifying information, including title of work, medium, size, date of work, copyright notice, photography and other relevant credits.

If your studio is not in a well-known part of town, your announcement might also include a small diagram or map showing collectors the exact location. If you have a series of multiples available, you might also include an order form on the back of the announcement for those collectors who cannot attend your show but who nevertheless want to purchase your work. And if you want

some idea of how many people might come to your show, you could include R.S.V.P. information in your announcement.*

You should mail your announcements approximately two weeks before your show: if the invitations are sent too early, those invited might forget about the show, and if the invitations are mailed too close to your show's dates, your prospective collectors may, of course, already have made other plans.

Some artists type or write their announcements and then simply have them photocopied—this method certainly is inexpensive. Other artists, however, believing that the impact of the announcement is crucial to the show's success, have their announcements professionally designed, typeset, and printed. (If this method appeals to you, don't forget to check out the possibility of trading your work in exchange for a designer's services. You might also want to collect announcements from friends' shows to see which invitations appeal to you and which don't.)

Of course, having your announcements professionally made entails additional preparations, additional time, additional expense, and additional consideration. Remember, never commit yourself to a printer without complete understanding and verification of what you expect and for what price. Know your job requirements. Select a printer to match your job. More specifically, choose a printer with the experience and equipment facilities to handle your job both economically and competently. Don't be afraid to ask questions. Know your needs concerning the following production details:

*Artist Jane Scott of Elkhorn, Nebraska, for example, sends out invitations with a perforated section that can be torn off and is already stamped and addressed to the artist. See "The Studio Show: One Artist's Experience," *American Artist Business Letter* (January 1982), 8(8):1–3.

- kind of work: announcement, invitation, booklet, postcard
- dimensions: size, format, number of pages
- quantity: number of copies and how handled
- printing: one side, two sides, ink(s), ink color(s)
- paper: kind, finish, weight, color
- copy: display and/or body type; font, weight, point size, leading
- illustrative material: photos, drawings, artwork specs. on screens, halftones, bleeds, sizes, and crops
- proofs
- finishing: trim, folding, binding
- delivery date and method of delivery
- total cost with itemization of services.*

(4) Organize your paperwork and office forms. In addition to the various forms mentioned in the section on studio viewings (résumés, price lists, budget forms, resale contracts), you should also have a guest book where your collectors can sign in. Often, one of your previous collectors will bring a friend to your show and you should have these new people's names and addresses for future reference.

(5) Make sure your studio or home is large enough to accommodate your show. Whereas a studio viewing can occur practically in any size studio (a small extra bedroom, your kitchen table, a converted garage), a studio show requires a minimum amount of room. You can't squeeze 50 to 100 collectors around your dining room table.

If your studio or home space is too small, you may check into the possibility of teaming with another artist who does have a large enough studio. Sometimes, a friend

*This information concerning production details was generously compiled by Virginia Mason of the Materials Committee of the Boston Visual Artists Union.

who is not an artist but who is a great fan of your work can act as a "host" and give you a show in his or her home if the house is large enough. Or sometimes, a few artists will get together and rent a space for a few days or a few weeks to exhibit their work. So if your studio is too small, you could check into these possibilities.

If you do decide to rent a large space with a group of artists, you may want to send out press releases and post flyers around town in order to attract more viewers to your show. Whereas most artists are understandably wary of inviting the general public into their private studios, you don't have to be quite so concerned if your "studio show" is in a rented public space. Your press release should be clear, to the point, with all the pertinent information. Make sure your press releases are sent out early: most newspapers and magazines have to have announcements several weeks in advance. (You can call your various local publications to learn their deadlines.) If you are renting a place to hold your studio show, you will also have to check out other variables, such as insurance needs, or whether you need a special license to serve wine to your viewers.

(6) Solicit the help of your friends or family. Whereas having a friend or spouse present during a studio viewing is optional, you will definitely need help during a studio show. You might need someone to greet guests, or serve refreshments, or guide people around the studio, or handle the sales desk. (The person who handles the sales desk should be familiar with your sales procedures—your resale contracts, invoices, whether you require identification for those paying by checks, and so on.) Your friends' help will allow you to talk with your collectors and to answer questions that only you can answer.

(7) Decide what refreshments you will provide for your guests, since most artists serve some food and drink during their studio shows—wine, cheese, crackers,

cookies, and some nonalcoholic beverage like fruit juice
or mineral water—plus the necessary napkins and plas-
tic glasses. Don't forget to place the refreshments in a
strategic place—either in a special part of the studio away
from your work, or, if possible, in another room alto-
gether. Some artists prefer to serve white wine instead
of red, because red wine stains more easily than white.*

COOPERATIVE GALLERIES

During the 1950s, various groups of New York artists, dis-
satisfied with the commercial gallery system, opened coopera-
tive galleries, that is, galleries founded, financed, and run by
the artists themselves. Cooperative galleries (or "alternative
spaces" as they are sometimes called) have grown increasingly
popular over the past thirty years, as it has become more and
more obvious that commercial galleries are unable—or unwill-
ing—to handle the full panoply of contemporary art.

At their best, cooperative galleries allow artists to show on
their own terms: an artist in a cooperative gallery usually can
exercise greater control over the conditions under which his work
is exhibited, avoiding the unpleasantnesses that so often mar artist-
dealer relations these days. Whereas organizations like mu-
seums "structurally represent first the board of directors, second
the institution itself, thirdly the curator, and finally the artist,"
alternative spaces attempt to reverse that order of priorities: the
artist comes first.† Cooperative galleries allow an artist to show
work that's often beyond the scope or financial interest of com-
mercial galleries—alternative spaces can expand our notion of
what art is or can be. And joining a cooperative gallery allows

*For more information on open studios, see: The Artists Foundation, Inc. *Open
Studio Event: An Artist's Planning Guide,* 110 Broad Street, Boston, Massa-
chusetts 02110.

†Bob Smith, director of the Los Angeles Institute of Contemporary Arts
(LAICA), quoted in "Alternative Exhibition Space," *State of the Arts* (May
1977), 1:5, unpaginated. Published by the California Arts Council.

an artist to interact with other artists, to discuss—and solve—common problems, to find a way, in short, to handle the isolation that unfortunately comes with the territory of being an artist.

But cooperative galleries also have their disadvantages. Artists who join cooperative galleries in the hope of avoiding the inequities of the commercial gallery system often find themselves in another equally unpleasant situation: bogged down in the administrative red tape of running a gallery. Alternative spaces can entail enormous amounts of time and energy. When you're a member of a cooperative gallery, you basically have to be both artist *and* dealer. There are meetings to attend, committees to join, bylaws to amend, records to keep, fees to collect. In certain situations, the cooperative gallery can almost amount to a "second job"; members of such galleries often find themselves having to leave their studios far more often than they desire. And although cooperative galleries often allow for supportive interaction among artists, sometimes such interaction backfires and artists in cooperative galleries find themselves in the midst of infighting, dissension, and wearisome disagreements.

Consider all these issues before joining a cooperative gallery. Don't forget to check out the cooperative galleries in your area much as you would check out commercial galleries. Visit several of their shows, attend their receptions if possible. Learn about their history, their "track record"—how long they've been in business, for example. If you know artists in cooperative galleries, ask about their experiences.

If after completing your research, you would like to approach a particular cooperative gallery, you should do so in the same manner you would approach a commercial gallery. That is, you should call up the cooperative gallery, ask if it is seeking new members, and if so, how best to set up an appointment for a viewing. In most cases, you would bring to that viewing what you could bring to any viewing—your résumé, slides and photos of your work, and a portfolio of several good pieces of your work. During the viewing, you should ask many of the ques-

tions you would ask of a commercial gallery—namely what the gallery expects from you should it decide to handle your work, and what *you* can expect from the gallery in return. Ask to see the cooperative gallery's bylaws so you learn the specifics. The bylaws usually include information on such matters as initiation fees; monthly membership fees; whether those fees include the financing of your show or whether each artist pays for his own show in addition to his monthly dues; how often each member can expect to have a major show; whether the cooperative gallery charges a commission on works sold through the gallery; and so on.

If you and a group of friends are interested in opening your own cooperative gallery, you must, of course, consider many other variables. First and foremost, you should realize that the amount of time—and money—necessary in establishing a gallery is enormous, far more than you probably anticipate. Don't forget that any gallery, co-operative or commercial, is a shaky economic enterprise, and that each year galleries close at an alarming rate. As critic H. J. Weeks has observed, "from the point of view of the business world, the economics of an art gallery are all wrong": the gallery should be in a good location, it must be large, well lit, inviting, and able to show and store items that are large, bulky, fragile, "and from the point of view of the majority of the world, absolutely unnecessary." To open the doors every day, the gallery must either collect enough fees from its members or sell enough work, day in, day out, month in, month out, to "pay the rent, heat, light, telephone, salaries of staff, items for publicity such as printing, photography, and advertising, and insurance plus taxes. None of these expenses will wait. None of the governmental units involved, the big companies or the landlord, will take aesthetic criteria into account if the money isn't paid." *

In addition to facing the financial difficulties inherent in opening any art gallery, you should also take a good long look at your

*From "Don't Open an Art Gallery," *Artweek* (January 22, 1972), 3(4):6.

group. Are the members compatible? Does the group include people with some experience in business? accounting? carpentry? Have you agreed upon what kind of work the gallery will show—whether you will exhibit many different styles or work in one direction? (Many of the cooperatives in the 1960s, for example, were devoted to figurative work in order to counterbalance the abstract style dominant at the time.) Have you researched the community you intend to serve to define your audience and its needs?

If after considering these general issues, your group is still interested in opening its own cooperative gallery, you should:

(1) Establish the legal status of your organization. Is the gallery a partnership? a corporation? a nonprofit corporation? Although setting up a corporation usually requires the services of a lawyer or of a legal-aid-to-artists organization, there are definite advantages to corporate status. Members of a partnership, for example, are responsible for all debts incurred by the partnership— partners can be personally sued for their business's unpaid bills. Members of a corporation, on the other hand, are not liable to such suits. If, for example, a corporation declares bankruptcy, the corporation's creditors cannot attach the personal assets of the corporation's members. So, if possible, seek corporate status.

Also, if your alternative space qualifies as a nonprofit organization (not all cooperative galleries qualify for such status), establish yourself as such, for again, there are definite advantages. For one thing, most private foundations and government funding agencies require that an organization be a nonprofit corporation before it can be considered for funding. Secondly, donations to nonprofit organizations are tax deductible: hence, most nonprofit organizations find it easier to solicit donations.*

*For more information see: Herrick K. Lidstone, and R. J. Ruble, *Exempt Organizations and the Arts* (New York: Volunteer Lawyers for the Arts, 1976).

(2) Determine the administrative structure of the group. Most
corporations, for example, are required to have a board
of directors with officers (president, vice-president, sec-
retary, treasurer), board members, committees, and so
on. If your group is initially large enough, you could
divide it into committees to, let's say, search for the
gallery's space, draft its bylaws, seek out new mem-
bers. You should also determine if your gallery will be
completely staffed by its members—that is, will mem-
bers be required to take turns sitting at the gallery? Or
will the gallery employ a full-time manager/director? As
mentioned, opening a gallery requires considerable work,
and it's usually best to allocate various jobs to specific
people or committees. Be organized: know who's re-
sponsible for getting the various tasks done.

(3) Find a suitable location for the gallery. When selecting
a site, use all available resources. Contact real estate
agents, read the classifieds, drive around looking for va-
cant buildings. Check to see if rental space is available
near other galleries, since the best location for a gallery
is one in the midst of an active arts scene. If possible,
rent facilities on the ground level: as a rule, storefront
locations attract more passersby than second-floor gal-
leries. (Does the location you're considering have, in fact,
a lot of foot traffic?) Make sure your facility is large
enough to accommodate your needs. Most galleries, co-
operative or commercial, need at least two exhibition
areas—one for major one-person shows and another to
display works of other gallery members—plus storage
space. Some alternative spaces rent extremely large fa-
cilities and then subrent some of their space to other arts

Eric Peterson, *Nonprofit Arts Organizations: Formation and Maintenance* (San
Francisco: Bay Area Lawyers for the Arts, 1977). Volunteer Lawyers for the
Arts. *To Be or Not to Be: An Artist's Guide to Not-for-Profit Incorporation*
(New York: Volunteer Lawyers for the Arts, n.d.).

groups, such as theater and dance companies: the additional rental income helps the gallery meet its own expenses.

Don't hesitate to have any location you're considering thoroughly inspected. Pay particular attention to the building's wiring, as most galleries have special electrical requirements. Is the building excessively humid or damp? Does it leak in the rain? Is the plumbing up to the code? Are there toilet facilities on the premises? Will there be sufficient heat in the winter and sufficient air conditioning in the summer? Are the walls suitable for art exhibition—that is, can art objects be easily hung? Are the floors strong enough for heavy sculpture? Are the doors large enough to accommodate large artwork? What is the security situation: are there back doors that would be easy targets for burglars? Does the building have its own burglar alarm? fire alarm? Is the location accessible by public transportation? Are there parking facilities? Will you be able to obtain insurance for the gallery, or will an insurance company refuse to insure you because of the building's condition?

Make sure the landlord is willing to sign a lease, and read any lease carefully, including the notorious "fine print." Exactly what does your rent include: maintenance? utilities? utilities on the weekend as well as during the week? Does the landlord's insurance cover you for liability? Do you have an option to extend the lease?

Once you've signed a lease, plan to renovate your facilities to meet your needs. Remember, most galleries do indeed need to be spacious, clean, well-lit, and attractive places, so think about the physical design of your gallery. Visit other spaces to learn what works and what doesn't. Try to develop a plan that allows for maximum flexibility—check out movable partitions, for example. Most likely, members of the cooperative will be doing

much of the renovating like painting and cleaning, but don't forget to seek out the advice of knowledgeable friends whenever needed. If you must use the services of a contractor, get *firm* estimates and ask for references. You might also check into the possibility of various businesses donating or discounting materials and supplies in return for appropriate acknowledgement. If, for example, a printer made your flyers free of charge, you could add a line at the bottom of those flyers that read, ''Printing kindly donated by————'' If you're a nonprofit corporation, it's even possible to persuade the landlord to donate space to your group to obtain a tax write-off and boost his public image.

Make a complete list of what's needed to furnish the gallery, which might include: a sales desk, typewriter, file cabinets, several chairs, a folding table for refreshments during receptions, vases for flowers, ashtrays, a coffee machine, a small refrigerator, slide projector, a basic tool kit, telephones, office supplies, wastebaskets, and so on. Many of these items can be supplied from the members' attics, basements, garages; others can easily be purchased at secondhand and thrift stores.

When ordering supplies for the gallery, try to order in large quantities—it's usually less expensive. Check out wholesale suppliers. If there are other cooperative galleries in your area, also investigate the possibility of group ordering to save money.

(4) Do both short-term and long-range financial planning. From the outset of your venture, you should pay special attention to all matters of finance: think carefully about how your gallery will be funded. Most cooperative galleries are, of course, financed by their members, but *how* those funds are collected varies from gallery to gallery. Some cooperative ventures, for example, charge flat monthly dues. Others also collect initiation fees whenever a member joins the cooperative in addition to

monthly dues.* Some cooperatives charge not a flat monthly fee; rather their members' dues fluctuate according to what funds the gallery generates through its other sources of income such as sales commissions or rents: the more money generated from these other sources, the less each member pays that month, and vice versa.

Will your gallery charge a commission on works sold through the gallery? (Most cooperatives take a commission between 10 percent and 25 percent, which is lower than the 33 percent to 50 percent charged by most commercial galleries.) If your gallery does charge a sales commission, how will that commission be distributed? Will it result in lower dues that month? Will it go into a general "emergency" fund? Will it go to the gallery's general director/manager if your gallery has employed such a person? Or will it be divided between the director and the general fund? Do the monthly fees include the financing of each member's show, or is each artist responsible for financing his own exhibit in addition to paying monthly dues? If the gallery pays for each show, how much will it spend? Who, in fact, is responsible for the gallery's bookkeeping—the treasurer of the board? the general director/manager? Who has power to sign the gallery's checks? For checks in excess of a certain amount (let's say $500), will two signatures be required? What measures will be taken if members are delinquent in paying their dues?

All of these and many other similar issues must be

*To compute their initiation fees, many cooperative galleries simply add up all their start-up costs (rental deposits, utilities deposits, renovations, furnishings, legal fees, a general "emergency" fund, and so on), and then divide by the number of members in the group. Similarly, to determine monthly dues, many cooperatives simply add up all monthly costs (rents, utilities, salaries, insurance, telephone, printing and so on), and then divide by the number of artists in the cooperative. (Cooperatives tend to have between twenty and twenty-five members, allowing each artist to have a major show once every two years.)

addressed by your group. Similarly, each member of the cooperative must make known any of his pertinent policies concerning finances, such as whether or not he permits budget or rental sales.

(5) Draft the gallery's bylaws, clearly delineating the gallery's organizational structure, voting procedures, and members' responsibilities. You must know what is expected of each member, besides, of course, monthly dues. Is there, for example, a minimum amount of time a member must stay in the cooperative? Could, for example, a member join, have a show, and then leave? Is each member responsible for financing his show, or are such expenses paid for by the gallery out of members' dues? How are new members selected—by majority vote of the entire membership? by approval of the board of directors? by approval of a special "membership" committee? How is the order of members' shows determined? What is the gallery's policy on studio sales? Must each member serve on a committee?

(6) Publicize the presence of your gallery. Although each of the gallery's shows should be appropriately publicized, you might want to mount an especially extensive campaign to announce the opening of your gallery. Compile a list of all the newspapers, magazines, newsletters, and free-lance critics in your area, and send them press releases. Check to see if your local radio and television stations make "community bulletin board" announcements; if so, send them press releases as well. You might also consider other publicity ventures, such as flyers or posters. If there is a merchants' association in your neighborhood, join it. Similarly, see if you want to join any of the art organizations in your community. Such groups can often provide advice, support, and connections, and your membership in such groups can be good public relations—it makes your presence in the community known.

This list comprises only the roughest outline of how to establish a cooperative gallery. As I have mentioned, starting such a venture really does entail enormous amounts of time, work, and energy.

COMMISSIONS

A commissioned work is one which a client has paid you to create from scratch—that is, it's a work made to order. The president of a large corporation, for example, could commission you to paint his portrait. Or a municipal arts council could commission you to create a mural for the recently renovated south terminal of the city's airport. Or a major architectural firm might announce it would soon commission artwork for the lobby of a new office tower downtown. Or a publisher of fine art prints might commission you to execute a suite of five etchings that it would then distribute.

The word "commission" might imply that it is the client who seeks out or approaches the artist, and that indeed is often the case. But if the idea of commissioned work appeals to you, you could be the one to take the first step. If, for example, you thought your work would work well on record covers or book jackets, you could arrange viewings with various book and record companies, some of which might result in their commissioning you to create several covers. Think about your potential market— about how you can connect to your public. If, for example, you did detailed drawings of birds or flowers, you could approach natural history, birding, or botanical societies to seek commissions. And don't forget to check announcements in the various art magazines that regularly list when various clients—architects, designers, arts councils, and so on—are viewing artists' portfolios in order to award commissions.

Although commissions can be a welcome addition to an artist's income, they are not without their potential dangers. When you are creating a commissioned work, you are not simply working in your studio in accordance with your own aesthetic

needs and desires—you are also working to meet the specified desires of your client. To a certain extent, a client who commissions an artwork is not so much a "collector" as a "customer," and it's important to remember that he can, on occasion, act very much like a "dissatisfied customer" at that. Artists' newsletters are full of horror stories about commissions gone wrong. An artist, for example, might slave day and night for three months to finish a commissioned work, only to have the work rejected by the client, who then refuses to pay the artist. Or a client who initially accepts the work, might later decide he doesn't like it and—without the artist's permission or knowledge—he will have the work altered or even destroyed: a mural will be painted over, a painting defaced, a sculpture melted down. This can happen to all artists, no matter how well known or established—David Smith, Calder, and Noguchi have all had commissioned works altered or destroyed against their wishes.

Many if not all of these disasters can be avoided if an artist has a comprehensive written agreement with his client. If you are ever commissioned to create a work, make sure that your client has enough familiarity with your work and style, and then be absolutely certain that you have a detailed contract which addresses the following concerns:

(1) Project Description. You should describe in detail the nature of the commissioned work—its dimensions, materials, construction methods, and so on. If, for example, you were commissioned to create the aforementioned suite of etchings, you should state the exact paper to be used, the paper's size, the size and nature of the plates, the number of images, how many prints of each image are to be made, whether it is a limited edition and the plates will be destroyed, and so on. If preliminary sketches or designs of the commissioned work have been made, you should have the designs photographed or photocopied, attach the reproductions to your contract, and mention them in this project description. Anything

that will describe or clarify the project might be mentioned. If, for example, you were creating the suite of etchings, you might also wish to state that the prints are created by a hand process, and that slight variations from print to print are normal, and that there is also a slight change in the plates from the first to last prints which is also part of the process. The more details, the better protected you are against subsequent claims of dissatisfaction.

If no preliminary sketches or designs have been made and your client is, in fact, asking you to submit such designs, this part of the contract should:

- describe the nature of the designs
- specify your fee for executing such designs
- stipulate that the fee is nonrefundable even should the client reject the designs
- give the client a certain period of time (two weeks, let's say) to accept the designs or request changes
- specify your additional fees should such changes be requested, and perhaps limit the number of changes or the amount of time necessary to make such changes
- mention that all designs are copyrighted in your name and that should the client reject the designs, you are free to use them as you please
- stipulate that should the client fail to inform you of his approval or rejection within a certain time (three weeks, let's say), the project has, in fact, been approved.

Most clients will require that should they accept the preliminary designs, any fees paid you will be deducted from the price of the actual commission.

(2) Project Timetable. Your contract should state the date

you are to begin the project as well as the project's completion date, delivery date, and method of delivery. You might also need to mention other intervening deadlines, depending upon the nature of your project. If, for example, you were creating the aforementioned suite of etchings, you might specify the date you will give the client sample proofs, and how much time the client has to approve those samples. Or if the project entailed a particularly difficult installation, you might specify the date the project will be completed, the date installation will begin, and its finish date. Citing these deadlines is actually to your advantage: each time your client sees the work in progress and the work continues, the client is, in effect, giving his approval, thus minimizing later disputes. (Upon the project's completion, you might even request a receipt that firmly acknowledges the client's satisfaction and acceptance.)

Your contract should also include a clause to the effect that your client cannot cancel the project if you are merely one day behind schedule. Most commission agreements, for example, stipulate that the contract is in effect until the artist is more than sixty (or in some cases ninety) days late in completing the project. And even this clause should have a rejoinder in certain cases. Let's say, for example, you were creating a mural for the city's new airport: you are about to start the mural when you are informed that there are unexpected delays in the construction of the walls. You should not be held accountable for delays you did not cause, and your contract should, in fact, include some clause to the effect that you are not responsible for such delays as those caused by labor disputes, scarcity of materials, unusual transportation delays, illness, acts of God and natural calamities outside the artist's control. In cases of such delays, you should be obliged to inform your client at the earliest possible moment and you should also be

permitted to extend the deadlines by an amount of time equal to the unavoidable delay.

(3) Payment Schedule. No artist should begin a commissioned project without receiving some money in advance. Frequently, for example, the client will give the artist one-half of the artist's fee upon signing the contract, and the other half upon completing the project. Another common arrangement is for the artist to receive one-third of his fee upon signing the contract, one-third midway through the project, and the final third upon its completion. Your contract should also specify that until payment has been received in full you retain full ownership of the work and title to the piece remains in your name.

All financial matters should, in fact, be clearly understood. Does, for example, your price include:

- the cost of materials?
- packing, shipping, and freight insurance?
- framing or installation costs?
- your own traveling and living expenses should the installation site be far away from your studio?
- living costs incurred during the creation of the piece such as long-distance telephone calls and telegrams?
- salaries and workmen's compensation coverage for any employees needed during the execution and installation of the work?
- rents for any additional work space and equipment necessary for the project?
- fire, casualty, and personal liability insurance on the work until installation is complete?
- any sales tax that may be required by law?
- consulting fees necessary to the work's creation and installation? (You might, for example, have to consult with engineers, contractors, architects, and

building permit departments for certain large-scale projects. And, similarly, you will most likely need to consult with lawyers about contracts.)*

*Most of these expenses are generally paid by the artist, so you must remember to figure in such costs whenever you quote a price to a client. The sales tax, however, is the client's expense and the contract should stipulate that. You should also negotiate to have the client cover the aforementioned insurance fees as well. But most of the other expenses are usually your responsibility. Hence, you must be incredibly thorough when estimating your price for a commissioned project. Really think about every possible expense. In addition to the above costs, you should also take into account your overhead, your own labor, material wastage, inflation (if your project entails your buying materials over a long period of time), and a margin of profit for you (after all, when taking on a commissioned work, you have to drop everything else in your studio, thereby losing private work time, and you should be compensated for such loss—generally speaking, a commissioned work should cost much more than a work you sell which is already executed).

If the commissioned project has been arranged by an agent or dealer, you you should also take into account the dealer's fee. Most dealers charge a smaller fee for commissioned works than for works sold on consignment in a gallery, and these different dealer's fees should have been specified in your artist-dealer contract. (See Chapter 13 and Appendix 2.) If the costs of materials for the commissioned work are especially high, you might also bargain with your dealer to have him take his fee on the price of the commissioned project *minus* the material costs. Why, for example, should your dealer receive his fee on the $4,000 you spend on bronze casting?

When a government agency is commissioning public artwork, the agency will often tell the artist how much money the agency has for the project, and the artist must see if he can work within that budget: in other words, the client quotes *you* the price. But in most other cases, *you* will be asked to quote the client a price. Many artists find this very difficult to do. I know one artist who, whenever asked to quote a price for a commission, always asked: "Well, how much can you afford?" I find this question very unprofessional. After all, if you were in a department store buying a suit or dress, would you really want to take the suit to the cashier and have the sales clerk ask you, "Well, how much can you pay for this suit?" No, you want the suit to have a price tag. And although an artwork, needless to say, is not exactly equivalent to a suit, the principle still holds true. You're a business person when dealing with clients, and should act as such. It's your product you're selling them, and you should know more than they do about how much your product costs. So don't be afraid to quote a price to a client. Just make sure the price you quote takes into account all the variables mentioned above.

Your contract should also stipulate that you will re-
ceive your payments within a set time (ten days, let's
say), that you reserve the right to charge interest on late
payments and to extend the time required to complete
the work proportionate to the delay in payments. You
might also want to include a clause that should pay-
ments be more than, let's say, sixty days late, you can
terminate the agreement if you so desire.

It's also a good idea to state that should the client ask
for substantial revisions or changes, you will receive a
certain fee for each substantial change. You may also
wish to set limits on the number of changes, the time
spent to make such changes, and the number of people
who can request them. For example, the city decides that
the originally commissioned 20' × 30' airport mural now
needs to be 25' × 35'. You should obviously be com-
pensated for the additional materials and labor needed to
execute and install the larger mural.

(4) Copyright and Reproduction Rights. Although your client
has commissioned you to create a work, the work should
nevertheless be copyrighted in your name, and you should
then have complete control over reproduction rights. All
preliminary sketches and designs should similarly be
copyrighted in your name. As mentioned in Chapter 10,
should your client wish to purchase reproduction rights,
you should charge him or her a considerably higher price.

(5) Moral Rights and Other Artist's Rights. Your contract
should stipulate that your client cannot knowingly alter,
change, modify, damage, or destroy your work, and that
he will take reasonable precautions to protect the work
against damage or destruction by external forces.* (In
order to facilitate the client's care of your work, you

*This clause would, of course, need some modification if your work were
something like a large mural affixed to a wall. In such a case, your contract
could state that in the event that the structure or wall be renovated or demol-
ished, the artist will be given proper notification and reasonable opportunity to
reclaim the work by removing it whole at the artist's own expense.

should provide him with a statement of maintenance. Of course, any maintenance expenses will be paid by the client.) Should the work be damaged or altered, the work will not be represented as your work without your written permission. In short, the client will not permit any use of your name or misuse of your work which would reflect discredit on your name or your reputation as an artist, or which would violate the spirit of the work.

Similarly, should the work need restoration in the future, the contract should require that you must be first consulted. You might also stipulate that you reserve the right to restore the work yourself, for which service you will be reasonably compensated.

Should the client later sell or transfer the work, you should be informed of the transfer, be given the new owner's name and address, and 15 percent of any profit made by the sale. Even if the transfer is temporary—for example, if the client is lending the work to a museum—you might require to be notified and to be given the right to supervise any necessary installation, for which labor you will be reasonably compensated. And if the work is being relocated by the client—from his old office to his new headquarters, for example—you also might want the right to be informed and to supervise the relocation.

If you think you may one day need to borrow the work for exhibition purposes such as a retrospective of your work, your contract should give the right to borrow the work for, let's say, no more than sixty days in a five-year period, at no expense to the client—that is, you will pay for packing, shipping, and insuring the work during the loan, and you will also guarantee that during any exhibition, the client will be entitled to appropriate identification as the work's owner.

And lastly, you must be sure your right to credit will always be observed. Assume you had created that aforementioned airport mural. Your contract should state that

a plaque or title card will be installed by the mural at the client's expense, listing the mural's title, your name, the year completed, and so on, in such manner as suits your taste. Similarly, should the work be reproduced for publicity or advertising purposes, any reproduction will always include your name, your copyright notice, the title of the work, its dimensions, medium, and so on.

(6) Cancellation and Cancellation Contingencies. Your contract should clearly state how the agreement can be terminated by either party and the consequence of each kind of cancellation. For example, suppose the city had commissioned you to create that airport mural, but the entire airport expansion project is later cancelled by the city. Your contract should state that in such circumstance, you are entitled to all fees already received by you and then due you, that you retain full title to any work already completed, including preliminary designs, and that you are free to complete the work and sell it to any other party. (If *you* cancel the contract, you may still stipulate that you retain rights to any work completed, but most likely your client will require you to return any fees already received.)

Your contract should also state that the client cannot cancel the contract without reasonable cause, that "if prior to the work's completion, the client observes or otherwise becomes aware of any fault or defect in the work or nonconformance with the design plan, he shall notify the artist promptly. However, the client's objection to any feature of the work not specifically indicated by the design but attributable to the exercise of the artist's aesthetic judgment in the creation of the work on the basis of the design plan shall *not* justify the client's withholding acceptance of or payment for the work." * In other

*This provision is from a commission contract written by Howard Thorkelson, former editor of *Art and the Law,* a publication of the Volunteer Lawyers for the Arts. Reprinted in Diane Cochrane's *This Business of Art* (New York: Watson-Guptill Publications, 1978).

words, the client must agree that sometimes it may not be possible to execute the work exactly as depicted in the design.

Your contract should also cover what happens should you sustain injury or incapacitating illness before completing the project. A provision could be included, for example, that states that you will notify the client of such delays caused by illness or injury, but that the project will not be cancelled unless such delays exceed a certain amount of time—perhaps six or twelve months.

Similarly, should you die before completing the commissioned work, you might wish to stipulate that the client cannot have another artist finish the project, or that the project can be completed only by an artist whom you yourself name. You should also state that in the case of your death, your heirs will be entitled to retain any payments already made by the client or then due you, and to have full title to any work already completed.

(7) Arbitration. Some artists like to include a provision that should a dispute arise (or a dispute not involving more than a specified amount of money), the dispute will be settled not in litigation in the courts, but by arbitration. In such case, you should designate the arbitrating party and state that such arbitration be in accordance with the standards and procedures of the American Arbitration Association. In those cases where litigation in the courts is, in fact, necessary, you might also want to stipulate that the prevailing party shall be entitled to attorney's fees in addition to any other entitled relief.

(8) Authenticity of Work. You should guarantee that the design or work being commissioned is the original product of your creative efforts, that the work is unique, that it is an edition of one (unless otherwise stipulated), and that it has not been accepted for sale elsewhere. You should also guarantee that you will notify the client of any change of your address within ninety days, so that

the client will be able to contact you should he be so obliged by the contract—that is, for reasons of restoration, transfer, relocation, and so on.

(9) Miscellaneous Issues. Your contract should state that:

- the agreement contains all of the covenants, promises, agreements, and conditions, either oral or written, between the parties
- no modifications or amendment of the terms of the agreement shall be effective unless made in writing and signed by authorized representatives of both parties
- the agreement shall be governed by the laws of the city and/or state where the agreement is signed
- neither party has the right to assign or transfer the rights and privileges granted by the agreement without the prior written consent of the other party
- the agreement shall be binding upon the parties, their heirs, assigns, and personal representatives
- and that the contract must be signed by both parties within ninety (or 120) days or then renegotiated so as to protect you from the damages of inflation.

Again, the above list of contractual issues is by no means exhaustive. Each commission has its own particulars and may thus call for certain other provisions. Certain of these issues may be essential to your project; others may not be quite so pertinent. These are issues to be discussed, negotiated, and, in certain cases, compromised on. But whatever agreement you make with your client, always get it in writing. Written agreements are much safer than verbal ones: written contracts minimize later disputes, refresh what would otherwise be faulty memories, and serve as excellent testimony should a dispute arise.

And again, never sign a contract without knowing exactly what it stipulates. Seek legal advice, especially from legal-aid-to-art-

ists organizations. And don't wait for your client to hand *you* a contract. Remember, if you're on top of things, you can draft your own agreement, let an attorney review it, and then hand it to your client. Know your rights, so you can protect your rights.*

GRANTS

For the past two decades, artists have heard quite a lot about grants. You can go the library and find shelf after shelf of books on the grants given by the more than 25,000 foundations in America alone. You can read any number of art journals and find regular listings of deadlines for any number of grant applications. You can consult bulletin boards in art schools and see announcements for grant workshops. There are even people who specialize in "grantsmanship," that is, whose job it is to help you write a "winning proposal." And there are organizations whose sole function is to collect and disseminate information about grants.

When exploring all this supposed wealth of information, it's important to remember one basic fact: it's really not that easy for an individual artist to get a grant. Most private and public foundations give grants extensively, if not exclusively, to non-profit organizations—and not to individual artists. Even those grants that are awarded to individual artists seldom allow the artist to work in his studio at his own discretion, but rather are designed to use the artists as a "public service"—that is, to put the artist "in residence" at a school, community outreach program, and so on.

I realize that this is not the standard, conventional pep talk about grants, but I still say that emerging artists who are just beginning to market their work should not put undue hope in the whole grants game. Consult Appendix 1 of this book to find the

*Many of the concepts in this chapter can be found in two articles by Caryn R. Leland: "Negotiating Commission Agreements," *Artworkers News* (March 1980), 9 (7): 20–21; and "A Model Agreement for Commissioned Artwork," *Artworkers News* (May 1980), 9 (9):32–33.

standard texts on grants. Send away for a few applications, and yes, hire a good grant consultant if you have time, money, and inclination. But then

prepare to wait, and to travel, and to wait, and to fill out forms, and to write, and to revise, and to wait, and to have polite appointments with people who make three times what you do for sitting at desks in comfortable offices shuffling papers, and to wait. If you are very fluent, and have a lot of good connections or well-connected friends, and are a very orderly record-keeper, and have a dynamite project that can be visibly executed in a specific geographical area and be clearly seen to "serve the population"; and, if, as well, the economy booms and the funders you approach have no major personal crises like death or management upheavals or a federal election, you might, with luck, see some money two years later. If you are just ordinarily fluent, and any of the other factors are working against you, you could well wait three or four more years before you ever see a penny of "unearned income," as grantors call their largesse. The art you aren't making while you follow through with grant applications, the fees or salaries you pay grantwriters or friends, the Procrustean antics through which your ideas must be put to make them fit the guidelines of a particular funding agency, all get chalked up to experience; each year you must start the process again. The average seeker of funds will wait nearly five years before seeing a penny from the average corporation. . . . Grant-seeking pays off about as often as any other game of chance.*

No one denies it would be great to have our work subsidized, to be rewarded grants by philanthropic organizations. But I still say it's important to keep in mind that when all is said and done,

*Elizabeth Richter Aimmer, "Grants in America," *Dance Scope* (1980), 14(4):66–67.

the *real* art philanthropists in this country are the artists them-
selves, who "support" the arts against great odds, considerable
difficulty, and often for little financial gain.

PRINTMAKING AND MULTIPLES

Some artists produce unique, one-of-a-kind works such as
paintings, watercolors, and drawings. Other artists are primarily
printmakers, creating "multiples" of serigraphs, etchings, block
prints, lithographs, and the like. For printmakers, multiples ob-
viously are not an "alternative" to their work, but rather *are*
their major work. In this sense, the following section is not pri-
marily intended for printmakers, but for those artists who, working
principally in one-of-a-kind media, have yet to experience the
advantages and joys of making multiples.

Shortly after my first one-person exhibition, I became inter-
ested in prints and spent six months creating a suite of seri-
graphs. The idea of "multiples"—of having many prints of the
same image—fascinated me. I liked the possibility of having my
work in many places: whereas a one-of-a-kind work can only be
in one place at any one time, a print can be in several places
simultaneously. It's possible to be selling a print in your studio
and have twenty galleries around the country selling them at the
same time as well. Prints, in short, increase your work's ability
to "travel" in the world. Prints allow you to connect with your
collectors in an entirely new and exciting way.

Since multiples also tend to be priced lower than one-of-a-
kind works, more people can not only *see* your work, but *buy* it
as well. There's a "democracy" of pricing possible with prints
that appeals to me. When I brought my paintings home from my
first one-person show, I thought, *My God, I must be painting
only for the very wealthy.* Whereas few of my collectors or friends
could afford the $900 to $1800 I was then asking for my paint-
ings, many people could purchase serigraphs priced from $50 to
$200. (In fact, a few years after my suite of serigraphs, I pub-
lished a set of postcards, so I could have work as inexpensive

as 25¢.) The increased exposure made possible by prints is effective "publicity": remember, a collector who buys a $100 lithograph is likely to return the next year for another print, or even for a one-of-a-kind work.

In short, the very concept of multiples is quite important for an artist to contemplate. Prints radically alter the way your work is "wedded" to the world, and I'm not merely talking on the level of finances. I'm intrigued, for example, by the fact that with prints you never have to part with the "original," that you can sell to a collector and still have a print for yourself.

Of course, printmaking is not without its difficulties. For one thing, certain printmaking procedures are expensive, and many artists find the costs beyond their means. Keep in mind, however, that as an artist you are also a business person, and just as businesses borrow money for purposes of expansion and development, you, too, can apply for a loan from a bank, friend, relative, or collector. Consider the loan an investment in the future well-being of your art business.

Printmaking can be time-consuming as well as costly, and when you start to create multiples you have to consider various time factors. For example, in creating an edition of 100 prints, some artists will not print all 100 at the same time; they will print the first ten, and the remaining 90 only as needed. Such artists don't want to spend all the time necessary to print the entire edition of 100 and then face the additional problems of having to store and preserve the prints. Although I can understand such thinking, I still believe it's best to create the entire edition all at once and have an "inventory" ready at all times. I once produced a suite of block prints, but only printed ten of each image instead of the complete edition of 100. The block prints became popular, and each time a gallery would order another one, I would have to stop whatever I was doing, go to my studio, make sure I had the proper paper and the right tools, clean my work space, put away some things I was currently working on, make the prints, and then wait for them to dry—all at a time when I was perhaps no longer "in sync" with the image in the way I was when I

made the first print. A few times, I even lost a sale because I didn't have a particular print on hand. Having an inventory of prints gives you the opportunity to sell it anytime a collector comes around, or to exhibit it anytime a dealer is interested. So although printing an entire edition entails time, energy, money, storage space, and conservation know-how, I still recommend it.

In addition to extra costs and time, printmaking can also entail additional record keeping. Some states, for example, have print laws requiring you to maintain "justification" sheets. These justifications are essentially a historical record, a disclosure, of your methods and procedures—where you made the prints, whether you had help making them, the kind of paper, the size of the paper, the size of the image, whether or not the screen or block was destroyed, and the number of prints with the number broken down into such categories as artist's proofs, numbered impressions, and so on.

The justification, though originally intended as a means to protect the consumer, also can serve the artist. As mentioned, collectors like information about your work, and the justification can be a selling tool, rich with details. (It's wise to keep a journal when making multiples, even if your state doesn't require it. Such a journal allows you to remember your color formulas, the kind of paper you used, and all the various details you might later need to refer to.)

In addition to justification documents, you should also keep a record of each and every one of your prints. This is actually easier done than it might initially appear. Let's say you have made 25 prints of a particular image. You should write the name of that print and its retail price at the top of a page of standard lined notepaper. Next, you should number the lines, 1 through 25, so that each print of the edition has its own line on the page. Each time a print leaves your studio (on consignment, to be framed, for exhibition, because it's been sold), make note of it. If the print has been sold, mark down the collector's name and the amount of money you take in, the commission (if any),

whether you or a gallery sold it, and so on. Such an easy-to-maintain system allows you to know the exact status of all your prints—how many have been sold, how many are in your studio, how many are on consignment, and where they all are. You might also want to keep a cross-reference system whereby each gallery handling your prints has its own page. That way, you can tell which gallery has produced the most sales for you, which gallery still has what prints on consignment, and so on.

The above discussion of printmaking is by no means comprehensive. Certain topics such as the pricing and signing of prints have been handled elsewhere in this book, and this chapter's section on commissioned artwork addresses the all-important issues that become relevant when someone approaches you to publish prints of your work. Other topics—such as the various kinds of printmaking, the actual technical procedures, the exact definitions of proofs, the possibility of employing master printers at professional print workshops, the controversy concerning exactly what constitutes a fine art print, and whether or not an artist should sign poster editions—are outside the scope of this chapter (see Appendix 1). The main thrust of this section is to remind those artists who work primarily in one-of-a-kind media that multiples are a promising and wonderful alternative.

16

AN ARTIST'S FINANCES AND RECORD KEEPING: TAXES, INSURANCE, WILLS

TAXES

If you're a hard-working artist, you owe it to yourself to know the basic facts of taxation. Whether you've been working one year, five years, or ten, whether you've been selling a lot of work or practically none at all, you still should know—*must* know—the particulars of an artist's taxes. Yes, I realize most artists find the subject of taxes complicated and confusing, when not downright depressing. And yes, there are certain tax laws that are especially unfair to, and hence especially frustrating for, artists—laws that might make artists wary of taxes altogether, that convince many artists that tax laws exist only to penalize the creative individual. But this is not totally true: if you know a few basic principles about taxation, you can be sure you won't be deprived of what you are actually entitled to in tax benefits. Following a few simple procedures can indeed save you time and heartache, not to mention money.

Because if you have another job where taxes are deducted, or if you're married and you file a joint return with your spouse who has taxes deducted from his or her paycheck, some tax

money can be "retrieved" from the I.R.S., so to speak. For example, you're an artist who also supports himself through teaching. Last year, you earned $15,000 as a teacher, and each of your paychecks had taxes withheld based on that $15,000 income. During the same year, you also spent $4,000 on your artwork—on supplies, postage, printing résumés, entertaining collectors and dealers, and so on. Your artwork, however, only brought in $1,000 that year—in sales, commissions, royalties or whatever. As a self-employed business person, you can then file a profit or loss form that details those $4,000 expenses and $1,000 earnings, thus showing that as an artist you actually lost $3,000 that year. You can then deduct that $3,000 loss from your $15,000 teaching income, which means that your income for the year for both of your jobs was only $12,000. By filing such a tax return, you are in effect telling the I.R.S., *Look, you taxed me on the basis of a $15,000 income, but I should have been taxed only on $12,000. Therefore, please refund the extra money you took out of my teaching paychecks.*

Although the above example is an obvious oversimplification, its basic principle is nevertheless sound: you owe it to yourself to keep records of your art finances so that you will receive any and all benefits you're legally entitled to.

During the past two decades, many books, pamphlets, and articles have been published detailing the particularities of an artist's taxes (see Appendix 1). Each year, there are also any number of tax "workshops" given for artists across the country. Many of these publications and workshops are undoubtedly useful, but many of them are almost too "useful"—that is, they are too complicated. Even those publications that are prefaced with the claim that the book or article is targeted for artists and hence has been written in a straightforward, easy-to-understand style, often are indecipherable or ask you to keep such complicated records that your studio time would be seriously diminished. Artists shouldn't have to double as certified public accountants, and artists shouldn't have to spend excessive time keeping books. To quote arts advocate Rubin Gorewitz (himself

a CPA), "The artist's main concern is art, not business, and any time devoted to the minutiae of business affairs could more creatively be spent producing art."*

Therefore, what follows is a capsule guide on how to handle your taxes legally, but as easily and as simply as possible:

(1) First of all, all artists should use an accountant to help them file their tax forms. I realize this advice runs counter to much of the "self-help" philosophy so prevalent these days, and counter to much of the advice given elsewhere in this book. But in the area of taxes, some outside professional help is necessary, useful, and in the long run, economical. For tax laws are not only complicated, they unfortunately change frequently. What might be a legal deduction one year won't be allowed the next. Federal tax laws might require one thing, and state laws something very different. Similarly, prerequisites for home-studio deductions vary from year to year, as do methods of calculating depreciation. Do you really want to follow all the convoluted ins and outs of tax legislation? For example, the Tax Reform Act of 1986, recently passed by the United States Congress, contains the most sweeping revisions of the Tax Code in more than thirty years. The revisions are indeed so sweeping that at the time of rewriting this chapter (December 1986), many of the applications of the new law were unknown or unclear.

Therefore, I say it's better to hire an accountant who's familiar with taxes for self-employed people such as artists, free-lance writers, actors, and so on. Find an accountant who's sympathetic to an artist's finances— that is, one who doesn't think all artists are merely

*From "Bookkeeping for Taxes," in *Are You Ready to Market Your Work?*, ed. Norma A. Fox (Boston: Boston Visual Artists Union, 1979), p. 53. Mr. Gorewitz is the author of several bills in Congress and the cofounder with Robert Rauschenberg of Artists Rights Today. As a certified public accountant, he represents over 600 artists in the New York area.

hobbyists. Ask other artists you know about their accountants—whether they're satisfied, whether their accountants have saved them money. When approaching an accountant, always know the fee in advance: most accountants charge by the hour, and the hourly fee can vary considerably from one accountant to the next. You will be surprised, however, that not all good accountants are as expensive as you might have thought. Some accountants might even take part or full payment in art. Make sure you find an accountant you trust. If considerable money is involved, don't hesitate to get a second opinion. A friend of mine, for example, found her income dramatically increased when she was commissioned by her city to create several murals. It was a huge venture, one that required her to hire a large staff, and one that brought her a considerable commission fee. Previously, her art-related income had been very modest, and she did not know a great deal about taxes. After the murals commission, she went to an accountant who told her she would have to pay more than $10,000 in taxes. I advised her to seek another accountant, one more familiar with artists and their lives. The second accountant re-examined her finances, and found quite legitimate ways to reduce her taxes by half, saving her more than $5,000!

(2) Keep in mind that just because you hire an accountant it doesn't mean you are free of all record keeping. The more work your accountant has to do for you, the more money you will have to pay him, and the opposite is true, too. So you should keep your own books.

It's actually not very hard to maintain your own financial records—that is, to keep an account of all expenses incurred and all income earned as an artist. Every time you sell a work or earn any money as an artist, you should enter the information in an "earned income register." This register can be a standard stationery store ledger, a three-ring notebook, or whatever other system

works best for you. Just make sure that each entry in
your income register includes all the pertinent informa-
tion, such as:

- the date of the transaction
- the nature of the transaction, whether it was a sale of
 a piece of work, royalty income, a copyright sale,
 a lecture fee, or whatever
- the title of the work sold (if the transaction was in-
 deed a sale of a piece of work)
- the size, medium, and date of the piece
- the name of the person to whom the work was sold
- the retail price
- the gallery's commission (if any)
- the amount due you, the artist (that is, retail price
 minus commission fee)
- and a checkbox when the amount has, in fact, been
 paid.

Depending upon your needs, you might want to di-
vide your income register into several areas:

- a general, all-inclusive section
- a section that includes a page for each of your var-
 ious galleries, allowing you to determine which
 galleries are working hard for you
- a collectors' section with, perhaps, a page for each
 of your major collectors, allowing you to know
 which works they own, when they last purchased
 a work, and so on
- a section for installment sales, so you can know ex-
 actly how much money is still owed you on in-
 stallment payments
- sections for any special body of work, such as an
 edition of prints you've published

Similarly, every time you *spend* money on your work,
you should keep a dated receipt. If a sales slip does not

mention what, in fact, was purchased, just jot it down on the slip. For example, when I invite a gallery owner to my studio for a viewing and I know he expects a drink, I buy a bottle of wine, and I put on the back of the sales receipt, "Wine for studio viewing with _____." I always make the notation when I make the purchase because otherwise I would go crazy four or six months later trying to figure out which receipt was for what expense. When keeping receipts, be comprehensive. Don't forget any expense. Consider:

- what percentage of your rent is business-related *
- what percentage of your telephone use is business-related
- what percentage of your utilities is business-related
- what percentage of your car expenses (gas, insurance, repairs, parking fees) or bus and taxi fares is business-related
- photography costs for photos and slides of your work

*Laws about home-studio deductions have changed in recent years. If you have a studio outside your home, you cannot deduct expenses for a second studio inside your home. But if your home studio is the principal and regular site of your art business, you can deduct certain studio expenses. Even if you are a teacher whose school provides you with an office for your teaching, you can still deduct expenses for a home studio: the school office is the principal site of your teaching profession, and the home studio is the principal site of your art business. (Recent laws allow each of your various professions to have a principal site.)

To determine what part of your rent should be considered studio expense, draw a floor plan of your apartment or home. Determine how much of that floor space you use for your work—where you paint, where you store the work, where you keep the supplies, where you might have an office (shelves and desk), where you write letters to galleries, bills to collectors, prepare your résumé, and so on. Determine the percentage of work space in the entire apartment or building. Then, when you consult with your accountant at year's end, tell the accountant what percentage of your home is work space.

This whole notion of home studios can be very complicated, and the I.R.S. has been known to be very particular about this issue. So if you have any questions, consult your accountant.

- entry fees for competitive exhibitions
- subscriptions to magazines and journals that are necessary to your art
- books that you purchased for your work
- membership dues to join art organizations
- expenses to entertain gallery owners, curators, collectors, and the like
- framing costs
- insurance premiums to insure your work, your studio, your tools and supplies, or any liability coverage you might have
- shipping and delivery fees for artworks transported to galleries, competitions, collectors
- advertising and publicity expenses, such as résumés, business cards, announcements for shows, posters, advertisements in newspapers and magazines
- postage fees for correspondence to your galleries and collectors
- accountant's fees*
- lawyer's fees
- salaries for any workers or subcontractors you might have hired
- traveling expenses, including room, transportation, food, and conference fees, for your art business
- photocopying expenses for duplicating résumés and reviews of your work
- checking account fees
- interest paid on art-related expenses
- consumable office and studio supplies such as paper, pencils, paint, glue, erasers, light bulbs, note-

*Under the Tax Reform Act of 1986, accountant's fees are not completely deductible. Deductible is only that portion of your accountant's bill that went directly for art-related, self-employment business documentation, such as for filling out your Schedule C form, etc.

books, typewriter ribbons, sandpaper, turpentine, rope, tape and nails
- nonconsumable goods and capital expenditures such as cameras, typewriters, adding machines, cars, trucks, phone-answering devices, home computers, brushes, easels, pans, presses, looms, in short, items that are *not* used up when you work and which are thus, in most cases, considered inventory items subject to depreciation each year*
- repair costs for equipment such as typewriters, adding machines, slide projectors
- donations of your artwork†
- studio maintenance expenses, such as fees for plumber, roofer, a new lock
- bad debts, such as uncollectable loans to a friend
- moving expenses, if you have moved your studio during the year
- admissions to museums, movies, and so on that are necessary to your work.

This list, though long, is not intended to be all-inclusive: it should be tailored to suit your own needs. But

*If you are going to an accountant for the first time and have never filed a profit or loss form before, you will not only have to supply your accountant with that year's expenses for nonconsumable items; you will also have to give him an inventory of studio equipment purchased prior to that year, including the approximate date of the equipment's purchase, its price, and so on.

†Donations can be very tricky. In certain situations, you will be allowed to deduct the fair market price of the work. In other cases, however, you can deduct only the material price of the work—that is, what it cost you in materials to make. In other words, if you've spent $50 in canvas, paint, and stretcher bars to create a painting that you would then normally ask $500 for, the law in certain situations might allow you to deduct only $50 if you donated that painting to a nonprofit organization. As with home-studio expenses, the I.R.S. has been known to be very particular about donations, and the laws governing donations change. So again, consult your accountant.

again, the important thing is to be thorough about your expenses. Really *think* about what money you've spent on your artwork. Everything you buy or use for your art business may be a bona fide expense. Several years ago, for example, I traveled to Greece. I went to Knossos for the first time and saw the most exquisite art. The frescoes I saw there inspired me, expanded my horizons— allowed me to continue to believe in the whole artistic process. I did some watercolors and drawings there, work that was to a large extent inspired by what I saw. I kept a travel diary, noting my daily activities—which museums and galleries I visited, and so on. I kept all receipts for air fare, hotels, food, museum admissions, and the like. When I returned home, I talked with my accountant who suggested I deduct 50 percent of the trip's cost as business expenses. Just as corporations deduct business trips or "on-site work" costs, so, too, can you.

Don't get me wrong. I don't believe in lying or exaggerating to the I.R.S. The most important thing I can tell you is to be honorable with your taxes—don't do anything you don't truly believe in. Don't deduct a single expense that you don't feel is proper, correct, and honest. If you use your car one-fourth of the time for business purposes, deduct one-fourth of your car expenses and *not* one-half. (If you really believe in your deductions, you'll have that much easier a time defending them should the I.R.S. ever ask for clarifications.)

How should you keep track of all these art-related expenses? Some artists maintain an "expense ledger" similar to their "income ledger"—that is, each time they spend money on their art, they enter their expense into a notebook, citing:

- the date of the expense
- the nature of the expense
- the amount

- whether it was paid by cash or check, and if by check, the check number.*

And just as some artists divide their income ledgers into various categories, so, too, they divide their expense ledgers. There could, for example, be separate divisions for Rent, Insurance, Publicity, Supplies, Capital Expenditures, and so on.

Many artists, however, think that such expense ledgers are far too time-consuming, that they simply don't have the time or the inclination to make an entry every time they buy a new typewriter ribbon or a new box of staples. It *is* true that the number of expenses tends to exceed the number of sales—that whereas sales come in fairly substantial amounts of, let's say, $100 or more, expenses frequently can be for very small items.

To simplify matters, what I and other artists I know do is this: we put all expense receipts (dated and annotated, if necessary) into a manila envelope, an accordion file folder, a shoe box, or whatever. We then go through these receipts periodically—let's say every six months, or even just once a year. On these periodic ''accounting'' days, we divide all the receipts into appropriate categories, such as Rent, Telephone, Utilities, Publicity, Insurance, and so on. (Should any category produce an especially large sum, it's always a good idea to break it down into subcategories. If, for example, you found out you spent $2,000 on publicity that year, you might subdivide that sum into $750 for printing, $250 for typesetting, $500 for fees for graphic artist, and so on.) We then give the totals for the various categories to our accountants—the actual receipts we keep ourselves. (The government requires that you maintain receipts for con-

*It's generally a good idea to pay for art-related expenses by check or credit card, for purposes of documentation. But certain cash transactions are unavoidable.

sumable items for a minimum of three years. Receipts for capital expenditures must be kept as long as you own that particular item.)

In short, each year you should give your accountant statistics for:

* the total earnings from your art
* the total earnings from any other jobs, such as teaching or waiting tables
* any income derived from interest, dividends, capital gains, and so on
* totals for each of your various categories of business expenses
* and the amounts of any taxes you may have already paid during the year, such as regular deductions from your paycheck, or quarterly payments.*

Your accountant will then "plug" these statistics into the various formulas required by the I.R.S. and will thus determine your federal income tax, your state income tax, and your social security or self-employment tax, if any.

(3) You should be familiar with the "hobbyist versus professional" distinction the I.R.S. is so fond of. If the I.R.S. thinks you're only a hobbyist, it will allow you to deduct art-related expenses only to the extent that such expenses exceed 2 percent of your adjusted gross income. If, however, you're a "professional" in the eyes of the I.R.S., you can claim more deductions for business-related expenses.

How does the I.R.S. distinguish the hobbyist from the

*If you are living entirely from your art-related income, or if your art is producing a large enough income in addition to any second job you might hold, you will be required to make quarterly tax payments to the government. That is, just as an employee has a certain amount of taxes deducted from each paycheck, you will have to "deduct" quarterly payments from your self-earned "paycheck." These payments are due on the fifteenth of April, June, September, and January. Your accountant will determine the amount of each payment, based upon your previous year's taxes.

professional? One general standard is this: if your art business has shown a profit, even a modest profit, in three of the previous five years, then you are considered to be a professional.* If your art business has *not* shown a profit in at least three of the previous five years, there are other ways the I.R.S. "tests" your professionalism. These tests include:

- Does the artist keep accurate records of income and expenses of artworks produced?
- How knowledgeable is the artist in his field? Has he or she received the recognition of being shown in galleries? Does the artist have an agent or dealer, or has he or she won any prizes for the art? Does he or she belong to professional organizations? Were there any critical articles ever written about the artist

*There are ways you can "help" your art business to show a profit. If, for example, in late November or early December of a particular year, you notice that your business is very close to showing a profit, you could (1) defer any payment on art-related expenses until January or after, and (2) make sure that any income due you is paid on or before December 31. These two steps will obviously decrease your expenses for the calendar year, while increasing your income, thus strengthening the likelihood that your art business will show a profit.

On the other hand, if in December you realize that your art has been producing enough income to raise your taxes, you could reverse the above two steps, that is, you could pay as many art-related expenses as possible before January 1, and delay any art-related income until after the first. (If, for example, a collector purchased a $5,000 painting on December 15, you could arrange to have part or all of that sum paid to you after the New Year.)

Similarly, you might want to check into Independent Retirement Accounts (IRAs) and Keoghs if you find yourself with an especially large taxable income, or if you wish to take care of your retirement finances. IRAs and Keoghs are investment plans offered by banks, credit unions, and other financial institutions that allow you to invest a certain amount of your income into tax-deductible savings accounts. The amounts permitted by law have varied in recent years, especially under the Tax Reform Act of 1986, and both plans are really beyond the scope of this book, so you should check with your bank or credit union for all the many, many details you need to know before opening an IRA or Keogh account.

in newspapers or magazines? Does the artist have expensive professional equipment he or she uses in producing the art? If the artist is a teacher, is it necessary for the artist to be a practicing artist in order to obtain such a teaching position?

- How much time does the artist spend in pursuing his or her career? How many hours a week are devoted to the production of art? Does the artist spend time going to galleries, museums, taking special courses or spending significant time in pursuing a career in this manner?
- Have the sales prices of the artist's work gone up in recent years? What success has the artist had in selling art? Even though several years go by without success in selling art, were there any years when there was significant sales activity? Has there been an increase in sales over a period of time? Were there occasional profits during any of these years? Is there a fair relationship between the sales of art and the cost of producing the art?
- Is the attempt at making sales and creation of artworks a fun thing for the artist or does the artist maintain a rigorous, hard-working schedule in order to achieve success in the art world?*

There have been cases in the tax courts in which an artist who did not show a profit from his or her artwork was nevertheless considered a "professional" artist and thus permitted to deduct art-related expenses. C. West Churchman, for example, had been a painter for more than twenty years. She wasn't dependent upon the sale of her artwork for her livelihood and did not make a profit from it. She had no gross income in 1970 or 1971. In

*These questions were formulated by Rubin Gorewitz in "Bookkeeping for Taxes" in *Are You Ready to Market Your Work?*, p. 55.

1972 she reported $250 of gross income and deducted $1,422 in art-related expenses, resulting in a net business loss of $1,172. The I.R.S. disallowed the $1,172 loss on the grounds that Churchman was not engaged in art for a profit. But the tax court disagreed, noting that while Churchman's work involved "recreational and personal elements," she did not stop at the creative stage, but went into the marketing phase of the art business, where the recreational element is "minimal." Her intent was, indeed, to make a profit even if no profit actually resulted, and even if there was no reasonable expectation of a profit. The court believed that Churchman might someday sell enough of her work to enable her "to recoup the losses which have been meanwhile sustained in the intervening years" (case citation C. West Churchman, 68 TC #59).

It's important to know the distinction the I.R.S. makes between a "hobbyist" and the "professional," but it's equally important to remember that it's the government's distinction—not your's or mine. You know whether you're a serious artist or not, and you really don't need the I.R.S. to say you're "professional" this year but not that year, just because one year your business showed a profit and the next year it didn't.

(4) Remember, if you live in a state that collects sales tax, you are responsible for collecting such tax on any works sold directly from your studio to a collector in your own state. The *sales* tax is, of course, completely independent of any state or federal *income* tax—it has nothing to do with the taxes discussed above. To find out about your responsibilities to collect sales tax, contact the equalization board in your state.

Although laws vary from state to state, generally speaking, your state will give you a seller's permit and a resale number with instructions on how to charge your collectors the appropriate sales tax and how to submit

those taxes to the state. Many states ask small busi-
nesses to file a report and send their collected sales tax
every three months, but you can frequently arrange to
make the payments only once a year if your income from
studio sales is not very large.

The resale permit does provide you with certain ad-
vantages. When you buy, let's say, the canvas that you
will later "resell" as a painting, you don't have to pay
sales tax on the canvas if you give the store your resale
certificate card: the state realizes that the sales tax on
the canvas (or on any other consumable items purchased
to make your artwork) will be collected later, when you
sell the finished work to a collector. Thus, a resale num-
ber allows you to save money—you don't have to pay
sales tax on consumable goods used in making your work.
(Another advantage in having a resale number is that
certain businesses will now consider you a wholesaler,
and will thus give you a discount on goods.)

Remember, when you sell work to a gallery or shop
that will then resell it to a collector, you do *not* have to
collect the sales tax from that gallery or shop: no, the
gallery or shop will collect the sales tax from the collec-
tor when the work is later sold. But you should obtain
the gallery's resale number for your records, so that
should any questions later arise, you can show that the
gallery, and not you, was responsible for collecting the
sales tax.

INSURANCE

Some artists argue that insurance is a luxury beyond their
means—that they can barely afford to create their work let alone
insure it. Other artists say their work is so important to them
that they can't afford *not* to insure it. It's up to you to decide
whether and to what extent you should insure your work, your
studio, your tools and equipment, and so on. Ask yourself how

you would feel if a major fire destroyed most of the work in your studio: would financial compensation soften the emotional blow?

If you're interested in insuring your work and your work space, you should talk with a good insurance broker—one who's familiar with an artist's needs. Ask other artists you know for their broker's name; look in the Yellow Pages; consult artists' organizations like Artists Equity that offer certain group insurance plans (see Appendix 1). Always shop around—prices *do* vary. And make sure you know exactly what coverage your policy provides. Is your work covered, for example, against fire? theft? vandalism? water damage? all risks? Is your work insured only when it's in your studio, or is it also insured while in transit to a gallery or collector?* Are your tools and equipment insured for their replacement cost, or only for their depreciated value?

Discuss with your broker how your artwork will be appraised: just because you say a painting is worth $10,000 doesn't mean your insurance company will believe it. Does the company need some documentation of a regular and consistent sales record, and if so, what kind of documentation—past invoices, price lists on gallery stationery, commission contracts? And what kind of proof will the insurance company require that the work indeed is in your possession? If, for example, fire destroyed your studio and you told your broker that fifty paintings were destroyed, would you have to prove that fifty works were indeed lost and not just twenty-five? Do you have to keep some kind of inventory of your work? Should you keep a set of photos and slides of your work in a safe place outside your studio? (It's always a good idea to do so, even if not required.)

Discuss these matters thoroughly with your broker, and make sure your coverage fits your individual needs. If, for example,

*If you are mailing work to a gallery or collector, always make sure the work is insured. Ask the Post Office, UPS, or whatever mail service you use about insurance coverage. And remember to ask them if they have special packing requirements in order to be eligible for an insurance claim.

collectors and tradespeople come to your studio quite regularly, you might need liability insurance should a collector slip and injure himself in your studio. Or should you have employees in your service, you need to look into workman's compensation insurance. In other words, really *think* about your needs.*

Life and health insurance are beyond the scope of this book, but if your second job doesn't provide health or dental coverage, you should check into these: no one needs to be told about the exorbitant costs of health care and the near impossibility of paying hospital costs for a major illness these days. Several artists' organizations offer group plans. (Again, see Appendix 1.)

WILLS

Most artists realize that they have considerable "wealth" in their work, but not all artists know that one of the best ways to take care of that "wealth" is by having a properly drafted will. A will allows you to determine to whom your estate will go, when it will go, and how it will go—how, after your death, you want your artwork to be sold, exhibited, reproduced, restored. If you do not have a will, these matters will be determined by state laws, and the law will seldom distribute your estate as you would have wished. The law, for example, will usually consider your blood relatives to be your heirs, whereas you might have wanted certain friends or colleagues to inherit your estate. Similarly, if you don't have a will, the court will appoint an administrator to handle your estate. In some cases, the administrator will be someone with no knowledge of the art world whatso-

*An "insured" studio is also a studio with a fire extinguisher and a smoke alarm—two reasonably priced items which you can purchase and install yourself. They could literally mean the difference between life and death.

Although health hazards are really outside the concerns of this book, it's important to remember that no studio is "safe" or "insured" unless an artist knows the occupational hazards of his or her work. Artists, of course, work with a great number of dangerous materials under hazardous conditions. Many artists, however, remain unaware of this. Don't be uninformed: learn the safest ways to work in your studio. (See Appendix 1.)

ever, and that lack of knowledge could be disastrous for your heirs, not to mention your work. If, on the other hand, you draft a will, you are the one who appoints the administrator or "executor," who will gather your property after you die, pay your debts and any necessary taxes, and then distribute the remaining property to the persons named in your will. The executor is often your spouse or the person who inherits the bulk of your estate, but you might decide to name two executors—one with a knowledge of the art world, another with financial acumen. In any case, you should always name an executor who knows and respects your work.

The need for a will, especially for an artist with a considerable body of work, should thus be obvious. A will can actually save your heirs money and unnecessary hardship: in some cases, your estate could owe more taxes if you hadn't made a will than if you had. Wills come in all shapes and sizes, so to speak: some are straightforward one-page documents; others are long and complicated. But all wills, short or long, need to be properly drafted—an improperly worded will can be declared invalid by the courts.

Because of their complexity, many people urge you to go to a lawyer to draft a will. If you do opt to consult a lawyer, make sure he or she is familiar with the art world and its financial structure—one who knows that you can will your copyrights separate from the work itself, to mention one small example of the many, many things you might have to consider in making out your will.

In certain states, you can draft your own will—it's called a "holographic" will. It must be *entirely* in your own handwriting, including your signature and the date. Nothing in such a will can be typed or crossed out. No witnesses, however, are required. But, as mentioned, if such a will contains improperly worded passages, the will may not be binding. If, for example, you are leaving your estate to friends or colleagues and *not* to your relatives, you must specifically mention that. Otherwise your relatives can have the will contested.

You may want to review your will every few years to make sure it still conforms to your wishes. Wills can be revised, updated, and drafted anew should new circumstances in your life warrant it. (You should have a new will made if, for example, you move from one state to another.) Remember to keep at least one copy of your will in a safe place—perhaps in a safe-deposit box, or a fireproof box, or with your lawyer. Also be certain that someone else will be able to find the will when you die.

This is hardly intended as an exhaustive overview of wills. Like taxes and insurance, wills warrant careful consideration and, in most cases, outside professional advice. If you have a particularly large estate or body of works, you should definitely consult a lawyer for estate planning—ways to set up trust funds, ways to decrease inheritance taxes, ways to make sure your work is handled as you want it to be.

RECORD KEEPING

Various records and documents have been discussed in this book—résumés, resale contracts, invoices, artist-photographer agreements, consignment sheets, price lists, and so on. Marketing your work may, in fact, require so many documents that sooner or later you'll have to find a way to organize all your various records to make them accessible. You can't, for example, keep a collector waiting in your studio while you spend an hour frantically searching for a resale contract for him to sign.

There is, of course, no ''one'' way to organize an office, but whatever method you choose should be easy to set up, easy to maintain, and should make sense to you. (After all, unless you have a very large art business with several employees, you'll probably be the only person who uses your office, so it should be organized according to your own ''logic.'') You might want to ask other artists you know about their offices, or visit large stationery stores, where you can find any number of handy organizing supplies. A little bit of common sense goes a long way in organizing an office: just make sure your system allows you

to put your hands on a particular document as easily and as quickly as possible.

One of the simplest ways to organize your various records is, of course, to put them in file folders that are then filed alphabetically in a file cabinet or in one of those inexpensive cardboard file boxes. Anything that is important to your work, anything that interests you could have its own folder. If, for example, you were especially concerned about health hazards, you could maintain a file on the subject: every time you come across an important article on a hazard that concerns you, put the article in its folder for easy future reference. You could have files for résumés, resale contracts, each year's taxes, supply contracts, and gallery correspondence. (It's also a good idea to keep a second copy of certain important documents outside your office or studio. You may, for example, want to have copies of your résumé, your artist's statement, and so on in a safe-deposit box or at a friend's.)

Most of the records relevant to marketing your work have already been discussed—the mailing list, the earned income register, the expense ledger, photos and slides of your work. But one important document has not been mentioned: an inventory of your work. Many artists are far too prolific to keep a record of every single sketch or watercolor they've ever created, and I'm certainly not suggesting you maintain an inventory of your entire output (unless, of course, such a monumental venture appeals to you). But it is a good idea to keep some record of your major works. You could maintain an inventory on index cards or in a three-ring notebook, or whatever way makes the most sense to you. Each work should have its own card or page, and each card or page should include whatever information you think most important, such as:

- the title of the work
- dimensions, medium, year completed
- copyright number, if officially registered
- approximate cost of materials

- exhibition history
- consignment history
- rental history
- competition history, including any prizes or awards
- selling history, including purchaser, date, terms of sale or trade, retail price, commission fee
- publicity history, that is, if the work has ever been reproduced in an article, review, announcements, poster
- documentation history, that is, whether you have a photo or slide of the photo, and if so, where
- insurance history, if you have itemized insurance policies
- and perhaps an "identifying" number such as "83–35–WC," which could mean that it was your thirty-fifth work created in 1983, a watercolor.

Your inventory cards or pages could be filed by title, date, or medium. You could easily put certain color tabs on those cards for works currently out on consignment, and other color tabs on cards for works already sold, and so on.*

Such an inventory system takes some time to set up, and some time to maintain, and by no means is such a system essential. But it could facilitate keeping track of your various works, and it could come in handy in certain cases such as insurance claims or I.R.S. audits. Like most record keeping, an inventory of your work would, of course, be easier to maintain if you had access to a computer, so if such electronic hardware and software appeals to you, you should check into it.

*William Soghor Company offers preprinted ArtIndexcards that have appropriate spaces for much of the information listed above. In addition, each card holds a 35mm slide to link an image with its appropriate information. For more details about these cards, contact the company at 172 East 90th Street, New York, NY 10028.

17

THE PRIVATE DOMAIN:
AN ARTIST'S PROBLEMS

I used to think that an artist only had three problems—not enough money to work, not enough time to work, not enough space to work—and that an artist could, at best, solve two but seldom all three of those problems. If, for example, the artist had enough time to work, it was usually because he was free of a second job, in which case he probably wouldn't have enough money or enough space to work. But, if he had enough money and enough space to work, it was usually because he had, in fact, found a decent-paying second job, in which case he probably wouldn't have enough time to work.

Needless to say, this dilemma is not very funny—it plagues just about every artist I know. But reconciling time, space, and money needs is hardly an artist's only dilemma. The list of problems an artist faces could go on and on and could easily include:

- self-discipline
- self-doubt
- self-respect
- too much isolation/privacy

- not enough isolation/privacy
- finding a public
- relating to that public
- producing too little work
- producing too much work
- societal pressures
- peer pressures
- self-pressures
- having a style that's too "derivative"
- having a style that's too "unusual"
- having so many outside interests that they distract you from your artwork
- being so engrossed in your artwork that you don't have time for any outside interests.

So far, this book has dealt extensively with the problems an artist faces when marketing his work, with such problems as researching the market, preparing a portfolio, arranging gallery viewings, negotiating with dealers. During the past decade, there indeed has been considerable emphasis on the business aspects of an artist's life—on the practical necessities of marketing artwork. Such emphasis is, I think, understandable and well-founded. An artist *should* have enough business savvy to conduct his own affairs. An artist *should* have enough legal know-how to protect his rights. And money *is* an inescapable part of our lives.

But when discussing all these practical and business details, it's important to remember their place: marketing problems are *not* the most important problems an artist faces. Artists are plagued with serious questions that have little, if anything, to do with marketing their work. Is my work good? How do I fit in historically? Is it important to have a unique style? What *is* a unique style and how do I "get" one? Art can be learned, but can it be taught? Have I "purged" my work of my teachers' various "prejudices"? What good is it to be an artist if I feel I'm "mediocre"—not a Picasso or a Da Vinci? Why do so many people think artists don't really work, but just have "fun"? What *is*

inspiration? What happens when I don't have any ideas or can't carry out ideas? Are there irreconcilable demands between career and romance? How can I deal with spending so much time alone, with not having enough time for other people and other interests? Is collaboration an alternative to isolation? What kinds of collaborations or "community" are possible for me? What *is* productivity? Is an artist who produces three paintings a year as productive as one who turns out hundreds of drawings? Can an artist do an hour's worth of work in an hour's worth of time? What is a slump? Could a slump really be a gestation period? Is an artist really an artist twenty-four hours a day, seven days a week, fifty-two weeks a year?

Of course, few of these questions have easy answers: they defy definitive advice and they are categorically different from a question like "How do I copyright my artwork?" There are definite, concrete things you can tell an artist who's curious about copyrighting his work, and the advice you give one artist would be quite similar to the advice you would give another. Business tips, in fact, tend to have wide applicability: the slide label of an artist who's been working for twenty years, to use a simple example, shouldn't look all that different from the slide label of an artist who's just started photographing his work.

But the serious problems that most artists face, such as isolation or doubts about talent, are, unfortunately, much more abstract, diffuse, complicated—more difficult to talk about and much more difficult to "solve." What works for one artist may not do for another, and what's good for you at one point in your career could be disastrous at another point. One moment, for example, you may decide that the best thing you could do is "lock" yourself in your studio and work for three solid months. At another moment, however you might realize that the best thing to do for your artwork is to live in a Greek village for three months, leaving your studio far behind—and you could indeed be right to think so. Or at a certain time in your work, you might want as much interaction with the art world as possible: you might want to go to museum shows, regularly check out the galleries, visit

friends' studios and bounce around ideas. At another time, you might need to be visually connected only to your own work—you may not want your work to be "diluted" by any other work whatsoever.

In short, there are no rules for how best to "protect" your work, and the very lack of rules can, of course, sometimes be a problem. (It can also be exciting, part of the reason why you're an artist.) Being an artist means making one decision after another, and being responsible for those decisions. You have to take risks: there are no all-purpose maps to guide you through the difficult problems all artists explore.

Many classes, seminars, and books that deal with artists' survival limit themselves to the discussion of marketing and business tips. The larger and more important issues are too "difficult," too risky. (When tackling these larger issues, you do indeed risk sounding pompous or stupid or simplistic or condescending.) But I don't think any "survival manual" for artists would be complete without at least some acknowledgment of these larger, more serious "nonmarketing" problems. And that's why I'd like to end this book with a few thoughts about two of these many, very complicated issues.

PRESSURES FROM OTHER ARTISTS

Alex Gross, a founding editor of *Art Workers News,* has often said that the real enemy of artists is not the "establishment," but *other* artists. "It would seem," Mr. Gross once argued, "that there is no sum of money so small, no crumb of reputation so paltry, no opportunity to show one's work so uninviting that it will fail as the reason for one artist to stab another in the back."*

That statement is, as they say, quite a mouthful. Although one could, perhaps, take exception to the intensity of Gross's bitterness, I don't think you could argue with his basic sentiments: we artists *do* put enormous pressures upon each other,

*"Artist Bites Artist," *Artworkers News* (April 1974), 4(3):5.

and ours *is* as much a dog-eat-dog world as any Wall Street corporation.

Which one of us hasn't been the victim of another artist's jealousy? Which of us hasn't experienced the cruelty of those awful "art snobbery," "keeping-up-with-the-Joneses" games? Haven't we all, at one time or another, been unfairly asked by another artist: *What art school did you go to? Who were your teachers? Do you have a New York gallery? Do you sell a lot of work? Are you in any museum collections?*

Despite our reputation for being "spiritual" and "sensitive to the core," we can push our silly elitisms to the hilt. Male artists put down female artists as *"minor figures, not really in the mainstream."* . . . Abstract painters disparage figurative painters for being *"corrupted by illusionism,"* imprisoned in the *"fallacies of realism."* . . . And East Coast artists dismiss West Coast artists as *"provincial, not really with it at all."* I've even seen one painter turn his nose up at another painter because the latter didn't have north light or use linen!

Although this snobbery among artists exists about everything (the size of your studio, the prices of your work, what materials you use), certain issues are especially conducive to our prejudices and jealousies. Namely:

(1) Media and Materials

Many years ago, at the very start of my career as an artist, I was a sculptor, and like most of the sculptors I knew at the time, I was absolutely convinced that sculpture was the purest, most serious and elemental of art forms. Like Henry Moore, I believed that sculpture was "the most difficult of all arts, certainly more difficult than the arts which involve appreciation of flat forms, shape in only two dimensions."* In comparison to sculpture, painting seemed somehow frivolous—like "perfume," I used to say.

*"Notes on Sculpture," by Henry Moore, reprinted in *The Creative Process,* ed. Brewster Ghiselin (New York: New American Library, 1952), p. 73.

One day, a painter friend of mine (who, not surprisingly, did not buy my "purity-of-sculpture" argument for a minute), said, "Here's a canvas, some paint, and some brushes. If painting is so easy and minor an art, why don't you try it and then let's see what *you* can paint."

As it turned out, making a painting fascinated me, and I, in fact, became a painter. Then something odd happened: once I was painting, I started hearing all my painter friends go on and on about how "painting is *really* where it's at."

Although we should all know better, many artists still place their art form at the top of some ridiculous hierarchy: fine artists think they're better than commercial artists, and painters think they're better than fiber artists, and fiber artists think they're better than jewelry makers, and just about everyone thinks they're better than photographers who, it's often argued, are not really "artists" at all. *(Oh, you take pictures? Big deal! Everyone I know has a camera!)*

Recently, I even heard one artist tell another, "You know, you could take that sketch you've just finished, transfer it to a canvas, add some color, and have a gorgeous piece. I mean, it's already gorgeous, but if it was a painting, it'd be a *real* piece, not just an exercise." That artist, in all his full-blown arrogance, was obviously implying that a painting is a piece of art in a way a drawing is not!

And unfortunately, there's just as much snobbery about the materials we use as about the medium we work in. For example, when one noted artist first started using baker's clay (flour, salt, and water), she was told "serious" sculptors did not use such impermanent, childish, and artsy-craftsy materials, although her experiments with bread dough ultimately resulted in wonderful, highly acclaimed works. And we've all heard one artist proudly announce that he paints "only on linen" and uses "only handmade paper . . . everything else is inferior, you know."

(To hear such comments about pieces of work, you would think the bottom line is what it's *on* and not what's on it. But I've

seen an absolutely gorgeous Max Beckmann drawing on a page from an everyday "ringed" notebook.)
I've even heard the opposite argument used: that a certain material was not "too inferior" but "too good" to use! When a sculptor friend of mine, for example, began carving a fantastically beautiful stone, other artists criticized her: *Why use such an inherently beautiful material? Isn't it gorgeous enough on its own?*
Of course we should care about our materials, and of course we should keep one eye on the preservation/conservation of our work. But why should we get so carried away that we use our own particular tastes as ammunition to attack other artists? Why *do* we create such crazy "ranking"? Isn't it better to respect the way other artists do whatever they do and just hope they create what they want to create? Just because *we* don't care to use a particular medium or material, does it really mean it's not a proper material/medium for another artist?

(2) Styles and Subjects

For many years, if you put abstract and figurative artists in the same room, the fur would fly: the abstract artists would argue that photography had made representational art "obsolete," and the representational artists would complain that abstract art was too cold and impersonal—"not in touch with humanity."
Although the war between representational and nonrepresentational art is no longer quite so heated, the truce has yet to be signed: just a few months ago, I heard one abstract painter try to convince a figurative painter that abstract artists took "more risks," that figurative art was "too safe" because it was "overly dependent" on the real world, whereas abstract art relied "solely on the artist's own brave imagination"!
I wish I could say the figurative *v.* abstract conflict was the only battle in the art snobbery game, but I can't. Unfortunately, there are many battles, many jealousies, many prejudices about our styles and subject matters:

- Artists who use "complicated" imagery argue their work is harder to do than work that merely uses "simple" imagery, and artists who use "simple" imagery counterattack with the less-is-more doctrine
- Artists obsessed with "clean" execution dismiss any art that's "messy" or "poorly executed," and "messy" artists often think "clean" artists are just uptight prigs who produce "clean work all right—a clean piece of nothing."
- Political artists attack nonpolitical artists for being "uncommitted" and "insensitive to the world's sufferings," while nonpolitical artists argue that political artists have been "corrupted by nonaesthetic issues" and that art should "never be confused with or reduced to propaganda."
- Entire movements—women's art, black art, Latino art, prison art—are categorically dismissed for being "merely minority concerns, not really up to mainstream standards."
- Every "ism" seems to hate all the other "isms": minimalists put down conceptualists who put down photo realists who put down "conventional" realists who put down social realists and everyone seems to put down video artists who, it's said, are "fancy-schmancy TV addicts" or "would-be Hollywood directors without any talent."
- Erotic artists are frequently attacked for peddling pornography. *Why do you do it?* they are asked accusingly. *What are you adding to the world that* Playboy *or* Penthouse *hasn't already given us?*

That most of these arguments and accusations have little validity hardly needs mentioning—or so you would think. Isn't it a pity that we artists have to be reminded that every style and every subject can accommodate great art? Even the most banal of all subjects—the circus life of clowns—can inspire wonderful work from the hands of someone like Picasso.

And certainly, no one style is "safer" or "less difficult" than another: we *all* take risks—enormous risks—in our studios. Sometimes we artists make up too many strict rules, too many rigid "rankings and ratings," and I must admit I can be as guilty as the next person. I always thought that "paintings to order" were "nowhere"—much too "stiff" and "unimaginative." Then I saw an absolutely incredible Rousseau painting, *Child on the Rocks,* which Rousseau had been commissioned to paint in commemoration of a dead child. When I saw that gorgeous painting and remembered my anti-paintings-to-order sentiments, I thought to myself, *You're so prejudiced it's disgusting.*

In short, there's always going to be some piece of work or some artist to defeat your arguments, break down your rules, and remind you just how petty we artists can be.

(3) Discoveries and Originality

When an artist discovers a new tool or technique, his first response is, quite frequently, to clam up: *I want to keep this a secret. Why should I let someone else steal my ideas? Why should I let another artist beat me to the punch? I don't want to go to a gallery and hear the dealer say, "But so-and-so was doing that last year" when I really was doing it first. No, I won't let anyone know about this at all until I'm ready to have a show.*

Although I can sympathize to an extent with such feelings, I don't think we should let our fears become so extensive that we lock ourselves away in some paranoid isolation tank. Sometimes we artists get so afraid of each other that we don't want to share anything: we're so secretive, so private, so scared, that after a while the secrecy itself becomes a problem, not a solution. There's so much pressure on us to be "unique" and "original" that sometimes we're not willing to share *anything* under *any* circumstances.

But are our fears really justified? Can someone really "steal" our work? After all, no matter how many women you put on a couch, you still can't paint a Matisse. And even if you turned your studio into a vault, would you have any guarantee that your

work would be like no one else's? Aren't we all, to some degree, products of history?

In the early 1960s, for example, a New York artist named Roy Lichtenstein began to do paintings of Mickey Mouse and Donald Duck in the manner of comic strips. Just across town, a commercial illustrator named Andy Warhol was doing a series of works based on Dick Tracy and Campbell soup cans. And downtown, James Rosenquist, who earned his living painting billboards in Times Square, was using details from advertisements—spaghetti with tomato sauce, toothpaste smiles, automobile fenders—as elements in his paintings. And none of them knew what the others were doing! In fact, one day when Warhol walked into Leo Castelli's gallery and saw Lichtenstein's comic-strip paintings in the back room, he was quite surprised: "I do paintings like that," he reportedly said, in a "small aggrieved voice." *

So you see that in many ways our paranoia is ineffective. Even if we keep to ourselves in our studios, even if we never share anything with anyone, we're still not "safe." No artist works in a vacuum, so, perhaps, wouldn't it be better if we weren't so paranoid in the first place?

(4) Success in the Marketplace

Here is where the jealousy—and the back-stabbing—reach their peak (or should I say "nadir"?) When it comes to marketing their work, artists often turn treacherous, nasty, and competitive. There is nothing too petty to overlook, nothing too minor to miss. *Everything* seems to arouse some artists' jealousy:

- How much work have you sold?
- Do you live off your work?
- Do you have a gallery?

*See Calvin Tomkins's illuminating profile of Leo Castelli, "A Good Eye and a Good Ear," in *The New Yorker* (May 26, 1980).

- Which gallery?
- How many galleries are you in?
- Do you have a New York gallery or any other out-of-town galleries?
- How often do your galleries give you shows?
- Do they take out ads for you? In the "good" newspapers and magazines?
- Do you get good reviews? Are they by the "important" critics?
- Did your gallery publish a poster or catalogue for your last show?
- Was it a big opening? Who attended the opening? The critics? Other major gallery owners? Any big collectors?
- Are you in any corporate collections?
- Has the city ever purchased a piece of yours?
- Has a museum ever shown or acquired your work?
- Have any museum curators been to your studio? Any critics?
- How many commissions have you done?
- What papers and art magazines have featured your work?
- Is a book out on your work?
- Have you won any prizes? Any grants?
- Were the grants "just" from a local organization or from a "prestigious" national one like the N.E.A.?
- How expensive are your works?
- Have your prices risen dramatically over the years?

Some of these jealousies would be downright silly if they weren't so cruel as well. Once, for example, an acquaintance of mine was making a series of prints on the theme of Famous New Yorkers. A well-known bank (in fact, one of the largest banks in the world) was willing to fund her project generously. But many of her art-world friends told her she would be "wrong" to take money from the bank: that the bank had no "heart," and that bankers were only cold, ruthless businessmen whose money

was "tainted." One of her friends actually tried to discourage her from the project just because banks weren't "well-meaning" or "interested in culture." "They're not really interested in your art," one friend advised, "they're just willing to give you the $100,000 so they have a tax write-off. Why get involved in such a greedy scene?"

My friend, who had initially been overjoyed by the bank's interest in her project, later spent many sleepless nights pondering her friends' jealousy-ridden advice. (By getting many more opinions, she finally realized how good it would be for her to accept the bank's "outright" funding.)

Needless to say, it was not a "pretty" experience, and although hers might have been an extreme case, I think all artists should be prepared to withstand such pressures from other artists. Seek other advice if you have to; get another opinion. But always do what you yourself think is best.

(5) "Second" Jobs

Because artists do not always make enough money to live completely off their work, many artists have "second jobs," and these jobs frequently provide yet one more occasion for "peer pressure." A young artist will often tell an older artist whose second job is teaching, *Oh, no, I won't be teaching when I'm your age. I'll be living off my work by then.* Or a single artist will tell a married artist, *Don't you think you'd be living off your work by now if you didn't have a family to drag you down?*

Strangely enough, the "job" snobbery runs both ways: sometimes an artist will look down at you if your second job is too "menial," like a waiter or a janitor or a cab driver. They think only teaching in a university is "good enough."

But sometimes an artist will attack you if your second job is too "straight," so to speak. If, for example, you're supporting your art by being a stockbroker or a real estate agent, other artists will sometimes attack you for "selling out" and "compromising" your art.

A painter friend of mine, for example, supported his art for several years by being a janitor. Finally, sick of sweeping hallways, he decided to use his other talents (he was quite good with statistics) to become an accountant. Becoming an accountant would, however, require a year's worth of hard studies, during which time he would have to give up his painting temporarily. After that year of studies, he would be able to make enough money from accounting to work only five months a year, giving him the rest of the year to paint hassle-free.

My friend was very enthusiastic about the whole thing: accounting, he argued, would at least relieve him from enough pressures to let him paint. He had a whole lifetime ahead of him, so what difference would one year of studies make? His other friends, however, gave him enormous trouble. They accused him of being a "quitter" and of losing his "integrity." They even said that accounting would be "harmful" to his work, that accounting wasn't "spiritual" enough.

But of course there's nothing wrong with having more than one interest, more than one career. Like everyone else, we artists can be complex, intricate people with a whole range of interests. And it's unfair for anyone—especially fellow artists—to pin us down to one set of interests and one set of rules. Almost any second career could, in fact, give you a whole new way of looking at your work: anything that intrigues and changes you can be to the good of your work.

The above list, of course, is hardly complete. As mentioned, almost any issue can be used as the occasion for one artist to look down at another: "prolific" artists sometimes call artists with fewer works "lazy," while those artists with fewer works on hand argue that prolific artists are "just into quantity, not quality—those guys churn out art like a factory."

Of course, not all artists are so petty and jealous, and it would be insane to deny that an artist can be as loyal and as good a friend as anyone else. But artists *do* put enormous pressures upon

each other, and we are indeed all too often our own worst ene-
mies.

Unfortunately, there's really no way around such pressures
other than to demand respect from others and work on educating
them. When you tell someone you're an artist and they laugh,
let them know there's nothing amusing about it. Get beyond the
idea that you have to "perform" in some special way to be an
artist; don't let other people, especially other artists, challenge
you about who you say you are. You're an artist and *you* know
it and that's enough!

And remember, as artists, we're *all* under attack, so why fight
with each other?

To paraphrase one famous writer: we must learn to thrive, not
merely survive.

SLUMPS

When I first started out as an artist, I was puzzled and con-
fused by slumps. During a slump, I would think I wasn't "really
an artist," that I had never even really been an artist, that I would
never, in fact, make another piece of work—at least not one I
truly liked or one that had any meaning. Sometimes, I would
"go to sleep" for a couple of weeks or even longer, so acute
were the doubt, fears, and depression. Of course, most artists
face similar fears: we all wonder at one time or another about
our cycles of productivity—why we feel like working one day
but not the next. I don't know anyone who has fully explained
slumps yet, but I do know this: after fighting a few bouts of them,
most artists begin to realize that slumps may just be a normal
part of an artist's work life—its pace, its rhythm, its ebb and
flow.

Of course, this is easy to say when you're in the flow. When
you're in the ebb it's tough to remember there even *was* a flow.
But it is indeed important to remember that nothing ever stays
at the same pitch all the time, that just because you're not as
"productive" this month as last, it's not the end of your life as

an artist. We all have to find something to do that allows us to work through—or around—slumps. We revise our résumé, update our mailing list, rearrange our studios, frame a series of works, sign a group of works, go to the art supply store, or read a materials and supply book from cover to cover, and try a few new tools and techniques. There are a lot of things about our work lives that can be drudgery—preparing canvas, cleaning the studio, sorting works—and such tasks can often be good things to do in a slump. These chores can help "move" things around a bit—stop the doubts, start the juices flowing again. There are so many things we can do during a slump—tasks that don't directly produce a work but that help us to get ready to work again. Almost all of us could benefit by knowing more about our tools and materials. Most artists could profit, for example, from mixing new colors, taking a seminar in papermaking, studying conservation methods or health hazards.

I know during my first slumps I would often explore new materials so as not to pressure myself to go back to the old ones. When I tried new tools and techniques, I had an excuse for doing "rotten" work: I was merely exploring something new. Whereas it's hard to excuse yourself from doing work you dislike when it's your proven medium, it's rather easy to save face with yourself when you change media—you're not really worried about turning out a "precious" object every time.

When you find that you're hesitant to go into your studio, think about *why* you may be avoiding your studio. Sometimes I "flee" my studio because I have some work there I can't stand and I don't want to see it—it hurts too much. And sometimes I flee my studio for the opposite reason: because I have work there I love but I don't want to look at it because I'm afraid I'm wrong about the work—that it's not as good as I think, that's it's "nothing and nowhere," so to speak.

But I also have a way of dealing with "studio flight": I have tools and paper and materials in every room of my house. That way, should there be something in my studio I don't want to see, I can sit in another room and do a little something to keep

my hand in my work—a little something that fortunately is un-
related to whatever is so "frightening" or difficult in my studio.
Of course, I don't always have access to everything I need in
these other rooms, but it's still a way for me to keep working,
to keep moving, to loosen up, to get over the temporary slump.
Most of the "cures" I've just mentioned entail continuing with
your artwork in one way or another. This may not, to be sure,
always work. You may not want to have anything whatsoever
to do with your work when you're in a slump. You may not
want to revise a résumé or try a new medium, and the sight of
an art gallery or museum might make you sick. It's important
to remember that at some point in our careers we might need—
and deserve—an escape from those careers. We might want to
take a rest, go on vacation, or indulge our other interests—find
a new sweetheart, get "reacquainted" with an old sweetheart,
go to the movies, spend time with family and friends. We might
just want to stop worrying, to stop berating ourselves for not
producing that week, that month, that year. And it is important
to remember that you may, in fact, be quite "productive" when
you're not even "working." You can get incredibly fruitful ideas
when you're having nothing to do with your work—ideas that
may not show up for a year or two.

I don't mean to be oversimplistic about slumps. Slumps *are*
difficult. Slumps *are* painful. And there's no one cure. some-
times, it's important *not* to worry about them. Other times, wor-
rying helps. During my slumps, I've often finally reached the
point where I say to myself, *Look at all the work you've lost by
letting this happen to yourself. Whatever you could have pro-
duced last month, whatever was going to come out, whatever
you were feeling—in whatever medium, in whatever size—is lost
for all time. Enough already with these "slump blues"! You're
a painter, and even if it takes fifty paintings to produce five good
ones, then it's time to get on with those forty-five bad ones. The
only way to keep the ratio up is to keep working. The more you
do, the more will happen."*

In the long run, my priority is my sanity, my survival. But if

one way to handle a slump is to "take it easy," perhaps another way is to be tough on yourself, to realize, *Well, maybe it's time today to get in there and start kicking. Maybe I'm strong enough to do one more lousy piece of work. Maybe if I don't get in there and start kicking, I'm going to miss something that shouldn't be missed: an incredibly beautiful piece of work.*

ARTISTS'
SURVIVAL MANUAL

APPENDIX 1

A SELECTED GUIDE TO ARTISTS' PUBLICATIONS AND ORGANIZATIONS

1. GENERAL MARKETING AND BUSINESS GUIDES FOR VISUAL ARTISTS

American Artist Business Letter. Published ten times a year, edited by Diane Cochrane. (Note: Ceased publication in 1983. Back issues, however, contain a wealth of useful information, so check your library or local arts organization.)

Art and Artists. Published monthly by the Foundation for the Community of Artists, 280 Broadway, Suite 412, New York, NY 10007. 212 227-3770. (Note: Previously published as *Artworkers News.*)

Art Marketing Letter. Published ten times a year by R. Lubow Publishing, 3608 Douglas Avenue, Suite 404, Racine, WI 53402.

Art New England: A Resource for the Visual Arts. Published ten times a year. 353 Washington Street, Brighton, MA 02135. 617 782-3008. (Note: Primarily for New England artists.)

Artweek. 44 issues a year. 1305 Franklin Street, Oakland, CA 94612. (Note: Primarily for West Coast artists.)

Atlanta Art Papers. Published six times a year. PO Box 77348, Atlanta, GA 30357. 404 885-1273. (Note: Primarily for Southeast artists.)

*Denotes a particularly useful publication or organization.

Berlye, Milton K. *How To Sell Your Artwork*. Englewood Cliffs, NJ: Prentice-Hall, Inc., 1978.

Caplin, Lee Evan, ed. *The Business of Art*. Englewood Cliffs, NJ: Prentice-Hall, Inc., 1983.

Chamberlain, Betty. *The Artist's Guide To His Market*. Rev. ed. New York: Watson-Guptill Publications, 1970. 1979, 1983.

City of New York, Department of Cultural Affairs. *The New York Fine Artist's Source Book*. Reading, MA: Addison-Wesley, n.d.

Cochrane, Diane. *This Business of Art*. New York: Watson-Guptill Publications, 1978.

**The Crafts Report: The Newsmonthly of Marketing, Management, and Money for Crafts Professionals*. Eleven issues a year. 700 Orange Street, Wilmington, DE 19801.

Cummings, Paul, ed. *Fine Arts Marketplace*. New York: R. R. Bowker Company, 1977. (Note: Much of its information, though now out of date, is still useful.)

Fox, Norma A., ed. *Are You Ready To Market Your Work?* Boston: Boston Visual Artists Union, 1979.

Frischer, Patricia, and Adams, James. *The Artist in the Marketplace: Making Your Living in the Fine Arts*. New York: M. Evans and Company, Inc., 1980.

Genfan, Herb, and Taetzsch, Lyn. *How To Start Your Own Craft Business*. New York: Watson-Guptill Publications, 1974.

Goodman, Calvin J. "Clear Documentation of Art Works: Action Kit No. 4." Washington, DC: Artists Equity Association, Inc., 1975.

Goodman, Calvin J. *Marketing Art: A Handbook for Artists and Art Dealers*. Los Angeles: Gee Tee Bee, 1972.

Graphic Artists Guild. *Pricing and Ethical Guidelines*. New York: Graphic Artists Guild, 1979. (Note: Primarily for commercial artists.)

Grode, Susan A, and Steiner, David Paul. *The Visual Artist's Manual: A Practical Guide to Your Career*. Los Angeles: Gore Graphics, 1981.

Harris, Kenneth. *How To Make a Living as a Painter*. New York: Watson-Guptill Publications, 1964.

Holz, Loretta. *How To Sell Your Art and Crafts*. New York: Scribners, 1977.

Hyman, Richard. *The Professional Artist's Manual*. New York: Van Nostrand Reinhold Company, 1980.

Katchen, Carole. *Promoting and Selling Your Art*. New York: Watson-Guptill Publications, 1978.

Knoll, Alfred P., and Sandison, Hamish. *Museums—A Gunslinger's Dream.* San Francisco: Bay Area Lawyers for the Arts, 1975.

Lapin, Lynne, and Wones, Betsy. *Art and Crafts Market.* Cincinnati: Writer's Digest. Revised annually.

McGuire, E. Patrick, and Moran, Lois. *Pricing and Promotion.* New York: American Craft Council Publications, 1979. (Note: Primarily for crafts.)

Mellon, Susan, and Crawford, Tad. *The Artist-Gallery Partnership: A Practical Guide to Consignment.* New York: American Council for the Arts, 1981.

Nakamoto, Kent, and Levin, Kathi. *Marketing The Arts: A Selected & Annotated Bibliography.* Madison, WI: Association of College, University, and Community Arts Administrators, Inc., 1978. Updated 1981 by Cate Elsten. (Note: Largely devoted to the performing arts, but includes useful references for arts organizations.)

New Art Examiner. Published ten times a year. 230 East Ohio Street, Chicago, IL 61610. 312 642—6236.

Newman, Joyce, and Goodman, Calvin J. "Marketing Art through Dealers: Action Kit No. 6." Washington, DC: Artists Equity Association, Inc., 1975.

Poduska, T. F., and Ashby, Lucius. "Business Practices for Artists: Action Kit No. 5." Washington, DC: Artists Equity Association, Inc., 1975.

Polking, Kirk, ed. *Artist's Market.* Cincinnati: Writer's Digest. Published annually. (Note: Largely for commercial artists, but includes many useful addresses.)

*Press, Jaques Cattell, ed. *American Art Directory.* New York: R. R. Bowker. Revised biennially. (Note: Directory of museums, galleries, schools, organizations, magazines, state arts councils, and exhibitions in the U.S.A. Invaluable encyclopedic information.)

Scott, Michael. *The Crafts Business Encyclopedia.* New York: Harcourt Brace Jovanovich, 1977.

Sculptors International Magazine. Published bimonthly. 1050 Potomac Street NW, Washington, DC 20007.

U.S. Small Business Administration, PO Box 15434, Fort Worth, TX 76119. Toll Free: 800 433–7212. (Note: The SBA publishes many pamphlets relevant to running your own business.)

Wettlaufer, George and Nancy. *The Craftsman's Survival Manual.* Englewood Cliffs, NJ: Prentice-Hall, Inc., 1974.

The Working Arts. Published quarterly by the Bay Area Lawyers for

the Arts, Fort Mason Center, Building C, San Francisco, CA 94123.
415 775–7200.

2. GENERAL LEGAL GUIDES FOR VISUAL ARTISTS

Alexander, James, ed. *Law and the Arts*. Chicago: Lawyers for the
Creative Arts, 1975.

**Art and the Law*. Published quarterly by Volunteer Lawyers for the
Arts, 1560 Broadway, New York, NY 10036. 212-575–1150.

Associated Councils of the Arts, The Association of the Bar of the City
of New York, and Volunteer Lawyers for the Arts. *The Visual Artist
and the Law*. New York: Praeger Publishers, 1974.

Bay Area Lawyers for the Arts. *Legislative Masterpieces: A Guide to
California Arts Legislation*. San Francisco: Bay Area Lawyers for
the Arts, 1980.

Cavallo, Robert; Sarbin, Hershell; and Kahan, Stuart. *Photography:
What's the Law?* New York: Crown Publishers, 1976.

*Crawford, Tad. *Legal Guide for the Visual Artist*. New York: Haw-
thorn Books, 1977.

Davidson, Marion, and Blue, Martha. *Making It Legal: A Law Primer
for The Craftmaker, Visual Artist, and Writer*. New York: McGraw-
Hill, 1980.

DuBoff, Leonard D. *Art Law: Domestic and International*. South
Hackensack, NJ: Fred B. Rothman & Co., 1975.

————. *The Deskbook of Art Law*. New York: Federal Publications,
Inc., 1978.

Duffy, Robert E. *Art Law: Representing Artists, Dealers, and Collec-
tors*. New York: Practicing Law Institute, 1977.

Feldman, Franklin, and Weil, Stephen. *Art Law: Representing Artists,
Dealers, and Collectors,* New York: Practicing Law Institute, 1982.

*————. *Artworks: Law, Policy, Practice*. New York: Practicing Law
Institute, 1974.

————. *Legal and Business Problems of Artists, Art Galleries, and
Museums*. Practicing Law Institute, 1973.

Freedman, Robert. *Basic Law for Artists*. San Francisco: Bay Area
Lawyers for the Arts, 1975.

Gignilliat, William. *Contracts for Artists*. Atlanta: Words of Art, 1983.

Hodes, Scott. *What Every Artist and Collector Should Know About the
Law*. New York: E. P. Dutton & Co., 1974.

Leland, Caryn R. *The Art Law Primer.* New York: Foundation for the Community of Artists, 1982. (Note: A series of articles on commissions, consignment, sales agreements, agents, etc.)

Lindey, Alexander. *Entertainment, Publishing, and the Arts,* 2 vols. New York: Clark Boardman Co., Ltd., 1963. Supp. 1975.

Merryman, John H., and Elsen, Albert. *Law, Ethics, and the Visual Arts: Cases and Methods.* 2 vols. New York: Matthew Bender, 1978.

Philadelphia Volunteer Lawyers for the Arts. *Legal Guide for Emerging Artists.* Philadelphia: Philadelphia Volunteer Lawyers for the Arts, 1982. (Note: Concentrates on copyright, leases, and taxes.)

Sandison, Hamish, ed. *A Guide to the New California Artist-Dealer Relations Law.* San Francisco: Bay Area Lawyers for the Arts, 1975.

———, ed. *The Visual Artist and the Law.* San Francisco: Bay Area Lawyers for the Arts, 1975.

Stone, Norman H. *An Introduction to Contracts for Visual Artists.* San Francisco: Bay Area Lawyers for the Arts, 1979.

3. COPYRIGHT AND THE VISUAL ARTIST

American Patent Law Association. *How To Protect and Benefit from Your Ideas.* Arlington, VA: American Patent Law Association, 1981.

Chickering, Robert B., and Hartman, Susan. *How To Register a Copyright and Protect Your Creative Work.* New York: Scribners, 1980.

*Crawford, Tad. *The Visual Artist's Guide to the New Copyright Law.* New York: Hastings, 1978.

Lower, Robert C., and Young, Jeffrey E. *An Artist's Handbook on Copyright.* Atlanta: Georgia Volunteer Lawyers for the Arts, 1982.

Nimmer, Melville. *Nimmer on Copyright.* 2 vols. New York: Matthew Bender, 1963. Supp. 1975.

Strong, William S. *The Copyright Book: A Practical Guide.* Cambridge, MA: MIT Press, 1981.

Sutton, Samuel J. *Copyright Law: A Primer for the Literary and Visual Arts.* Phoenix: Arizona Commission for the Arts and Humanities, 1977.

U. S. Copyright Office. Register of Copyrights, The Library of Congress, Washington, DC 20559. (Note: For a list of materials write for ''Publications of the Copyright Office.'' For special questions

phone 202 287–8700 weekdays between 8:30 A.M. and 5:00 P.M. EST.)

4. GALLERY AND MUSEUMS GUIDE

Art in America. *The Art in America Annual Guide to Galleries, Museums, and Artists.* Art in America, 850 Third Avenue, New York, NY 10022. (Note: A compilation, arranged alphabetically by state and city, of solo exhibitions held during the past calendar year at museums, galleries, and alternative spaces in U.S.)

**Art Now/U.S.A.: The National Art Museum and Gallery Guide.* Published monthly by Art Now, Inc., 144 N. 14th Street, Kenilworth, NJ 07033. 201 272–5006. (Note: A monthly national magazine with comprehensive up-to-date information about exhibitions in over 900 galleries and museums across the country, plus major gallery area maps. Also published separately according to seven geographic areas: New York City, Boston, Philadelphia, Chicago, the Southwest, the Southeast, and California.)

Chicago Artists' Coalition. *An Artist's Guide to Approaching Chicago Galleries.* Chicago: Chicago Artists' Coalition, 1983.

Chicago Artists' Coalition. *Other Spaces . . . Gallery Alternatives.* Chicago: Chicago Artists' Coalition, 1982. (Note. A list of alternative spaces in the Chicago area.)

Dolin, Jane Stauffer. *Bay Area Gallery Guidebook.* Oakland, CA: Jane Stauffer Dolin, 1981.

Exhibit Press. *Exhibit Boston: Gallery Approach Guide to Artists.* Phoenix: Exhibit Press, 1982.

The Official Museum Directory. Skokie: National Register Publishing Company. Published annually. (Note: Listing of 6,000 museums in Canada and the U.S.)

Press, Jaques Cattell, ed. *American Art Directory.* New York: R. R. Bowker. Revised biennially.

5. ALTERNATIVES TO GALLERY EXHIBITS

A. Cooperative Galleries

Association of Artist-Run Galleries, 152 Wooster Street, New York, NY 10012.

Clark, Leta W. *How To Open Your Own Shop or Gallery.* New York: St. Martin's Press, 1978.

Honingsberg, Peter Jan; Kamaroff, Bernard; and Beatty, Jim. *We Own It: Starting and Managing Co-ops, Collectives, and Employee-Owned Ventures.* Laytonville, CA: Bell Springs Publishing, 1982.

Mutti, Barbara. *The Works: A Gallery Administration Handbook.* Oakland, CA: Demian Books, 1981.

The Los Angeles Institute of Contemporary Art. *The New ArtsSpace: A Summary of Alternative Visual Arts Organizations.* Los Angeles: The Los Angeles Institute of Contemporary Art, 1978.

U. S. Small Business Administration, PO Box 15434, Fort Worth, TX 76119. Toll Free: 800 433-7212. (Note: The SBA publishes a wide variety of materials useful to those interested in starting a co-op gallery. Check your local government bookstore.)

B. Cooperatives and Finances

American Institute of Cooperation. *Cooperatives and Taxation.* American Institute of Cooperation, 1800 Massachusetts Avenue NW, Suite 508, Washington, DC 20036.

Gross, Malvern J., and Warshauer, Jr. *Financial and Accounting Guide for Nonprofit Organizations.* New York: John Wiley & Sons, 1979.

Henke, Emerson O. *Accounting for Non-Profit Organizations.* Belmont, CA: Wadsworth Publishing Co., 1977.

The Metropolitan Cultural Alliance. *Accounting for Culture: A Primer for Non-Accountants.* Boston: Metropolitan Cultural Alliance, Inc., 1980.

Nelson, Charles A., and Turk, Frederick J. *Financial Management for the Arts: A Guidebook.* New York: American Council for the Arts, 1975.

C. Grants

Center for Arts Information. *Money for Artists.* New York: Center for Arts Information, 1983. (Note: Primarily for New York State artists, but bibliographic references useful nationally.)

Coe, Linda C.; Denney, Rebecca; and Rogers, Anne. *Cultural Directory II: Federal Funds and Services for the Arts and Humanities.* Washington, DC: Smithsonian Institution Press, 1980.

Dowley, Jennifer, ed. *Money Business: Grants and Awards for Creative Artists.* Boston: The Artists Foundation, Inc., 1978. Revised, 1982.

*The Foundation Center. Information (toll free): 800 424-9836. Branches: (1) 888 Seventh Avenue, New York, NY 10106. 212 975-1120. (2) 1001 Connecticut Avenue NW, Suite 938, Washington, DC 20036. 202 331-1400. (3) 739 National City Bank Building, 629 Euclid Avenue, Cleveland, OH 44114. 216 861-1933. (4) 312 Sutter Street, San Francisco, CA 94108. 415 397-0902. (Note: The national clearinghouse for information on philanthropy.)

The Foundation Center. *The Foundation Directory.* New York: Columbia University Press, 1983.

The Foundation Center. *Foundation Grants to Individuals.* New York: The Foundation Center, 1982.

The Foundation Center. *Grants for Arts and Cultural Programs.* New York: The Foundation Center, 1983.

Gault, Judith G. *Federal Funds and Services for the Arts.* Washington, DC: U.S. Government Printing Office, n.d.

Hillman, Howard, with Chamberlain, Marjorie. *The Art of Winning Corporate Grants.* New York: Vanguard Press, 1980.

Kurzig, Carol. *Foundation Fundamentals: A Guide for Grantseekers.* New York: The Foundation Center, 1980. Revised 1981.

Millsaps, Daniel. *Grants and Aid to Individuals in the Arts.* Washington, DC: Washington International Arts Letter, 1980.

National Endowment for the Arts, 1100 Pennsylvania Avenue NW, Washington, DC 20506. Public affairs general information: 202 682-5400. The Visual Arts Program: 202 682-5448.

Union of Independent Colleges of Art. *A Guide to Grants and Funding for the Visual Artist.* Kansas City, MO: Union of Independent Colleges of Art, 1976.

White, Virginia L. *Grants for the Arts.* New York: Plenum Publishing, 1980.

D. Emergency Grants and Funds

Artists' Fellowship, Inc., Arthur Harrow, Pres., 47 Fifth Avenue, New York NY 10003. 212 255-7740. (Note: Provides funds to artists in

financial distress because age or disability has interrupted or ended their income.)

Center for Arts Information. *A Quick Guide to Loans and Emergency Funds.* New York: Center for Arts Information, 1982.

Change, Inc., PO Box 705, Cooper Station, New York, NY 10013. West Coast branch: PO Box 480027, Los Angeles, CA 90048. (Note: Founded in 1970 by Robert Rauschenberg to provide emergency funds for artists.)

The Emergency Materials Fund, Artists Space/Committee for the Visual Arts, Inc., 195 Hudson Street, New York, NY 10013. 212 226-3970. (Note: Aids artists in completing work scheduled for shows in nonprofit galleries.)

Materials for the Arts, Dept. of Cultural Affairs, 2 Columbus Circle, New York, NY 10019. 212 974-1150. (Note: Collects and redistributes free materials and equipment to artists' organizations.)

E. Grants for Artists' Colonies

Boston Visual Artists Union. *BVAU Guide to Art Colonies.* Boston Visual Artists Union at the Art Institute of Boston, 700 Beacon Street, Boston, MA 02215, 1982. 617 227-3076.

Center for Arts Information. *Artist Colonies.* New York: Center for Arts Information, 1982.

Letter 203, Guide to Artists' Colonies. Washington International Arts Letter, PO Box 9005, Washington, DC 20003.

F. Art Fairs, Sidewalk Exhibitions, and Competitive Shows

Dorst, Claire V. *The Artist's Guide to Sidewalk Exhibiting.* New York: Watson-Guptill Publications, 1980.

Exhibitors Calendar. Exhibit Planners, Box 55, Delmar, NY 12064. (Note: Current listing of juried shows.)

Gadney, Alan. *How to Enter and Win Fine Arts and Sculpture Contests.* New York: Facts On File, Inc., 1982.

Mears, Mary Ann. "Ethical Guidelines for Juried Shows: Action Kit No. 7." Washington, DC: Artists Equity Association, Inc., 1975.

Ramsauer, Joseph F. *Directory of Competitive Art Exhibitions in the Midwest.* Caesar Press, 5701 38th Ave., Moline, IL 61265, 1983.
―――. *Directory of Good Quality Midwest Art Fairs.* Moline, IL: Caesar Press, 1983.
―――. *Directory of International and National Competitive Art Exhibitions.* Moline, IL: Caesar Press, 1983.
―――. *The Twenty Five BEST Art Fairs in The Midwest, East, & Southeast.* Moline, IL: Caesar Press, 1983.
Wasserstein, Susan. *Collector's Guide to U.S. Auctions and Flea Markets.* New York: Penguin Books, 1981.
Writer's Digest. *1982/1983 National Directory of Shops/Galleries, Shows/Fairs: Where To Exhibit and Sell Your Work.* Cincinnati: Writer's Digest, 1982.

G. Printmaking and Multiples

Adams, Clinton, and Antreasian, Garo: *The Tamarind Book of Lithography: Art and Techniques.* New York: Harry N. Abrams, Inc., 1971.
Adams, Clinton, ed. *The Tamarind Papers: Technical, Critical and Historical Studies of the Art of the Lithograph.* Published semiannually by the Tamarind Institute, 108 Cornell Avenue, SE, Albuquerque, NM 87131.
Auvil, Kenneth. *Silk Screen Technique for the Artist.* Englewood Cliffs, NJ: Prentice-Hall, 1965.
Chamberlain, Walter. *Manual of Woodcut Printmaking.* New York: Charles Scribner's Sons, 1978.
Erickson and Sproul. *Printmaking without a Press.* New York: Van Nostrand Reinhold Company, 1966.
Fossett, R. O. *Screen Printing Photographic Techniques.* Cincinnati: ST Publications, n.d.
Gilson, Thomas. *How to Silkscreen on Cylindrical and Contoured Surfaces.* Cincinnati: ST Publications, n.d.
Kosloff, Albert. *Photographic Screen Printing.* Cincinnati: ST Publications, n.d.
―――. *Textile Screen Printing.* Cincinnati: ST Publications, n.d.
Kurosaki, Akira. *Contemporary Woodblock Printmaking.* Tokyo: Bijitsu Shuppansha, 1978.
Maxwell, William C. *Printmaking: A Beginning Handbook.* Englewood Cliffs, NJ: Prentice-Hall, 1977.

Romano, Clare, and Ross, John. *The Complete Collograph*. New York: The Free Press, 1981.

———. *The Complete Printmaker*. New York: Macmillan Co., 1972.

Saff, Donald, and Sacilotto, Deli. *Printmaking: History and Process*. New York: Holt, Rinehart, and Winston, 1978.

Turner, Silvie, ed. *Handbook of Printmaking Supplies*. London: Printmakers Council, 1977.

World Print Council. *Print News*. San Francisco: Published bimonthly.

H. Art Purchase Programs

(Note: Many of the government's percent-for-art programs are limited to artists who reside in that city or state. But here's a listing of programs that will consider nonresidents as well.)

Alaska: Chris D'Arcy, Visual Arts Coordinator, Alaska State Council on the Arts, 619 Warehouse Ave., Suite 220, Anchorage, AK 99501. Preference to Alaska residents, but "certain artists from other areas may, because of their unique talents or style," be the logical choice of an art advisory committee.

Baltimore, MD: Doris Weber, Department of Public Works, Bureau of Construction Management, Division of Public Building Construction, Room 700, Municipal Building, Baltimore, MD 21202. No residency requirement. Artists recommended by architect on project.

Cambridge, MA: Arts on the Line, Cambridge Arts Council, City Hall, Cambridge, MA 02139. Priority to Cambridge artists, artists in Greater Boston area, New England, then others

Chicago, IL: Percent for Art, Chicago Council on Fine Arts at the Cultural Center, 78 E. Washington St., Chicago, IL 60602. Primary source for artists is Chicago Council on Fine Arts slide registry. However, panel members may submit any artist for consideration.

Colorado: Art in Public Places, Colorado Council on the Arts and Humanities, 770 Pennsylvania, Denver, CO 80203. Preference to state artists, but will choose out-of-state artists.

Dade County, FL: Art Coordinator, Metropolitan Dade County, Room 1108, 140 W. Flagler St., Miami, FL 33130. No residency requirement.

Florida: Marsha Orr, Department of State, Division of Cultural Affairs, Capitol, Tallahassee, FL 32301. Any artist may submit résumé and slides for slide registry.

General Services Administration: Art-in-Architecture Program, General Services Administration, Public Buildings Service, Washington, DC 20405. Any artist may send a résumé and slides for GSA slide registry.

Illinois: Art in Architecture, Capitol Development Board, 3rd Floor, William G. Stratton Bldg., 401 S. Spring St., Springfield, IL 62706. Illinois artists are given preference, but non-state residents are also considered.

Maryland: Fine Arts in Public Buildings (Pilot Program), Maryland State Arts Council, 15 W. Mulberry St., Baltimore, MD 21201. No residency requirement.

National Endowment for the Arts: Patricia Fuller, Art in Public Places, 2401 E St., N.W., Washington, DC 20506. No residency requirement.

New Jersey: Jackie Rubel, New Jersey State Council on the Arts, 109 W. State St., Trenton, NJ 08608. Preference for New Jersey artists but will choose out-of-state people.

Oregon: Visual Arts Coordinator, Oregon Arts Commission, 805 Summer St., N.E., Salem, OR 97301. All artists in Northwest areas are eligible; preference may be given to Oregon artists.

Philadelphia, PA: Fine Arts Coordinator, Redevelopment Authority, 1234 Market St., 8th Floor, Philadelphia, PA 19107. No residency requirement.

Seattle, WA: Art in Public Places, Seattle Arts Commission, 305 Harrison, Seattle, WA 98109. "At least one-half of the money expended over a five-year period . . . should be to artists associated with the Pacific Northwest"; otherwise, no residency requirement.

Veterans Administration: Art in Architecture Program (083D), Veterans Administration, 810 Vermont Ave., N.W., Washington, DC 20005. Artists of local, regional, and national reputation are eligible to enter. Send résumé and slides.

Washington: Art in State Buildings, Washington State Arts Commission, 9th and Columbia Bldg., Olympia, WA 98504.1. State artists, 2. Pacific Northwest, 3. Western states, and 4. All other states and territories.

6. AN ARTIST'S EMPLOYMENT AND FINANCES

A. Employment Guides

American Artist. *1983 American Artist Directory Of Art Schools & Workshops.* Annually. Billboard Publications, Inc. (Note: usually published in March issue of *American Artist.*)

Artists Career Planning Service, 434 Avenue of the Americas, New York, NY 10011. 212 460–8163.

Center for Arts Information. *Careers in the Arts: A Resource Guide.* New York: Center for Arts Information, and Opportunity Resources for the Arts, 1981.

Center for Arts Information. *Jobs in the Arts and Arts Administration.* New York: Center for Arts Information, 1981.

Holden, Donald. *Art Career Guide.* New York: Watson-Guptill Publications, 1973.

Listing of Positions. College Art Association, 16 East 52nd Street, New York, NY 10022. 212 755–3532.

The National Arts Jobbank. Published biweekly. 141 E. Palace Avenue, Santa Fe, NM 87501. 505 988–1166.

Opportunity Resources for the Arts, 1501 Broadway, New York, NY 10036. 212 575–1688. (Note: A national placement agency.)

Union of Independent Colleges of Art. *Career Resources List for Visual Artists*. Kansas City, MO. Union of Independent Colleges of Art, 1976.

B. Taxes

Abouaf, Jeffrey. *Tax and the Individual Artist*. San Francisco: Bay Area Lawyers for the Arts, 1976.

Helleloid, Richard. *The Tax Reliever: A Guide for Artists, Designers, and Photographers*. St. Paul, Minnesota: Drum Books, 1979.

Holcomb, Bill, and Striggles, Ted. *Fear of Filing: A Beginner's Handbook*. New York: Volunteer Lawyers for the Arts, 1976. Revised regularly.

Isicson, Anita. "Taxation For The Artist: Action Kit No. 8." Revised by L. Sevilla. Washington, DC: Artists Equity Association, Inc., 1977.

Lidstone, Herrick K., ed. *A Tax Guide for Artists and Arts Organizations*. Lexington, MA: D. C. Heath and Company, 1979.

Lidstone, Herrick K., and Olsen, Leonard R. *The Individual Artist: Recordkeeping, Methods of Accounting, Income and Itemized Deductions for Federal Income Tax Purposes*. New York: Volunteer Lawyers for the Arts, 1976.

*Marios, Kim, ed. *The Art of Deduction: Income Taxation for Performing, Visual, and Literary Artists*. San Francisco: Bay Area Lawyers for the Arts, 1979. Revised 1982.

Redfield, Emanuel. *Artists' Estates and Taxes*. Washington, DC: Artists Equity Association, 1971.

C. Insurance

(Note: The following organizations offer insurance for visual artists. In most cases, it is not necessary to be a resident of the area in which the organization is located, but you must be a member of that organization. Membership fees are usually minimal.)

Artists Equity Association, 1725 "K" Street NW, Suite 1003, Washington, DC 20006. 202 628–9633. (Note: Offers all-risk, fine arts coverage, major medical, and life.)

American Craft Council, 104 Park Avenue South, New York, NY 10016. 212 696–0710. Through: Association and Society Insurance

Corp., 13975 Connecticut Avenue, Silver Spring, MD 20906. 301 460–0300. (Note: Offers major medical, hospital indemnity, life insurance, and studio policy.)

California Confederation of the Arts, 849 South Broadway, Suite 611, Los Angeles, CA 90014. 213 627–9273. (Note: Offers life, health, dental, and maternity.)

Chicago Artists' Coalition, with Washington National Health Insurance Program, Russell W. Holmquist Agency, 5154 N. Clark, Chicago IL 60640. 312 334–1215. (Note: Offers group health insurance plan.)

Foundation for the Community of Artists, 280 Broadway, New York, NY 10007. (Note: Offers health and hospitalization.)

Graphic Artists Guild, 30 E. 20th Street, New York, NY 10003. 212 777–7353. (Note: Offers life, health, and disability.)

International Sculpture Center, 1050 Potomac Street NW, Washington, DC 20007. 202 965–6066. (Note: Offers fine art insurance for sculptors.)

Marin Arts Council, 1400 Lincoln Avenue, San Rafael, CA 94901. 415 454–7441. (Note: Offers major medical, dental, and life insurance.)

Society of Illustrators, 128 E. 63rd Street, New York, NY 10021. 212 838–2560. (Note: Offers life, health, and disability.)

Support Services Operations, Inc., 1457 Broadway, Suite 712, New York, NY 10036. 212 398–7800. (Note: Offers life, Blue Cross–Blue Shield, disability, dental, and vision.)

Visual Artists and Galleries Association, Inc., One World Trade Center, Suite 1535, New York, NY 10048. 212 466–1390. (Note: Offers major medical.)

D. Wills and Estates

Bressler, Martin. "Counsel on the Arts," a series of articles on wills for artists, *American Artist,* February–April, 1983.

Cooper, Tina. "Estate Planning for Artists: Approaching the Future Creatively," *The Working Arts,* vol. 2, no. 4 (Spring 1981), Bay Area Lawyers for the Arts.

*Crawford, Tad, ed. *Protecting Your Heirs and Creative Works: An Estate Planning Guide for Artists, Authors, Composers, and Other Creators of Artistic Works.* New York: Graphic Artists Guild, 1980.

7. AN ARTIST'S WORK SPACE AND WORK HABITS

A. *Artists' Housing*

Artists Equity Association. *Artists Live/Work Space: Changing Public Policy.* Artists Equity Association, 1981. Northern California Chapter, 81 Leavenworth Street, San Francisco, CA 94102.

Artists Foundation. *Artists' Space: A Study of the Development of Artists' Living and Working Space in Boston.* Boston: Artists Foundation, 1981.

Artists Foundation: The Artists Living and Working Space Program, 100 Boylston Street, Boston, MA 02116. (Note: Provides artists and artist-groups with the architectural, legal, financial, and related technical assistance necessary to acquire and rehabilitate living and working space.)

Artists' Housing Hotline, NYC, 212 285 2133. (Note: An information and referral service.)

Volunteer Lawyers for the Arts. *Housing for Artists: The New York Experience.* New York: Volunteer Lawyers for the Arts, 1976.

Wilkie Farr & Gallagher. *Special Space: A Guide to Artists' Housing and Loft Living.* New York: Volunteer Lawyers for the Arts, Inc., 1981.

B. *Health Hazards*

Art and Artists. Includes regular columns on health hazards. (Note: See "General Marketing and Business Guides" for more information.)

**Art Hazards Newsletter.* Published ten times a year by the Center for Occupational Hazards, 5 Beekman Street, New York, NY 10038.

Barazani, Gail Coningsby. *Ceramics Health Hazards: Occupational Safety and Health for Artists and Craftspeople.* New York: Center for Occupational Hazards, 1979.

Carnow, Bertram W. "Health Hazards in the Arts," *American Lung Association Bulletin,* January–February, 1976.

**Center for Occupational Hazards, 5 Beekman Street, New York, NY 10038. 212 227–6220. (Note: COH is a national clearinghouse for research and information on health hazards in the arts. It offers physician referrals, lecture programs, intensive courses, and distributes

over 50 books, pamphlets, and data sheets on art hazards. For pub-
lication list, send a SASE to above address.)

Hazards in the Arts, 5340 N. Magnolia, Chicago, IL 60640. 312 728–
5795. (Note: Disburses information on health hazards.)

*McCann, Michael. *Artists Beware.* New York: Watson-Guptill Pub-
lications, 1979.

McCann, Michael, and Barazani, Gail, eds. *Health Hazards in the Arts
and Crafts.* Washington, DC: Society for Occupation and Environ-
mental Health, 1980.

McCann, Michael. *Health Hazards Manual for Artists.* New York:
Foundation for the Community of Artists, 1979.

Moses, Cherie; Purdham, James; Bowhay, Dwight; and Hosein, Ro-
land. *Health and Safety in Printmaking.* Alberta: Alberta Labor Oc-
cupational Hygiene, 1978.

National Institute for Occupational Safety and Health, c/o Information
Officer, Centers for Disease Control, Don Barreth, Building 1, Room
2067, 1600 Clifton Road NE, Atlanta, GA 30333. 404 329–3286.

Occupational Safety and Health Administration, Department of Labor.
Office of Information and Consumer Affairs, Room N3637, Francis
Perkins Building, 3rd Street & Constitution Avenue NW, Washing-
ton, DC 20210. 202 523–8151. (Note: OSHA sets and enforces oc-
cupational, safety, and health standards. It maintains approximately
80 branches/offices around the country. For your local branch write
to the above address.)

Siedlicki, Jerome T. "The Silent Enemy: Potential Health Hazards in
the Arts and Their Control: Action Kit No. 3." Washington, DC:
Artists Equity Association.

Waller, Julian, and Whitehead, Lawrence, eds. *Health Hazards in the
Arts: Proceedings of the 1977 Vermont Workshops.* Burlington,
Vermont: University of Vermont Department of Epidemiology and
Environmental Health, 1977.

C. Conservation and Preservation of Artworks

American Institute for Conservation of Historic and Artistic Works,
Journal of the American Institute for Conservation. 1522 K Street
NW, Suite 804, Washington, DC 20005.

Banks, Paul. *Matting and Framing Documents and Art Objects on Pa-
per.* Chicago: Newberry Library, 1976.

Brill, T. B. *Light, Its Interaction with Art and Antiquities.* New York: Plenum Publishers, 1980.

Clapp, Anne F. *Curatorial Care of Works of Art on Paper.* Oberlin, Ohio: Intermuseum Conservation Association, 1974.

Dolloff, Francis W., and Perkinson, Roy L. *How To Care for Works of Art on Paper.* Boston: Museum of Fine Arts, 1971.

Duren, Lista. *Frame It.* New York: Houghton Mifflin Company, 1976.

Eastman Kodak Company. *Preservation of Photographs.* Rochester, New York: Eastman Kodak Company, 1980. (Kodak Publication No. F–30.)

Fall, Frieda Kay. *Art Objects: Their Care and Preservation.* La Jolla, CA: Museum Publications, 1967.

Finch, Karen, and Putnam, Greta. *Caring For Textiles.* New York: Watson-Guptill Publications, 1977.

Glaser, Mary Todd. *Framing and Preservation of Works of Art on Paper.* New York: Parke-Bernet Galleries, CA. 1971.

Keck, Caroline K. *A Handbook on the Care of Paintings.* New York: Watson-Guptill Publications, 1965.

————. *On Conservation.* Washington, DC: American Association of Museums, n.d.

Levison, Henry W. *Artists' Pigments: Lightfastness Tests and Ratings.* Hallandale, FL: Colorlab, 1976.

Perkinson, Roy L. *Conserving Works of Art on Paper.* Washington, DC: American Association of Museums, n.d.

Plenderleith, H. J. *The Conservation of Antiquities and Works of Art.* London: Oxford University Press, 1974.

Pomerantz, Louis. *Is Your Contemporary Painting More Temporary Than You Think?* Chicago: International Book Co., 1962.

Remple, Siegfried. *The Care of Black and White Photographic Collections: Identification of Processes.* Ottawa: Canadian Conservation Institute, 1979.

Rogers, Hal, and Reinhardt, Ed. *How To Make Your Own Picture Frames.* New York: Watson-Guptill Publications, 1966.

Rowlison, Eric B. *Rules for Handling Works of Art.* Washington, DC: American Association of Museums, n.d.

Schonberg, Jeanne. *Questions To Ask Your Framer and Answers You Should Get.* Los Angeles: Tamarind Lithography Workshop, Inc. Revised 1973.

Stolow, Nathan. *Controlled Environment for Works of Art in Transit.* London: Butterworth, 1966.

Stout, George L. *The Care of Pictures.* New York: Dover Publications, Inc., 1975.

Toscano, Eamon. *Step-by-Step Framing.* New York: Golden Press, 1971.

Zigrosser, Carl, and Gaehde, Christa M. *A Guide to the Collecting and Care of Original Prints.* New York: Crown Publishers, 1965.

8. ARTISTS' AND ARTISTS' AID ORGANIZATIONS

(Note: The following list does not include state art councils. Find the address of your local art council in the white pages of your telephone directory and make sure you are on the council's mailing list. For a directory of artists' associations see Helen Shlien's *Artists Associations in the U.S.A.: A Descriptive Bibliography,* Boston Visual Artists Union, 1977; and Jaques Cattell Press's *American Art Directory,* R. R. Bowker. Revised biennially.)

Alabama Volunteer Lawyers for the Arts Committee, Sirote, Permutt, Friend, Friedman, Held, and Apolinsky, P.A., 2222 Arlington Avenue South, PO Box 55727, Birmingham, AL 35255. 205 933-7111.

American Council for the Arts (ACA), 1285 Avenue of the Americas, New York, NY 10019, 212 077-2544.

American Craft Council, 104 Park Avenue South, New York, NY 10016. 212 696-0710. (Note: A national, nonprofit organization to stimulate interest in crafts.)

The American Federation of Arts (AFA), 41 East 65th Street, New York, NY 10021. 212 988-7700. (Note: A national, nonprofit organization aiming to cultivate a greater knowledge of art throughout the U.S.A., and of American art abroad. Organizes traveling exhibits.)

American Society of Artists, Inc., 1297 Merchandise Mart Plaza, Chicago, IL 60654. 312 751-2500. (Note: A national member organization of professional artists. Has crafts branch: American Artisans.)

*Artists Equity Association, Inc., 1725 K Street NW, Suite 1003, Washington, DC 20006. 202 628-9633. (Note: A nonprofit organization that fights for rights of the visual artist. Branches across the nation. Provides numerous services, including newsletter, group insurance, model contracts, action kits, etc.)

Artists For Economic Action, Ron Blumberg, 974 Teakwood Road,

Los Angeles, CA 90049. 213 472-8008. (Note: Dedicated to improving economic conditions of artists.)

Artists' Foundation, Inc., 110 Broad Street, Boston, MA 02110. 617 482-8100. (Note: An arts services organization that provides fellowships to Massachusetts artists, publishes books and pamphlets.)

Art PAC, Bob Bedard, 210 Seventh Street SE, Suite A-18, Washington, DC 20003. 202 547-5146. (Note: Art PAC is a political action committee dedicated to interests of individual artists rather than institutions and administrators.)

Artists' Rights Association, 165 Park Row, Apt. 19D, New York, NY 10038. 212 732-3873 (unlisted). (Note: Mounts national educational and publicity campaigns to correct inequities in the sale and transfer of artworks.)

*Bay Area Lawyers for the Arts, Fort Mason Center, Bldg. C, Room 255, San Francisco, CA 94123. 415 775-7200.

*Boston Visual Artists Union at the Art Institute of Boston, 700 Beacon Street, Boston, MA 02215. 617 227-3076. (Note: Publishes newsletter among its many services.)

Center for Arts Information, 1285 Avenue of the Americas, New York, NY 10019. 212 977-2544. (Note: An information clearinghouse for and about the arts in New York State and the nation.)

Center for Visual Arts, 1515 Webster Street, Suite 425–443, Oakland, CA 94612. 415 451-6300.

*Chicago Artists' Coalition, 5 West Grand, Chicago, IL 60610. 312 670-2060. (Note: Publishes useful newsletter.)

College Art Association, 149 Madison Avenue, New York, NY 10016. 212 889-2113.

Colorado Lawyers for the Arts, % Colorado Council for the Arts and Humanities, 770 Pennsylvania Street, Denver, CO 80203. 303 866-2617.

Cultural Alliance of Greater Washington, 633 E Street NW, Washington, DC 20004. 202 638-2406.

*Foundation for the Community of Artists, 280 Broadway, Suite 412, New York, NY 10007. 212 227-3770. (Note: Publishes *Art and Artists* and operates "Artists' Hotline," an information and referral service: 212 285-2133.)

Georgia Volunteer Accountants for the Arts, 32 Peachtree Street NE, Suite 521, Atlanta, GA 30303. 404 577-3654.

Georgia Volunteer Lawyers for the Arts, 32 Peachtree Street NE, Suite 521, Atlanta, GA 30303. 404 577-7378.

Graphic Artists Guild, 30 East 20th Street, New York, NY 10003. 212 777-7353.

International Sculpture Center, 1050 Potomac Street NW, Washington, DC 20007. 202 965-6066.

Lawyers/Accountants for the Arts, % Artists Foundation, 110 Broad Street, Boston, MA 02110. 617 482-8100.

Lawyers Committee for the Arts, 2700 Q Street NW, Washington, DC 20007. 202 337-8688, or 202 483-6777.

Lawyers for the Creative Arts, 220 S. State Street, Suite 1404, Chicago, IL 60604. 312 987-0198.

Los Angeles Lawyers for the Arts, % David Abel, President, 617 South Olive Street, Suite 515, Los Angeles, CA 90014. 213 688-7404. (Note: Refers clients to the L.A. County Bar Association, since at the moment they are not volunteer lawyers.)

Minnesota Lawyers for the Arts, Attn: Fred Rosenblatt, 1200 National City Bank Bldg., Minneapolis, MI 55402. 612 339-1200.

Philadelphia Volunteer Lawyers for the Arts, 260 South Broad Street, 20th Floor, Philadelphia, PA 19102. 215 545-3385.

Pro Arts, 1920 Union Street, Oakland, CA 94607. 415 763-7880.

Rhode Island Volunteer Lawyers for the Arts, % Adler, Pollock, and Sheehan, 1 Hospital Trust Plaza, Providence, RI 02903. 401 274-7200.

Society of Illustrators, 128 E. 63rd Street, New York, NY 10021. 212 838-2560.

Visual Artists' and Galleries' Association (VAGA), 1 World Trade Center, Suite 1535, New York, NY 10048. 212 466-1390. (Note: A clearinghouse for licensing rights of reproductions and policies against unauthorized reproductions.)

*Volunteer Lawyers for the Arts, 1285 Avenue of the Americas, New York, NY 10019. 212 575-1150. (Write for association nearest you.)

Washington Area Lawyers for the Arts, 420 7th Street NW, Washington, DC 20004. 202 724-5613.

Washington Project for the Arts, 400 7th Street NW, Washington, DC 20004. 202 347-8304.

Washington Volunteer Lawyers for the Arts, 66 Bell Street, Seattle, WA 98121. 206 223-0502.

APPENDIX 2

SAMPLE
ARTIST–GALLERY
AGREEMENT

Note: This Sample Artist–Gallery Agreement is exactly that: a sample *agreement. As it would be impossible to cover every contingency that might occur in every specific case, this sample agreement should be adapted to suit your own individual situation. Please keep in mind that state laws vary and change, and that before entering any contractual relationship, you should consult a lawyer knowledgeable in the area. Always make two copies of any contract (one for you, the other for the second party), and have the relevant parties sign* both *copies: your copy of the contract should never have photocopied signatures.*

*This contract is best read in conjunction with Chapter 13, "Questions To Ask Your Gallery" ***

*This contract has been adapted from the following sources: Norman H. Stone, *An Introduction to Contracts for the Visual Artist* (San Francisco: Bay Area Lawyers for the Arts, 1979); Tad Crawford, *Contracts for Artists* (American Artist Business Letter, 1979); and Lawyers for the Arts Committee of the Philadelphia Bar Association, "Model Form of Artist–Gallery Agreement with Explanatory Annotations," 1975.

Agreement made this _____day of _____, 19 ___, between _____
(hereinafter called "the Artist"), residing at _____and
(hereinafter called "the Gallery), located at _____.

WITNESSETH THAT:

WHEREAS, the Artist is a recognized professional artist,
WHEREAS, the Artist wishes to have certain of his/her artworks represented by the Gallery, and;

WHEREAS, the Gallery wishes to represent the Artist under the terms and conditions of this Agreement;

NOW, THEREFORE, in consideration of the mutual covenants hereinafter contained, the parties hereto agree as follows.

1. SCOPE OF AGENCY. The Artist appoints the Gallery his/her
_____[enter "nonexclusive" or "exclusive"] agent
for the purpose of exhibition and sale of the consigned works of art in
the following geographical area: _____.

2. CONSIGNMENT. The Artist shall consign to the Gallery and the Gallery shall accept consignment of the following works of art during the term of this Agreement:

CHECK
WHICHEVER
APPLY

☐ The works described in the Consignment Sheet (Schedule A of this Agreement) and such additional works as shall be mutually agreed upon and described in a similar Consignment Sheet.

☐ All new works created by the Artist, excluding works reserved by the Artist for his/her private collection, in the following media: _____.

☐ All works which the Gallery shall select, excluding works reserved by the Artist for his/her private collection, in the following media: _____.

☐ All new works created by the Artist, excluding works reserved by the Artist for his/her private collection, and excluding works reserved by the Artist for studio sales made directly by the Artist, in the following media: _____.

☐ All works which the Gallery shall select, excluding works reserved by the Artist for his/her private col-

lection, and excluding works reserved by the Artist
for studio sales made directly by the Artist, in the
following media: _____.
☐ Not less than _____mutually agreed upon works
per year, in the following media: _____.

The Artist shall be free to exhibit and sell any work not consigned to
the Gallery under this Agreement. Upon Gallery's request, Artist will
inform Gallery of other agents representing Artist's work.

3. TITLE AND RECEIPT. The Artist warrants that he/she created and
possesses unencumbered title to all works of art consigned to the Gal-
lery under this Agreement. Title to the consigned work shall remain in
the Artist until he/she is paid in full. The Gallery acknowledges receipt
of the works in the Consignment Sheet (Schedule A of this Agree-
ment) and shall give the Artist a similar Consignment Sheet to ac-
knowledge receipt of all additional works consigned to the Gallery under
this Agreement.

4. CONTINUOUS SALES REPRESENTATION AND PROMO-
TION. The Gallery shall use its best efforts to promote the sale of the
Artist's consigned works, to support a market for the Artist's work,
and to provide continuous sales representation, in the following manner:
_____.*

5. SALES PRICE. The Gallery shall sell the consigned works at the
retail price specified in writing in the Consignment Sheet.
 a. The Gallery, however, may give a customary trade discount [which
shall not exceed _____% of sales price without the Artist's writ-
ten consent] of sales to museums, other galleries, decorators, and

*Here you should list, in as clear but detailed a manner as possible, every-
thing the Gallery will do to best represent you: whether the Gallery will visit
your studio regularly to get a better idea of the full range of your work; where
the Gallery will exhibit your work—on the walls, in bins, drawers, sliding
panels, etc.; whether you will be included in the Gallery's regular advertising
throughout the year, etc. For more details, see "Questions To Ask Your Gal-
lery," checkpoints 1, 11, 22, and 23.

architects. In the case of such discount sales, the amount of the discount shall be deducted from the Gallery's sales commission.

b. Sales price specified in writing in the Consignment Sheet does not include any applicable sales tax. Any such applicable tax will be collected by the Gallery on works sold by the Gallery. The Gallery will supply the Artist with its signed resale certificate and its resale number, for the Artist's records.

c. Sales price specified in writing in the Consignment Sheet does not include costs of delivering said work to customer. Delivery costs (including packing, transportation, and insurance) will be paid by the Gallery.

d. Artist will support the efforts of the Gallery and will maintain the fair market value of the work in any studio sales.*

6. REMOVAL FROM GALLERY, RENTALS, APPROVAL AND INSTALLMENT SALES. The gallery shall not lend out, remove from its premises, rent, or sell on approval or installment any of the consigned works, without the written consent of the Artist.

a. The Gallery shall not permit any consigned work to remain in the possession of a customer for the purpose of sale on approval for a period exceeding seven (7) days.

b. No rental period may exceed _____weeks unless a longer period is approved by the Artist in writing.

c. If after renting one of Artist's consigned works, a customer desires to purchase said work, the rental fees paid _____[enter "shall" or "shall not"] be deducted from the sales price.

d. Although the Gallery may arrange for representation of the Artist by another agency with the Artist's written consent, the Gallery shall pay such agency by splitting its own commission.

e. When, with the Artist's written approval, the Gallery lends out or removes from its premises one of the Artist's works for the purposes of rental, approval sales, installment sales, or representation by another agency, then the costs of delivery from and if necessary to the Gallery (including packing, transportation, and insurance) shall be paid by the Gallery.

*Your Agreement might also consider other factors with regard to sales prices. These factors include: the pricing of works purchased by Gallery of its own account and the right of the Gallery to sell at auction.

7. SALES COMMISSION. The Gallery shall receive the following sales commission:

a. _____% of the agreed retail price on sales made by the Gallery.

b. _____% of any rental fees on rentals arranged by the Gallery.

c. _____% of the price of any commissions given to Artist to create works of art when such commissions are obtained for him/her by the Gallery.

d. _____% of the amount received for prizes and awards granted to the Artist when such prizes and awards are obtained for the Artist by the Gallery.

e. _____% of lecture fees for lectures arranged for the Artist by the Gallery.

f. _____% of the amount paid for studio sales of referrals by the Gallery.

g. _____% of the amount paid for studio sales made directly by the Artist.

h. _____% of any rental fees on rentals arranged directly by the Artist.

i. _____% of the price of any commissions given to Artist to create works of art when such commissions are obtained directly by the Artist.

j. _____% of the amount received for prizes and awards granted to the Artist when such prizes and awards are obtained directly by the Artist.

The remainder shall be paid to the Artist. Pursuant to Paragraph 5a, in the case of discount sales, the amount of the discount shall be deducted from the Gallery's sales commission. Pursuant to Paragraph 6d, in the case of the Gallery's arranging for representation of the Artist by another agency, the Gallery shall pay such agency by splitting its own commission.*

*The Paragraph delineating the commission arrangement is, of course, one of the most important provisions in your Agreement, and it should be tailored to your particular situation. If, for example, the cost of materials for your work is quite high, you might stipulate that the costs of materials, installation, and foundry fees, etc. shall be deducted *before* the Gallery's commission is calculated. If much of your work is framed, this Paragraph could include a pro-

8. PAYMENT ON GALLERY'S SALES. With respect to sales made under Paragraph 7a,b,c,d,e:

a. On outright sales, the Gallery shall pay the Artist's share within thirty (30) days of purchaser's payment to the Gallery.*

b. On installment sales, the Gallery shall first apply the proceeds from sale of the work to pay the Artist's share. Payment shall be made within thirty (30) days after the Gallery's receipt of each installment.

The Gallery shall hold the proceeds from sale of the consigned works in trust for the benefit of the Artist. The Gallery agrees to guarantee the credit of its customers, and to bear all losses due to the failure of the customer's credit.

9. PAYMENT ON ARTIST'S SALES. With respect to sales made under Paragraph 7f,g,h,i,j:

a. On outright sales, the Artist shall pay the Gallery its sales commission within thirty (30) days of purchaser's payment to Artist.

b. If purchaser pays in installments, the Artist shall first apply the proceeds from sale of work to pay his/her own share. Payment to Gallery shall then be made within thirty (30) days after the Artist's receipt of each installment.

vision that the Gallery's commission will be on the retail price of the work *minus* the cost of the frame. (See Chapter 13, checkpoint 18.) In another situation, you might arrange for a sliding commissions scale: the Gallery could take a 50% commission on works under $3,000, a 40% commission on works in the $3,000 to $8,000 range, and a 30% commission on works over $8,000. On those sales arranged directly by you (Paragraph 7g,h,i,j) the commission should be lower than on those sales arranged by the Gallery (Paragraph 7a,b,c,d,e,f). In fact, in some cases, you might want to stipulate that the Gallery receives no commission on sales made directly by the Artist. Or you might arrange that in such Artist-arranged sales, the Gallery receives no commission unless it generates annual sales for you in excess of a certain amount. (See Chapter 13, checkpoints 5 and 10.) This Paragraph of your Agreement could also cover any cash advances the Gallery might provide you. (See Chapter 13, checkpoint 2.)

*You might want to include a provision that for sales in excess of a certain amount, the Gallery will pay you as soon as the Purchaser's check clears. That way, you won't have to wait thirty days for your share.

10. STATEMENTS OF ACCOUNT. The Gallery shall give the Artist a Statement of Account within fifteen (15) days after the end of each calendar quarter beginning with _____. 19__. The Statement shall include the following information:

 (1) the works sold or rented
 (2) the date, price, and terms of sale or rental (that is, whether by cash, barter, exchange, credit, partial payment or other)
 (3) the commission due to the Gallery
 (4) the name and address of each purchaser or renter
 (5) the amount due to the Artist
 (6) the location of all unsold works, if not on the Gallery's premises, and if on the Gallery's premises, whether at time of said Account, the work is on display or not.

The Gallery warrants that the Statement shall be accurate and complete in all respects. The Artist shall have the right to inspect the financial records of the Gallery pertaining to any transactions involving the Artist's work. (The Gallery shall have the right to inspect the financial records of the Artist pertaining to any transaction involving the Gallery.)

11. EXHIBITIONS. During the term of this Agreement, in addition to continuous sales representation, the Gallery shall arrange, install, and publicize at least one solo exhibition of the Artist's work of not less than _____ weeks duration each, every _____ months, and shall use its best efforts to arrange other solo exhibitions for Artist and for the inclusion of the Artist's work in group exhibitions in other galleries or museums, provided, however, that the Artist's work may not be included in any group or solo exhibition without the Artist's written consent.

 a. The Gallery shall give the Artist at least _____ months notice of said solo exhibition.

 b. The Gallery will give the Artist reasonable notice of any deadlines for said solo exhibition, including but not limited to: when work is due at the Gallery, date of reception, hours of Gallery during exhibition, deadlines for résumés or press photographs that may be required, when unsold work will be returned after the exhibition. The Gallery will also give the Artist all information concerning all physical restrictions in advance, including but not limited to: what weight works the Gallery's floors can support, what size works can fit through the Gallery's doors.

c. The Artist will give the Gallery reasonable notice of any special requirements of his/her solo exhibition.

d. Prior to any exhibition of the Artist's work, the Gallery and Artist shall agree on the extent of, and division of, the artistic control of and financial responsibility for the costs of exhibitions and other promotional efforts to be undertaken in connection with such exhibition, including but not limited to, installation, advertising, printing, postage, reception, framing. Neither the Gallery nor the Artist shall be entitled to reimbursement from the other for any expense incurred by him/her or it without the prior written approval of the other.*

e. If the Artist gives the Gallery his/her mailing list to use for any exhibition, the Gallery shall respect confidentiality of same.

f. After the exhibition, the frames, photographs, negatives, and any other tangible property created in the course of the exhibition shall be the property of the Artist.

g. After the exhibition, the Gallery will provide the Artist with copies of all reviews Gallery has received concerning said exhibition.

12. DELIVERY OF WORKS. _____ shall be responsible for delivery of the consigned works to the Gallery. All costs of delivery (including packing, transportation, and insurance) shall be paid as follows: _____% by the Artist, _____% by the Gallery.

13. RETURN OF WORKS. _____ shall be responsible for return of works from the Gallery to the Artist. All costs of return (including packing, transportation, and insurance) shall be paid as follows: _____% by the Artist, _____% by the Gallery.

a. The Gallery may return any consigned work on thirty (30) days written notice.

b. The Artist may withdraw his/her consigned work on thirty (30) days written notice.

c. If the Artist fails to accept return of the works within _____ days after written request by the Gallery, the Artist shall pay reasonable storage costs.

*You might want your Agreement to specify exactly what your Gallery will do for you during your solo exhibitions. See Chapter 13, checkpoints 21 and 22 for issues to be outlined in this part of your Agreement.

d. The Gallery agrees to return consigned works in the same good condition as received, subject to the provisions of Paragraph 14.

14. LOSS OR DAMAGE. The Artist and Gallery hereby agree as follows:

a. The Gallery shall not intentionally commit or authorize any physical defacement, mutilation, alteration, or destruction of any of the consigned works. The Gallery shall be responsible for the proper cleaning, maintenance, and protection of consigned work, and shall also be responsible for the loss or damage to the consigned work, whether the work be on the Gallery's premises, on loan, on approval, or otherwise removed from its premises pursuant to Paragraph 6.

b. Upon Gallery's request, the Artist will supply Gallery with a Statement of Maintenance (similar to Schedule B of this Agreement) for the consigned works.

c. If restoration is undertaken for any consigned work, all repairs and restoration shall have the Artist's written permission. The Artist shall be consulted as to his/her recommendations with regard to all such repairs and restoration, and will be given first opportunity to accomplish said repairs and restorations for a reasonable fee.

d. In the event of loss or damage that cannot be restored, the Artist shall receive the same amount as if the work had been sold at the retail price listed in the Consignment Sheet. The Gallery shall not deduct a commission from this payment. The damaged work will be returned to Artist upon his/her request.

e. For the benefit of the Artist, the Gallery will provide at its expense all risk insurance on all of the Artist's works of art shown in the Consignment Sheet for _____% of the retail price.*

15. COPYRIGHT. The Artist and the Gallery hereby agree as follows:

a. The Artist hereby reserves for himself/herself the common law copyright, including all reproduction rights and the right to claim statutory copyright in all works consigned to the Gallery.

b. The Gallery will not permit any of the works of art to be copied,

*If possible, try to be named on the insurance policy as the beneficiary in case of a claim. Most galleries, however, will not permit this.

photographed, or reproduced without the written approval of the Artist.

c. All approved reproductions in catalogues, brochures, advertisements, and other promotional literature shall carry the following notice: © by _____, 19__.

d. The Gallery will have printed on each bill of sale in a prominent place the following notice: "The right to copy, photograph, or reproduce the work(s) of art identified herein is reserved by the Artist, _____."

e. The Gallery will display in a prominent place in its Gallery a sign advising its customers that Artist's work may not be copied, photographed, or reproduced and that it will use its best efforts to prevent violations thereof.

f. Notwithstanding the foregoing, reproduction rights may be specifically sold by Gallery with the Artist's prior written consent. Gallery shall not receive any commissions on royalties or sales of reproduction rights unless sold or arranged by Gallery, in which case Gallery's sales commission shall be _____%. In such case, the Gallery will pay the Artist his/her share within thirty (30) days of purchaser's payment to Gallery.

16. MORAL RIGHT. The Gallery will not permit any use of the Artist's name or misuse of the consigned works which would reflect discredit on his/her reputation as an artist or which would violate the spirit of the work.

17. SECURITY. The consigned works shall be held in trust for the benefit of the Artist, and shall not be subject to claim by a creditor of the Gallery. In the event of any default by the Gallery, the Artist shall have all the rights of a secured party under the Uniform Commercial Code.

18. CONTRACT FOR SALE. The Gallery shall use the Artist's own Contract for Sale (a copy of which is appended to this Agreement) in any sale of the consigned works.*

*Append a copy of the Artist's Transfer Agreement and Record (Resale Contract) if you use such an agreement. You may want to draft your own version of a sales contract to be appended here (see Appendix 4).

19. DURATION AND TERMINATION OF AGREEMENT. This
Agreement shall commence upon the date of signing and shall con-
tinue in effect until the _____ day of _____, 19__.

 a. Either party may terminate this Agreement by giving sixty (60)
 days prior written notice, except that the Agreement may not be ter-
 minated ninety (90) days prior to the opening of the Artist's solo
 exhibition, or ninety (90) days following the close of the Artist's
 solo exhibition.

 b. The Agreement shall automatically be terminated with the death
 of the Artist; the death or termination of employment of _____
 with the Gallery; if the Gallery moves outside of the area of _____;
 or if the Gallery becomes bankrupt or insolvent.*

 c. Upon termination of this Agreement, the Gallery shall return within
 thirty (30) days all Artist's works which are held by it on consign-
 ment and all accounts shall be settled.

20. ARBITRATION. Any dispute hereunder between the parties shall
be resolved by resort to binding arbitration by a mutually agreed upon
party in accordance with the standards and procedures of the American
Arbitration Association, and the arbitration award may be entered for
judgment in any court having jurisdiction thereof.

 a. Notwithstanding the foregoing, either party may refuse to arbitrate
 when the dispute is for a sum of less than $_____
 (_____ dollars), or more than $_____ (_____ dol-
 lars).†

 b. All proceedings of the arbitration shall be public and all records
 and documents open to the public.

 c. In the event such arbitration services are not available, all other
 legal remedies shall be available to all the parties.

 d. If any action at law or in equity is brought to enforce or interpret
 the provisions of this agreement, the prevailing party shall be enti-
 tled to reasonable attorney's fees in addition to any other entitled
 relief.

*When you first join a gallery, you may do so because of your personal re-
lationship with and confidence in a particular employee of the Gallery. This
provision of your Agreement gives you the option to terminate your Agree-
ment should that particular employee be dismissed or die.

†In the space provided "for less than _____," you may want to insert the
jurisdictional amount of the local small claims court. This usually provides an
even easier forum than arbitration for settling disputes.

21. NO ASSIGNMENT OR TRANSFER. Neither party hereto shall have the right to assign or transfer this agreement without the prior written consent of the other party. The Artist, however, shall retain the right to assign any payments provided for by this Agreement. The Gallery shall notify the Artist in advance of any change in personnel in charge of the Gallery or any change in ownership of the Gallery.

22. ASSIGNS. This Agreement shall be binding upon the parties hereto, their successors, assigns, and personal representatives, and references to the Artist and the Gallery shall include their successors, assigns, and personal representatives, notwithstanding anything to the contrary herein.

23. NO WAIVER. No waiver of full performance by either party shall be construed or operate as a waiver of any subsequent default of any of the terms, covenants, and conditions of this Agreement.

24. SEVERABILITY. If any part of this Agreement is held to be illegal, void, or unenforceable for any reason, such holding shall not affect the validity and enforceability of any other part.

25. ENTIRE AGREEMENT. This Agreement contains all of the covenants, promises, agreements, and conditions, either oral or written, between the parties, and may not be changed or modified except in writing signed by both parties.

26. ADDRESS NOTICE. All notices to the Artist shall be delivered to _____, and all notices to the Gallery to _____. Each party shall notify the other party in case of change of address prior to such change.

27. GOVERNING LAWS. The validity of this Agreement and of any of its terms, as well as the rights and duties of the parties under this Agreement, shall be governed by the laws of the State of _____.

IN WITNESS WHEREOF the parties hereto have executed this Agreement on the day and year first above written.

BY _____ BY _____
 (The Artist) (The Gallery)

SCHEDULE A: CONSIGNMENT SHEET

Date: _____ Received from: _____ the Following Works of Art on Consignment:

Title/Description:	Date:	Medium:	Dimensions:	Edition #: (if print)	Installation: (frame, base, etc.)	Retail Price: "Framed" "Unframed"	Commission: (consignee's %)	Net Due Artist:
1.								
2.								
3.								
4.								
5.								
6.								
7.								
8.								
9.								
10.								
11.								
12.								

The above works received in perfect condition unless otherwise noted.

Artist's Signature: _____ For the Gallery: _____

SCHEDULE B: STATEMENT OF MAINTENANCE

Artist: _____ Address: _____

Gallery: _____ Address: _____

Title of Work: _____

Medium: _____ Dimensions: _____

Specific Materials Used in Execution of Piece (Brand name and type of paint, paper type, fiber content, specific metals, etc.):

Specific Materials Used in the Presentation of Piece (Composition of base or backing, framing, matboard, protective covering, hanging rods, base, etc.):

Recommendations and Cautions Regarding Maintenance and Care of Work (Cleaning, avoiding exposure to direct sun, exposure to dampness, fragility factor, instructions for assembling, etc.):

Gallery agrees to deliver a copy of this Statement to Purchaser of artwork named above.

Date: _____

_____ _____
Artist's Signature Gallery's Signature

APPENDIX 3

SAMPLE COMMISSION AGREEMENT

Note: This commission contract is general as to form and your specific circumstances may require a different agreement. It would be impossible to foresee every contingency that might occur in every individual or specific case. State laws vary, and while this reflects general principles at the time of its writing, laws change. Therefore, before entering into any contractual relationship, you should consult a lawyer knowledgeable in this area. *

Agreement made this _____ day of _____, 19__, between _____ (hereinafter called "the Artist"), residing at _____, and _____ (hereinafter called "the Purchaser"), residing at _____.

WITNESSETH THAT,

WHEREAS, the Artist is a recognized professional artist, and;

WHEREAS, the Purchaser acknowledges sufficient familiarity with the style and quality of the work of the Artist, and;

*This contract has been adapted from the following sources: Tad Crawford, *Legal Guide for the Visual Artist* (New York: Hawthorn Books, 1977); Caryn R. Leland, "A Model Agreement for Commissioned Artwork," *Artworkers News,* (May 1980), 9 (9):32–33; Norman H. Stone, *An Introduction to Contracts for the Visual Artist* (San Francisco: Bay Area Lawyers for the Arts, 1979); Tad Crawford, *Contracts for Artists* (American Artist Business Letter, 1979).

WHEREAS the Purchaser desires the Artist to create a work of art (hereinafter called "the Work") in the Artist's unique style, and;

WHEREAS, both parties wish the integrity and clarity of the Artist's ideas and statement in the Work to be maintained;

NOW, THEREFORE, in consideration of the mutual covenants hereinafter contained the parties hereto agree as follows.

1. DESCRIPTION OF WORK. The Artist shall create the following work of art:

Title:

Materials:

Approximate Size upon Completion:

Description of the Artwork:

Scope of the Artist's Work:

It is hereby understood and agreed that it may not be possible to create the Work exactly as described herein or as depicted in preliminary designs, and the Artist shall only be bound to use his/her best aesthetic judgment to create the Work according to the style and intent of the design. The Artist is hereby free to make design modifications as the Work progresses.

2. PRICE AND PAYMENT SCHEDULE. The Artist shall sell the Work to the Collector, subject to the conditions herein, for a price of $_____ (_____ dollars), payable as follows:

ONE THIRD upon the execution of this agreement;

ONE THIRD upon artist's giving written notification that one-half of the Work is completed;

THE BALANCE upon Artist's giving written notification that Work is completed.

a. The Purchaser shall pay all applicable taxes in the Work with the final payment.

b. The following expenses incurred by the Artist in the course of creating, executing, and installing the Work, including but not limited to traveling expenses, shall be reimbursed by the Purchaser, upon the receipt of proper documentation: _____.*

*For a list of possible expenses involved in creating, executing, and installing commissioned works, see Chapter 15, checkpoint 3, "Payment Schedule." If the Purchaser pays for major expenses, you should include a clause stipulating that the Purchaser pays for such expenses at the time they are incurred, so that you don't have to lay out, let's say, $4,000 for foundry fees.

c. The Purchaser agrees to pay all amounts due within two (2) weeks of receipt of notice.

d. If the Purchaser fails to make any payment when due, Artist reserves the right to charge interest of the then prevailing interest rate for banks on the amounts past due. It is understood that delay of payment may proportionately extend the time required to complete the Work.

e. The Purchaser shall have the right to inspect the Work in progress upon reasonable notice to the Artist.

3. DATE OF DELIVERY. The Artist agrees to complete the Work within _____ (_____) days of the signing of this agreement.

a. The completion date shall be extended for such period of time as the Artist may be disabled by illness preventing progress of the Work.

b. The completion date shall also be extended in the event of delays caused by events beyond the control of the Artist, including but not limited to fire, thefts, strikes, shortage of materials, and Acts of God. Time shall not be considered of the essence with respect to the completion of the Work.

c. The Artist will immediately notify the Purchaser of any delays occurring or anticipated.

d. Completion of the Work is to be determined by the Artist who shall use his/her professional judgment to deviate from any preliminary designs as he/she in good faith believes necessary to create the Work.

e. Upon nearing completion of the Work, the Artist will give the Purchaser five (5) days advance notice of specific date of delivery so that the Purchaser will be ready to receive the Work and sign the Agreement of original transfer of work of art.

f. The Collector shall deliver to the Artist within two (2) weeks after completion of the installation of the Work, a copy of a letter officially accepting the Work.

4. INSURANCE, SHIPPING, AND INSTALLATION. The Artist agrees to keep the Work fully insured against fire and theft until delivery to the Purchaser. In the event of a loss caused by fire or theft, the Artist shall use the insurance proceeds to recommence the making of the Work.

a. Upon completion, the Work shall be shipped F.O.B. artist's studio at the expense of the Purchaser to the following address: ___.
b. If any special installation is necessary, the Artist shall assist in said installation as follows: _____
_____.

5. TERMINATION: This Agreement may be terminated on the following conditions:

a. The Purchaser shall have the right to terminate this Agreement if the Artist fails without cause to complete the Work within ninety (90) days of the completion date in Paragraph 3. In the event of termination pursuant to this subparagraph, the Artist shall return to the Purchaser all payments made pursuant to Paragraph 2, but shall not be liable for any additional expenses, damages, or claims of any kind based on the failure to complete the Work.

b. The Purchaser shall have the right to terminate this Agreement if, pursuant to Paragraph 3, the illness of the Artist causes a delay of more than six (6) months in the completion date, or if events beyond the Artist's control cause a delay of more than one (1) year in the completion date, provided, however, that the Artist shall return all payments made pursuant to Paragraph 2, and shall not be liable for any additional expenses, damages, or claims of any kind based on the failure to complete the Work.

c. If Purchaser does not find the Work as it progresses fulfilling his expectations or needs and therefore wishes to terminate the Agreement, Purchaser shall immediately notify the Artist of the termination. The Artist shall thereupon be entitled to retain all payments which Artist has received or was entitled to receive pursuant to his agreement prior to such notification.

d. The Artist shall have the right to terminate this Agreement in the event the Purchaser is more than sixty (60) days late in making any payment due pursuant to Paragraph 2, provided, however, that nothing herein shall prevent the Artist bringing suit based on the Purchaser's breach of contract.

e. This Agreement shall automatically terminate on the death of the Artist, provided, however, that the Artist's estate shall retain all payments made pursuant to Paragraph 2.

f. The exercise of a right of termination under this Paragraph shall be written and set forth the grounds for termination.

6. OWNERSHIP. Title to the Work shall remain in the Artist until Artist is paid in full.

a. In the event of termination of this agreement pursuant to Subparagraphs a, b, c, and d of Paragraph 5, the Artist shall retain all rights of ownership in the concept, design, and Work itself, including the right to complete, exhibit, and sell the Work.

b. In the event of termination of this agreement pursuant to Subparagraph e of Paragraph 5, the Purchaser shall have the right to keep copies of the preliminary design and the Work in progress for the sole purpose of completing the Work, provided, however, that the Work be completed by the following person(s), whom the Artist herein designates to complete the Work: _____ and/or _____.
If the Purchaser chooses not to have the Work completed by the designated artist(s), then all copies of preliminary designs, incidental works, and the Work in progress immediately shall become the property of the Artist's estate and promptly be returned to the Artist's estate.

7. ARTIST'S RIGHTS.

a. *Copyright and Right to Credit.* The Artist reserves to himself all rights of reproduction and all copyrights in the Work, the preliminary design, and any incidental works made in the creation of the Work. Copyright notice in the name of the Artist shall appear on the Work, and the Artist shall also receive authorship credit in connection with the Work, in the following form: Copyright, Artist's name, All Rights Reserved, date, in such a manner and location as shall comply with the U.S. Copyright Law. The Artist agrees to give a credit substantially in the following form, in any public showing or reproduction of the Work: Original owned by _____.*

*If the commissioned work is going to be displayed in a public place, such as an airport or office building lobby, you might also want to include a clause stipulating that "a plaque identifying the Artist, the title of the work, if any, and the year of the completion, will be displayed in the immediate location of the installed work. The plaque shall be of such medium and design as to be appropriate to the Work itself and the permanent location of the Work, and must have the written approval of the Artist. The creation and installation of this plaque will be done at the expense of the Purchaser."

b. *Right to Possession.* The Artist and the Purchaser agree that the Artist shall have the right to show the Work for up to sixty (60) days once every five (5) years at no expense to the Purchaser, upon written notice not later than ninety (90) days before opening of show and upon satisfactory proof of insurance. All costs incurred from door-to-door are the responsibility of the Artist.*

c. *Nondestruction/Alteration.* The Purchaser agrees that he/she will not intentionally destroy, alter, damage, modify, or otherwise change the Work in any way whatsoever, without the Artist's written permission.

d. *Repairs/Maintenance.* The Purchaser shall be responsible for the proper cleaning, maintenance, and protection of the Work in its possession, if on loan or otherwise exhibited, notwithstanding anything contrary herein. The Artist shall provide the Purchaser with a Statement of Maintenance (Attachment A). All repairs and restorations made during the Artist's lifetime shall have the Artist's written permission. The Artist shall be consulted as to his/her recommendations with regard to all such repairs and restorations, and will be given the opportunity to accomplish said repairs and restorations, for a reasonable fee. If Purchaser and Artist cannot agree regarding repairs, then the Purchaser may accomplish such repairs as he/she deems necessary. In that event the Work will no longer be represented as the Work of the Artist without his/her written permission.

e. *Resale of Work.* If the Purchaser later sells or transfers the Work, the Purchaser shall pay to the Artist a sum equal of fifteen (15)% of the appreciated value of the Work and shall obtain from the new purchaser or transferee a binding undertaking to observe all of the provisions of this Agreement in the interest of the Artist. The Artist shall be given the new owner's name and address. For the purposes of this agreement, appreciated value shall mean the sales price of the artwork less the original purchase price as stated in this agreement.

f. *Relocation of Work.* The Artist shall be notified if the Work is to be relocated from the address specified in Paragraph 4, Subparagraph a. The Purchaser shall notify the Artist of any proposed al-

*This paragraph applies only in the case of works which are easily removable and transportable.

teration of the site or adjoining area that would affect the intended character and appearance of the Work, and shall consult the Artist in the planning of any such alteration, for which the Artist will receive a reasonable fee. If any alteration of such Site or Areas of the Work is made without the express written approval of the Artist, the Artist may elect to enter upon the site and at the expense of the Purchaser to remove or obliterate his credit in the work, including but not limited to any signature or other emblem identifying the Artist with the Work. This paragraph shall apply to any alteration of the site, such areas of the Work, whether intentional, accidental, with or without the control of the Purchaser or otherwise.*

g. *Moral Right.* The Purchaser will not permit any use of the Artist's name or misuse of the Work which would reflect discredit on his/her reputation as an artist or which would violate the spirit of the Work.

8. DISAGREEMENT/ARBITRATION. Any dispute hereinunder between the parties, not involving money claims by either party in excess of $_____ (_____ dollars), shall be resolved by resort to arbitration by a mutually agreed upon party in accordance with the standards and procedures of the American Arbitration Association.

a. Within twenty (20) days of the arbitrator's award, each party to the action shall file a notice of intent to comply with the award, or a notice of intent to file an action in the appropriate court.

b. All proceedings of the arbitration shall be public and all records and documents open to the public.

c. In the event such arbitration services are not available, all other legal remedies shall be available to all the parties.

d. If any action at law or in equity is brought to enforce or interpret the provisions of this agreement, the prevailing party shall be entitled to reasonable attorney's fees in addition to any other entitled relief.

9. WARRANTY. The Artist warrants that the design being purchased is the original product of his/her own creative efforts. The Artist war-

*This paragraph primarily pertains to works commissioned for public spaces and would not have much relevance to a work commissioned for the private home of a collector.

rants that unless otherwise stipulated, the Work is unique, that it is an edition of one (1), and that it has not been accepted for sale elsewhere.

10. NOTICES AND CHANGES OF ADDRESS. All notices shall be sent to the Artist at the following address: ⸺⸺⸺⸺ and to the Purchaser at the following address: ⸺⸺⸺⸺. Each party shall give written notification within sixty (60) days of any changes of address.

11. NO WAIVER. No waiver of full performance by either party shall be construed or operate as a waiver of any subsequent default of any of the terms, convenants, and conditions of this agreement.

12. NO ASSIGNMENT OR TRANSFER. Neither party hereto shall have the right to assign or transfer this agreement without the prior written consent of the other party. The Artist shall, however, retain the right to assign any payments provided for by this agreement.

13. HEIRS AND ASSIGNS. This agreement shall be binding upon the parties hereto, their heirs, successors, assigns, and personal representatives, and references to the Artist and the Purchaser shall include their heirs, successors, assigns, and personal representatives.

14. SEVERABILITY. If any part of this Agreement is held to be illegal, void, or unenforceable for any reason, such holding shall not affect the validity and enforceability of any other part.

15. ENTIRE AGREEMENT. This agreement contains all of the covenants, promises, agreements, and conditions, either oral or written, between the parties, and may not be changed or modified except in writing signed by authorized representatives of the parties hereto.

16. GOVERNING LAWS. The validity of this agreement and of any of its terms, as well as the rights and duties of the parties under this agreement, shall be governed by the laws of the State of ⸺⸺⸺.*

*This contract is primarily intended for unique, one-of-a-kind, commissioned artworks. If you were commissioned to create a multiple, such as an image for a poster, your contract would also have to address the following issues:

IN WITNESS WHEREOF the parties have hereunto set their hands.

BY _____ BY _____
 Artist Purchaser

(1) Limitation of Use: Are you, for example, giving the Purchaser the right to produce a certain number of posters during a certain amount of time?

(2) Royalties: The Purchaser should give you a royalty on the gross sales income derived from the sale of the multiple, so that you can share in the profits of the project's success. This paragraph should stipulate the exact percentage of your royalty, how often you will receive reports of sales activity with any royalty payments then due, and in what manner you have the right to question such reports.

(3) Retail Pricing: Should the price of the multiple be altered in the future, the Purchaser should recognize the necessity of protecting the Artist's standing in the art market and should hence agree to consult with the Artist in any decision affecting the price of the Work. You may want to reserve the right to approve any such changes in price in writing.

(4) Sales and Distribution: The Purchaser should inform and consult with the Artist with respect to the sale and distribution of the multiple.

(5) Supervision and Quality Control: The Artist should have the right to supervise reproductions of the Work, including such pertinent matters as color matching, checking of images and proofs, etc. You should also maintain the right to veto poor workmanship and/or changes in the Work's reproduction.

(6) Additional Benefits: The Artist should receive a certain number of the multiples for his/her own use.

APPENDIX 4

SAMPLE
TRANSFER AGREEMENT
AND RECORD
(RESALE CONTRACT)

Note: The accompanying form is the second edition of the Artist's Reserved Rights and Sale Agreement, conceived by Seth Siegelaub and drafted by Robert Projansky, a New York attorney, in 1971. It has been revised by Mr. Projansky and slightly modified by me. The original contract was well received by artists, but distribution was limited and its legal language was rather forbidding. The version published here is much shorter, easier to read, and hence easier to use.

The following instructions were written by the contract's authors:

When To Use the Contract

The contract form is to be used when the artist parts with each work for keeps: whether by sale, gift, or trade for things or services; whether it's a painting, a sculpture, a drawing, a nonobject piece or any other fine art; whether to a friend, a collector, another artist, a museum, a corporation, a dentist, a lawyer—anyone. It is *not* for use when you lend your work or consign it to your dealer for sale. It *is* for use when your dealer sells your work, or if he buys it himself.

How To Use the Contract

1. Photocopy the contract form. You'll need two copies for each transfer. Save this original to make future copies and for reference.
2. Fill out both copies.

You may want to enter "Artist's Address" as c/o your dealer.

Note that the contract speaks in terms of a "sale"; the word "sell" is used for the sake of simplicity. (Likewise, we use the word "purchaser" because it's the most all-inclusive word for this purpose.) In a sense, even if you are giving or trading your work, you are "selling" it for the promises in the contract plus anything else you get.

In Paragraph 1, enter the price *or* the value of the work. You can enter any value that you and the new owner agree upon. If he sells it later for more, he will have to pay you 15 percent of the increase, so the higher the number you put in originally, the better break the purchaser is getting. If you are giving a friend a work or exchanging with another artist (be sure to use two separate contracts for the latter situation), you might want to enter a very low value, so you will get some money even if he/she resells it at a bargain price.

If there are things you wish to delete or modify, cross out what you don't want and make any small changes directly on the form, making sure that both parties initial all such strikeouts and changes. If you don't have room on the form for the changes you want, add them on separate sheets entitled "Rider to Contract" and be sure both are signed by parties and dated. You should consult an attorney for extensive changes.

3. You and the purchaser sign both copies so each will have a legal original.

4. Before the work is delivered, be sure to cut out the NOTICE from the lower right corner of one copy and affix it to the work. Put it on a stretcher bar or under a sculpture base or wherever it will be aesthetically invisible yet findable. Protect it with a coat of clear polyurethane or the like.

If your work simply has no place on it for the NOTICE or your signature (in which case you should always use an ancillary document which describes the work, which bears your signature and which is transferred as a legal part of the work) glue or copy the NOTICE on that document.

Resale Procedure

When a work is resold the seller makes three copies of the Transfer Agreement and Record ("TAR") from the original contract, fills them out entering the value that he and the next owner have agreed upon, and both of them sign all three copies. The seller keeps one, sends one to the artist with the 15 percent payment (if required), and gives one to the new owner along with a copy of the original agreement, so he will know his responsibilities to the artist and have the TAR form if the work is resold again.

The Dealer

If you have a dealer, he will be very important in developing your use of the contract. He should make use of the contract a policy of the gallery, thereby giving the artists in the gallery collective strength against those collectors and institutions who don't really have the artist's interests at heart.

Remember, your dealer knows all the ins and outs of the art world: he knows the ways to get the few reluctant buyers to sign the contract—the better the dealer, the more ways he knows. He can do what he does now when he wants something for one of his artists—give the collector favors, exchange privileges, discounts, hot tips, advice, time and all the other things buyers expect and appreciate. It even gives him an opportunity to raise the subject of prospective increase in the value of your work without seeming crass.

The contract helps dealers do what they try to do now anyway. Dealers try to keep track of the work they have sold, but now they can only rely on hit-or-miss intelligence and publicity. The contract creates a simple record system which will automatically maintain a biography of each work and a chronological record of ownership. It makes giving a provenance no trouble at all. And it's almost costless to administer—only another few minutes of typing for each sale.

Using the contract is mostly a state of mind. If your dealer doesn't think the benefits of the contract are important, he will have dozens of reasons why he can't get the buyers to sign it; if he cares and wants those benefits for you, he'll use it every time and he won't lose a sale.

The Facts of Life: You, the Art World, and the Contract

The vast majority of people in the art world feel that this idea is fair, reasonable, and practical. Reservations about using the contract can be summed up in two basic statements:

(1) "The economics of buying and selling art is so fragile that if you place one more burden on the collectors of art, they will simply stop buying art"; and

(2) "I will certainly use the agreement, but only if everyone else uses it."

The first statement is nonsense. Clearly, the art will be just as desirable with as without the contract, and there's no reason why the value of any work should be affected, especially if this contract is standard for the sale of art, which brings us to the second statement. If there's a problem here, it's the concern of artists or dealers that the insistence on use of this contract will jeopardize their sales in a competitive market. Under careful scrutiny, this proves to be mostly illusory.

All artists sell, trade, and give their work to only two kinds of people:

(1) those who are their friends;

(2) those who are not their friends.

Obviously, your friends won't give you a hard time. The only trouble will come with someone who isn't your friend. Since surely 75 percent of all serious art that's sold is bought by people who are friends of the artist or dealer—friends who drink together, weekend together—resistance will come only in some of the 25 percent of your sales to strangers. Of those people, most will wish to be friendly with you and won't hesitate to sign the contract to show their respect for your ongoing relationship with your work. This leaves perhaps 5 percent of your sales which encounter serious resistance over the contract, and even this should decrease toward zero as the contract comes into widespread use.

In short, this contract will help you discover who your friends are.

If a buyer wants to buy but doesn't want to sign, tell him that all your work is sold under the contract, that it's standard for your work.

You can point out to the reluctant buyer:

The contract doesn't cost anything unless your work appreciates in value; most art doesn't;

If he makes a profit on your work, you get only a small percentage of it—about the equivalent of a waitress's tip;

If you like you can offer to take your prospective 15 percent payment in something other than money, or to give him a partial credit against a new work;

Or you can offer to put in an original value that's more than what he's paying, giving him a free ride on part of any prospective profit.

Of course, if a collector buys a work refusing to sign the contract, he will have to rely on goodwill when he wants you or your dealer to appraise, restore, or authenticate it. Why he should expect to find good will there is anybody's guess.

Is the buyer really going to pass up your work because you ask him to sign the contract? Work that he likes and thinks is worth having? If the answer is "Yes," given the fact that it doesn't cost him a thing to give you, the artist, the respect that you as the creator of the work deserve—if that will keep him from buying, he is too stubborn and foolish for anyone to tell you how to enlighten him. Nonuse of this contract is a dumb criterion for selecting art.

Enforcement

First, let's put this in perspective: most people will honor the contract because most people honor contracts. Those who are likely to cheat you are likely to be the same ones who gave you a hard time about signing the contract in the first place. Later owners will be more likely to cheat you than the first owner, but there are strong reasons why both first and future owners of your work should fulfill the contract's terms.

What happens if owner No. 1 sells your work to owner No. 2 and doesn't send you the transfer form? (He's not sending your money, either.)

Nothing happens. (You don't know about it yet.)

Sooner or later, you do find out about it because the grapevine will get the news to you (or your dealer) anyway. Then, if owner No. 1 doesn't come across, you can sue him. He will be stuck for 15 percent of the profit he made or 15 percent of the increase in value to the time you heard about it, which may be much more. Also, if you have to sue to enforce any right under the contract, Paragraph 14 gives you the right to recover reasonable attorney's fees in addition to any other remedy to which you may be entitled. Clearly, owner No. 1 would be foolish to take the chance.

As to falsifying values, there will be as much pressure from new

owners to put in high values as there is from old owners to put in low values. In 95 percent of the cases, the amount of money to be paid the artist won't be enough to make them lie to you (in unison).

Summary

We realize this contract, like its predecessor, will disturb some dealers, museums, and high-powered collectors, but the ills it remedies are universally acknowledged to exist and no other practical way has ever been devised to cure them.

Its purpose is to put you—the artist—in the same position as the man behind the rent-a-car counter. He didn't write his contract, either, but he says: If you want it, sign here. You do the same.

Using this contract doesn't mean all your art world relationships will be strictly business hereafter or that you have to enforce every right down to the last penny. Friends will be friends and if you want to waive your rights you can, but they will be *your* rights and the choice will be *yours*.

The contract in its prior form has been used by many artists—known, well-known, and unknown. Use it. It's enforceable. The more artists and dealers who use it, the better and easier it will be for everybody to use it. It requires no organization, dues, meetings, registration, or government agency—just your desire to protect the integrity of your art.

What it gives you, the artist, is a legal tool you can use to establish continuing rights in your work at the time you transfer it, but whether or not you use the contract is up to you. Consider the contract as a substitute for what is available otherwise: nothing.

This has been created for no recompense to the author, but just for the pleasure of attacking a challenging problem. It is based on the feeling that should there ever be a question about artists' rights in reference to their art, the artist is more right than anyone else.

ARTIST'S RESERVED RIGHT TRANSFER AND SALE AGREEMENT

Agreement of Original Transfer of Work of Art

Artist: _____ Address: _____
Purchaser: _____ Address: _____

WHEREAS Artist has created a certain Work of Art (hereinafter, "the Work"):
Title: _____ Dimensions: _____
Medium: _____Year:_____

WHEREAS the parties want the Artist to have certain rights in the future economics and integrity of the Work. The parties mutually agree as follows:

1. SALE. Artist hereby sells the Work to Purchaser at the agreed value of $_____ (_____ Dollars).

2. RETRANSFER. If Purchaser in any way whatsoever sells, gives, or trades the Work, if it is inherited from Purchaser, or if a third party pays compensation for its destruction, Purchaser (or the representative of his estate) must within thirty (30) days:
 a. Pay Artist fifteen (15) % of the "gross art profit," if any, on the transfer; and
 b. Get the new owner to ratify this contract by signing a properly filled-out "Transfer Agreement and Record" (TAR); and
 c. Deliver the signed TAR to the Artist; and
 d. "Gross art profit" for this contract means only: "Agreed value" on a TAR less the "agreed value" on the last prior TAR, or (if there hasn't been a prior resale) less the agreed value in Paragraph 1 of this contract.
 e. "Agreed value" to be filled in on each TAR shall be the actual sale price if the Work is sold for money or the fair market value at the time, if transferred any other way.

3. NONDELIVERY. If the TAR isn't delivered in thirty (30) days, Artist may compute "gross art profit" and Artist's fifteen (15) % as if

it had, using the fair market value at the time of the transfer or at the time Artist discovers the transfer.

4. NOTICE OF EXHIBITION. Before committing the Work to a show, Purchaser must give Artist notice of intent to do so, telling the Artist all the details of the show that Purchaser then knows.

5. PROVENANCE. Upon request, Artist will furnish Purchaser and his successors a written history and provenance of the Work, based on TAR's and Artist's best information as to shows.

6. ARTIST'S EXHIBITION. Artist may show the Work for up to sixty (60) days once every five (5) years at a nonprofit institution at no expense to Purchaser, upon written notice no later than one hundred twenty (120) days before opening and upon satisfactory proof of insurance and prepaid transportation.

7. ARTIST'S ACCESS. Artist may have access to photograph the Work at no expense to Purchaser and upon reasonable notice to Purchaser.

8. NONDESTRUCTION. Purchaser will not permit any intentional destruction, damage, or modification of the Work. Upon Purchaser's request, the Artist will supply Purchaser with a Statement of Maintenance for the Work.

9. RESTORATION. If the Work is damaged, Purchaser will consult Artist before any restoration and must give Artist first opportunity to restore it, if practicable.

10. RENTS. If the Work is rented, Purchaser must pay Artist fifty (50) % of the rents within thirty (30) days of receipt.

11. REPRODUCTION. Artist reserves all rights to reproduce the Work.

12. NOTICE. A Notice, in the form below, must be permanently affixed to the Work, warning that ownership, etc., is subject to this contract. If, however, a document represents the Work or is part of the Work, the Notice must instead be a permanent part of that document.

13. TRANSFEREES BOUND. If anyone becomes the owner of the Work with notice of this contract, that person shall be bound to all its terms as if he had signed a TAR when he acquired the Work.

14. EXPIRATION. This contract binds the parties, their heirs, and all their successors in interest, and all Purchaser's obligations are attached to the Work and go with ownership of the Work, all for the life of the Artist and Artist's surviving spouse plus twenty-one (21) years, except the obligations of Paragraphs 4, 6, 7, and 9 shall last only for Artist's lifetime.

15. ATTORNEY'S FEES. If any proceeding to enforce any part of this contract, the aggrieved party shall be entitled to reasonable attorney's fees in addition to any available remedy.

16. MORAL RIGHT. The Purchaser will not permit any use of the Artist's name or misuse of the work which would reflect discredit on his/her reputation as an artist, or which would violate the spirit of the Work.

17. ADDRESS NOTICE. All notices to the Artist shall be delivered to _____. and notices to the Purchaser to _____. Either party shall notify the other party in case of change of address prior to such change.

18. Unless otherwise noted, the Work was received by the Purchaser in perfect condition.

DATE: _____ _____

 (Artist's Signature)

 (Purchaser's Signature)

TRANSFER AGREEMENT AND RECORD

Title: _____ Dimensions: _____
Medium: _____Year: _____
Ownership of the above Work of Art has been transferred between the undersigned persons, and the new owner hereby expressly ratifies, assumes, and agrees to be bound by the terms of the Contract dated _____between:
Artist: _____ Address: _____and
Purchaser: _____ Address: _____
Agreed value (as defined in said contract) at the time of this transfer:
$_____ (_____ Dollars).
Old owner: _____ Address: _____
New owner: _____ Address: _____
Date of this transfer: _____

SPECIMEN NOTICE	cut out, affix to Work NOTICE
Ownership, transfer, exhibition, and reproduction of this Work of Art are subject to a certain Contract dated_____ between: Artist: _____ Address: _____ and Purchaser: _____ Artist has a copy.	Ownership, transfer, exhibition, and reproduction of this Work of Art are subject to a certain Contract dated_____ between: Artist: _____ Address: _____ and Purchaser: _____ Artist has a copy.

APPENDIX 5

SAMPLE INSTALLMENT SALES AGREEMENT

Note: This sample installment sales agreement, like the other sample contracts included in these appendices, is general as to form. Your specific circumstances may require a different agreement. It would be impossible to foresee every contingency that might occur in every individual or specific case. State laws vary, and while this sample agreement reflects general principles at the time of its writing, laws change. Therefore, before entering into any contractual relationship, you should consult a lawyer knowledgeable in this area.

AGREEMENT OF INSTALLMENT SALE OF WORK

Artist: _____ Address: _____ Phone: ____
Purchaser: _____ Home Address: _____
 Business Address: _____Home Phone: _____
 Business Phone: _____

 WHEREAS Artist has created a certain Work of Art (hereinafter, "the Work"):
Title: _____ Dimensions: _____
Medium: _____ Year: _____
Installation (frame, base, etc.): _____

WHEREAS the Parties want the Artist to have certain rights in the future economics and integrity of the Work. The Parties mutually agree as follows:

1. SALE. The Artist hereby sells the Work to the Purchaser, subject to the conditions herein, at the agreed price of $_____ (_____ dollars), payable as follows:

> $_____ (_____ dollars) upon the execution of this Agreement.
>
> _____ (___) subsequent payments of $_____ (_____ dollars) each, due and payable on the _____ day of each month, beginning on _____, 19___, and ending_____.

a. Title to the Work shall remain with the Artist until he/she is paid in full, at which time title shall pass directly to the Purchaser.

b. The Work shall be delivered to the Purchaser's address listed herein upon _____ [enter "the execution of this Agreement," or "final payment" or "_____ (___) consecutive payments"].

c. The costs of delivery of Work to Purchaser (including packing, transportation, and insurance) shall be paid by the _____.

d. If Work is delivered to the Purchaser before final payment is made, the Work shall be held in trust for the benefit of the Artist, and shall not be subject to claim by a creditor of the Purchaser. In the event of any default by the Purchaser, the Artist shall have all the rights of a secured party under the Uniform Commercial Code.

e. The Purchaser shall pay all applicable taxes on the Work with the final payment, notwithstanding anything to contrary herein.

f. If the Purchaser fails to make any payment within _____ (___) days when due, the Artist reserves the right to charge interest at the rate of _____%.

g. If the Purchaser fails to make _____ (___) consecutive payments, the Artist reserves the right to terminate this Agreement upon written notification to the Purchaser. In case of such termination:

> (1) The Work will be returned to the Artist within fourteen (14) days.
>
> (2) The Purchaser will consult with the Artist regarding the safe and proper method of return.
>
> (3) The cost of returning the Work to the Artist (including packing, transportation, and insurance) shall be paid by the Purchaser.

(4) The Purchaser shall pay all applicable taxes on the work then due.

(5) The Purchaser will return the Work in the same condition he/she received it in. If Artist deems that Work has been damaged, altered, or modified while in the Purchaser's care, all costs of repair shall be paid by the Purchaser.

(6) All payments already made by the Purchaser at the time of termination shall be _____.*

Note: The rest of this Installment Sales Agreement should include your version of the Sample Transfer Agreement and Record, Paragraphs 2–18, plus, of course, the appropriate signatures and date of signing (see Appendix 4). In other words, an Installment Sales Agreement is basically a standard Resale Contract: only Paragraph 1 is different.

*Indicate how you wish the money to be handled: whether you will allow the Purchaser to return Work in exchange for work(s) equal to the amount of payments already made; whether you will return the payments to the Purchaser *minus* "rental" fees determined as $_____ per month, etc.

APPENDIX 6

SAMPLE
CONSIGNMENT SHEET

Note: As mentioned in Chapter 3, you should never leave work on consignment without obtaining a receipt. The following Consignment Sheet can serve as such a receipt. You should adapt it to suit your own needs and particular situation.

Remember, this Sample Consignment Sheet is not really needed if you have a contract with a gallery similar to the contract given in Appendix 2. "Schedule A" of that Sample Artist–Gallery Agreement serves as your receipt.

In other words, the following Sample Consignment Sheet is intended to be used with those galleries and dealers with whom you do not have a contract.

A Consignment Sheet may, in fact, be the only written agreement you have with many dealers. So make sure your Consignment Sheet includes all protections you desire.

Artists should feel free to photocopy and enlarge this Sample Consignment Sheet for their individual use.

CONSIGNMENT RECEIPT SHEET

Date: _____ Received from: _____ the Following Works of Art on Consignment:

Title/Description:	Date:	Medium:	Dimensions:	Edition #: (if print)	Installation: (frame, base, etc.)	Retail Price: "Framed" "Unframed"	Commission: (consignee's %)	Net Due Artist:
1.								
2.								
3.								
4.								
5.								
6.								
7.								
8.								
9.								
10.								

1. The above works were received in perfect condition unless otherwise noted.
2. Payment to the artist for work sold will be completed within 30 days of purchaser's payment to consignee. Name and address of the purchaser will be given to the artist. The artist may withdraw his/her works on demand of 30 days notice. The consignee may return works on demand of 30 days notice.
3. Consignee assumes full responsibility for work lost, stolen, or damaged by any possible cause while in the consignee's possession.
4. Consignee assumes the risk of customers' credit. All losses due to bad credit are to be born by the consignee.
5. The artist reserves copyright including all reproduction rights to the above works.

6. Title to the above works shall remain with the artist until he/she is paid in full, at which time title shall pass directly to the purchaser.
7. None of the above works may be removed from the consignee's premises for the purposes of rental, installment sales, and/or approval sales without the artist's written consent.
8. The retail price of the above works may not be changed without the artist's written consent.
9. The consignee shall not intentionally commit or authorize any physical defacement, mutilation, alteration, or destruction of any of the above works.
10. The consigned works shall be held in trust for the benefit of the artist, and shall not be subject to claim by a creditor of the consignee. In the event of any default by consignee, the artist shall have all the rights of a secured party under the Uniform Commercial Code.

Artist's Signature: _____ Phone #: _____
Artist's Address: _____

Consignee's Signature: _____ Phone #: _____
Consignee's Address: _____
Consignee's/Gallery's Name: _____

© Toby Judith Klayman, *The Artists' Survival Manual*, 1984.

SAMPLE BILL OF SALE

BILL OF SALE

Date:_____

Artist's Name:_____ Address:_____ Phone:_____

Purchaser's Name:_____ Address:_____ Phone:_____

Business Business

Address:_____ Phone:_____

Description of Work: [Title, date completed, size, medium, including
or not including frame, base, etc.]

Purchase Price: $_____(_____Dollars)

Sales Tax (if applicable): $_____(_____Dollars)

Delivery or Shipping Charges

(if applicable): $_____(_____Dollars)

BALANCE DUE: $_____(_____Dollars)

Terms of Sale: [If the sale of this work is covered by a Resale Con-
tract, an Installment Sales Agreement, or any other
contract, then the Terms of Sale here should state: "The
sale of this artwork is also subject to an Agreement
signed on such and such a date." If the sale of the work
is *not* covered by any such contract, then the Terms of
Sale here should include those clauses of the Resale
Contract you consider most important, such as your
copyright protection, the nondestruction clause, etc.]

_____ _____
Artist's Signature Purchaser's Signature

APPENDIX 8

SAMPLE RÉSUMÉ

CLARA SIMON

Biographical Information

Born: 1942. Albany, New York.
Education: B.A., *summa cum laude*, University of Pennsylvania, 1964.
Current Address: 252 Waller Street, San Francisco, California 94102
Telephone: 415 289-5323.

Solo Exhibitions

1971 Nathan Gallery. San Francisco. Paintings, drawings, and watercolors.
1972 Marcus Gallery. Los Angeles. Paintings and watercolors.
1972 Caleb Williams Gallery. Palo Alto, California. Paintings, drawings, and watercolors.
1976 Gallery of Contemporary Art. New York City. Paintings.
1979 Downtown Graphics. San Francisco. Serigraphs.

Selected Group Exhibitions

1969 Nathan Gallery. San Francisco. Watercolors on exhibit.
1970 David Brown Gallery. Larkspur, California. Group painting show.
1973 Women's Building. Los Angeles. "Contemporary Ameri-

can Women Printmakers." (Traveling Exhibition: to Santa
Fe, Phoenix, Salt Lake City, Dallas, and Houston.)
1975 Jameson Graphics. Chicago. Serigraphs on exhibit.
1977 San Francisco Museum of Modern Art Rental Art Gallery.
San Francisco. Paintings and watercolors on exhibit.
1980 Nathan Gallery. San Francisco. Anniversary Group Show.

Selected Awards and Prizes

1972 San Francisco Art Commission. City of San Francisco. Pur-
chase Award for painting.
1978 California Arts Council. State of California. Artists-in-Res-
idence Grant.
1981 National Endowment for the Arts. Artists' Fellowship Award.
1981 Los Angeles Art Festival. Second Prize: Watercolors.

Selected Public Collections

1978 Pacific Telephone. San Francisco. Serigraphs.
1978 San Francisco Museum of Modern Art. San Francisco.
Painting.
1980 Bank of America. Los Angeles. Watercolors.
1982 Stanford University Museum. Stanford, California. Paint-
ing.

Selected Bibliography

Friedlander, Morris. "Clara Simon: Purism and Primitivism," *San
Francisco Chronicle,* December 25, 1971, page 35.
Link, Richard. "Clara Simons: Arresting Fantasy." *American Art-
ist,* January–February, 1973, pages 44–47.
MacIntyre, Ted. "The Art of Clara Simon," *Los Angeles Times,*
June 19, 1975, page 77.

Teaching and Lecturing

1970–74 San Francisco Community College. Art Department.
Instructor in drawing, painting, and printmaking.

1975–present	San Francisco State University. Art Department. Instructor in painting and printmaking. Tenure granted June 1980.
1979	Guest Lecturer, "Legal Rights for Artists," Art Department, University of California at Berkeley.
1980	Guest Lecturer, "From the Workbench to the Collector: Thoughts on Being an Artist," Art Department, Stanford University; Palo Alto, California.
1981	Panel Member, "Showing and Selling Your Artwork," Printmaking Department Symposium, San Francisco Art Institute.

Professional Affiliations

1971–present	Artists Equity. National and Local Chapters.
1972–present	Foundation for the Community of Artists. New York City.
1974–present	Women's Caucus for Art.
1979–present	Visual Artists and Galleries Association (VAGA). New York City.

INDEX